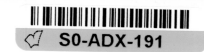
PETER VOULKOS

1. *(overleaf) Voulkos at a demonstration, 1976. (Photographer: Ryusei Arita)*

PETER VOULKOS

A Dialogue with Clay

Rose Slivka

New York Graphic Society
in association with American Crafts Council

First Edition

T 03/78

LIBRARY OF CONGRESS CATALOGING IN PUBLICATION DATA
Slivka, Rose.
 Peter Voulkos: a dialogue with clay.
 Bibliography: p.
 1. Voulkos, Peter. 2. Sculptors—United States—
Biography. I. Title.
NB237.V64S58 1978 730′.92′4 [B] 77–17166
ISBN 0-8212-0712-1

Designed by Susan Windheim

New York Graphic Society books are published by Little, Brown and Company.
Published simultaneously in Canada by Little, Brown and Company (Canada) Limited.

Printed in the United States of America

Preface

This is the most extensive book on a major figure in modern American crafts. It surveys the range of the Voulkos oeuvre—the ceramics, bronzes, and paintings—from 1948 to 1978. My intention is to extend the experience of encounter with the work by bringing into focus the energies that made it possible—in the artist, in the man, and in his times. The retrospective exhibition of Peter Voulkos organized by the Museum of Contemporary Crafts was the springboard for the publication of this book, which documents the content of the exhibition as well as works and acts that go beyond the scope of the show.

To write about a man as beloved and widely known as Peter Voulkos—whose art is so integrated into his ways and life-style—is a singular experience. His generosity in making himself accessible to the clay community, to the art world, and to his students has been phenomenal. Over the last twenty years he has made more than two hundred appearances in lecture/demonstrations, seminars, juries, panel discussions, has taught more than ten thousand students, has had twenty one-man shows, participated in more than one hundred group shows, and has been a nucleus to which artists everywhere gravitate. This, then, is a book about an artist who is probably known personally, at firsthand, by more people than any artist ever before. The situation is unique to Voulkos and to his times in this immense country, yet natural for this artist.

In discussing the Voulkos legend—and he is by now a legend—with his many contemporaries, I found considerable variations in facts, dates, and interpretations. Experience is subjective, and Voulkos has been and is an experience. Whenever discrepancies persisted, I went to the artist as final arbiter, drawing on his interpretation and his intentions. But as everyone who knows Peter Voulkos knows, it is not easy to pin him down.

I am grateful to my associates at the American Crafts Council for the important roles they played in the preparation of this book. I wish to thank Paul Smith, director of the Museum of Contemporary Crafts, of the American Crafts Council, for his generous cooperation and collaboration on every level; Lois Ladas, whose early research for the exhibition made it possible to trace the bulk of the works; Lois Moran, director of the Research and Education Department of ACC, for her always constructive outlook and advice; Aileen Osborn Webb, for what has been a lifetime of enthusiasms; Donald Wyckoff for his support during the initial stages of the project.

PETER VOULKOS

v

Many people across the country provided invaluable help. My thanks to Don Ackland for believing in this book; Ann Adair Stockton for her help and many kindnesses to me during my visits to Voulkos; Pauline Annon, John Mason, James Melchert, Ed Primus, Vaea, and Bryon Wahl for their interest in the project and their very special contributions to it; Fred Marer and Susan Peterson for their valuable criticisms of the manuscript; Susan Foley and Henry Hopkins of the San Francisco Museum of Modern Art, Jan de Vries, recent director of Contemporary Crafts Association, Portland, Oregon, and Ruth Braunstein, of Braunstein/Quay Gallery, for their cooperation and resources; Otis Cavrell for his insight into my work.

My *Craft Horizons* co-workers were a constant source of spiritual support and practical assistance. My thanks to Pat Dandignac, managing editor of the magazine, my steadfast colleague and friend, for her valuable suggestions; to Mary Jane Fortunato for her fine rendition of the manuscript and photographic files; to Cathy Sidwaski, who labored with me nights and weekends, and with whose grace and patience we finally got things done.

A large debt of gratitude goes to Betty Childs for her skills and understanding as my editor at the New York Graphic Society; and to the National Endowment for the Arts for its grant toward the preparation of the color reproductions.

Above all, I wish to thank my children, Marc and Charlotte Slivka, for their radiant support and encouragement throughout this project—literally "for the love of Pete"—for their dependability and independence which made it possible for me to take my distance from the immediate pressures of day-to-day living in order to write this book.

Rose Slivka
New York, November 1977

Contents

PETER VOULKOS

Illustrations in Black and White

1924 Born January 29 in Bozeman, Montana, the third of five children of Greek-born parents, Efrosine and Harry Voulkos.

1941 Graduates from Gallatin County High School.

1941–1943 Apprentice molder making parts for Liberty ships.

1943–1946 Serves in U.S. Army Air Force as a nose gunner in the Pacific theater.

1946 Enters Montana State University, planning to major in art.

 Meets Rudy Autio.

 Studies painting with Robert De Weese, pottery with Frances Senska, and printmaking and painting with Jessie Wilber.

1949 Develops wax-resist techniques with inlaid and raised lines for painting and drawing on pottery. Receives first prize for pottery, Montana State Fair, Great Falls; wins Potters Association Prize, Ceramics National Exhibition, Syracuse, New York; continues to exhibit and win prizes in this important annual until 1958.

1951 Receives BS degree from Montana State University.

1950–1952 Goes to California College of Arts and Crafts, Oakland, for graduate studies in ceramics and sculpture; graduate thesis on lidded jars.

 Meets sculptor Manuel Neri.

1952 Receives MFA degree.

 Returns to Bozeman and meets Archie Bray, Sr. With Rudy Autio, establishes a ceramic workshop at the Archie Bray Foundation, teaching and producing pottery and working in the brickyard of Archie Bray's adjoining factory in Helena, Montana. Meets Shoji Hamada and Bernard Leach at the Archie Bray Foundation.

 One-man show at Gump's, San Francisco, and at America House, New York.

 First prize for pottery, Wichita Decorative Arts Annual show, Wichita, Kansas; continues to exhibit and win prizes in this show until 1959.

1953 Teaches three-week summer session at Black Mountain College, Asheville, North Carolina, at the invitation of Karen Karnes and David Weinrib. Meets Josef Albers, M. C. Richards, John Cage, Merce Cunningham, and other leaders of the American avant-garde.

 Visits New York City and stays with M. C. Richards. Meets Franz Kline and other abstract expressionists.

 Exhibits at the University of Florida, Gainesville.

 Returns to the Archie Bray Foundation, continues making production pottery and conducts workshops with guests Marguerite Wildenhain, F. Carlton Ball, James and Nan McKinnell, and others. One-man show at the Oregon Ceramic Studio, Portland.

1954 Moves to Los Angeles to become chairman of the new Ceramics Department, Otis Art Institute, Los Angeles, at invitation of director Millard Sheets.

Organizes and builds physical facilities with first student, Paul Soldner. Builds kilns with ceramics engineer Mike Kalan.

Group forms around Voulkos, including Billy Al Bengston, Michael Frimkess, John Mason, Malcolm McLain, Kenneth Price, Jerry Rothman, and Henry Takemoto.

Meets collector Fred Marer and artists Arthur Ames, Leonard Edmondsen, Richards Ruben, among others.

1955 Receives Gold Medal, International Exposition of Ceramics, Cannes, France, the sole American to be so recognized.

Begins to break with classical pottery forms; collages elements on plates and pots and adds slabs for surface relief.

Sees show of Fritz Wotruba's sculpture at Los Angeles County Art Museum, an important influence.

Is exposed to the mainstream of contemporary American art in museums and galleries.

Teaches summer session at the Archie Bray Foundation, Helena, where he begins to experiment with stacked forms.

Begins to manipulate and combine thrown and slab elements and to cut through surfaces.

1956 Continues to develop stacked construction of thrown and manipulated spheres, cylinders, and slabs.

One-man show, Felix Landau Gallery, Los Angeles.

Begins study of the guitar with Theodore Norman.

Receives commission for ceramic construction for Kaiser Hawaiian Village, Honolulu.

1957 One-man show, University of Southern California.

One-man show, Art Institute of Chicago.

Ceramics and painting exhibition at the Museum of Contemporary Crafts, New York.

Speaker at First National Conference, American Crafts Council, Asilomar, California.

Shares studio on Glendale Boulevard, Los Angeles, with John Mason; facilities include walk-in kiln, painting studio.

Begins work on major ceramic sculptures.

1958 Speaker at Second National Conference, American Crafts Council, Lake Geneva, Wisconsin.

Teaches ceramics and sculpture classes at the University of Montana, Missoula.

Second one-man show of ceramics and painting, Felix Landau Gallery, Los Angeles.

Initiates the use of epoxy paints for color along with slips and glazes.

With students, starts gallery in Los Angeles called "The Ivory Tower."

Exhibits at World's Fair (U.S. Pavilion, "Contemporary American Art"), Brussels.

1958–1959 Produces major ceramic sculptures.

1959 One-man show of large ceramic sculptures and abstract expressionist paintings at Pasadena Art Museum.

Appointed assistant professor of ceramics, University of California, Berkeley, where he installs facilities for ceramics department.

Receives commission for *Gallas Rock.*

Speaker at American Craft Council's Third National Conference, Lake George, New York.
Meets sculptor David Smith.

Teaches summer session at University of Montana, Missoula.

Wins silver medal, International Ceramics Exhibition, Ostend, Belgium.
Wins Rodin Museum Prize for sculpture, First Paris Biennale, Musée National d'Art Moderne, Paris.

Third one-man show of ceramics and painting at the Felix Landau Gallery.

1960 One-man show of major ceramic sculpture and painting, Museum of Modern Art, New York.

Starts bronze-casting foundry called "Garbanzo Works" with Don Haskin and Harold Paris.

Meets ceramic artist Vaea, who becomes Voulkos's technical teaching assistant at the university.

1960–1964 Teaches summers in New York at Greenwich House Pottery and at Teachers' College, Columbia University.

1961 Completes and installs *Gallas Rock* for Mr. and Mrs. Digby Gallas.

Establishes studio on Shattuck Avenue, Berkeley.

One-man show of bronze sculptures, ceramics, and paintings at Primus-Stuart Gallery, Los Angeles.

New group forms around Voulkos, including Robert Arneson, Clayton Bailey, Steven De Staebler, Robert Hudson, Marilyn Levine, James Melchert, Ron Nagle, Richard Shaw, Vaea, Brian Wahl.

1962 Completes major bronze sculpture, *Lady Remington*, 8 × 10 × 4 feet, and installs at the Litton Savings & Loan, Pomona, California.

Participates in major group exhibitions:
 Third International Ceramic Exhibition, Prague
 "Forms of the Earth," Museum of Contemporary Crafts, New York
 "Fifty California Artists," Whitney Museum of American Art, New York
 "The Molten Image," San Francisco Museum of Modern Art.

Receives sculpture commission for San Francisco apartment house.

1963 "Creative Casting" exhibition, Museum of Contemporary Crafts, New York, New York.

Receives Ford Foundation Purchase Grant for bronze sculpture, *Honk*, 4 × 7 × 4 feet, installed at the Pasadena Art Museum.

Moves studio to warehouse on Third Street, Berkeley.

1964 One-man show of slashed, cracked, and painted ceramics at Hansen-Fuller Gallery, San Francisco.

Speaker at First Conference of World Crafts Council at Columbia University, New York.

Completes *Vargas II*, bronze with wood base and steel wheels, 8 × 8 × 5 feet, and installs at the Phoenix Art Museum.

Completes *Bad Day at Shattuck*, bronze, 4 × 6 × 3 feet, and installs at the home of Mr. and Mrs. Monte Factor, Beverly Hills.

Completes *Big Remington III*, bronze and steel with wood base and steel

wheels, 7 × 9 × 5 feet, and installs at La Jolla Museum of Contemporary Art, La Jolla, California.

"California Sculpture Today," Kaiser Center, Oakland.

"The American Craftsman," Museum of Contemporary Crafts, New York.

1964–1965 Participates in International Exhibition of Contemporary Ceramic Art, National Museum of Modern Art, Tokyo.

One-man show, Los Angeles State College.

1965 One-man show of four major ceramic sculptures and six bronze sculptures at the Los Angeles County Museum of Art.

Participates in "White House Festival of the Arts," Washington, D.C.

Completes *Big A,* bronze and aluminum, 6½ × 6 × 4 feet, and installs at City Mall, Fresno.

Completes *Dunlop,* bronze sculpture, 7 × 3 × 4 feet, and installs at the Albany Mall, Albany, New York.

1966 Wins sculpture competition for San Francisco's Hall of Justice commission.

Exhibits in "Abstract Expressionist Ceramics," University of California, Irvine.

Los Angeles County Museum of Art purchases *Firestone,* 6 feet 8 inches × 6 × 4 feet, bronze and aluminum.

1967 Travels to Italy for five weeks. Visits artists Arnoldo Pomodoro, Lucio Fontana, and others.

Returns to Berkeley and starts series of black pots.

Completes *Pirelli,* bronze sculpture, 7½ × 13 × 6 feet, and installs at the home of Stephen D. Paine, Boston.

One-man show of bronzes at the David Stuart Gallery, Los Angeles.

Exhibits in "American Sculpture of the Sixties," Los Angeles County Museum of Art.

1968 Receives Doctorate of Humane Letters from Montana State University, Bozeman.

One-man show of black pots, Quay Gallery, San Francisco.

Completes *Solea,* copper-nickel, Monel, and bronze, 10 × 6½ × 4 feet, and installs at Long Beach Museum of Art, Long Beach, California.

1969 Exhibits large bronze sculpture, *Osaka,* 10 × 40 × 12 feet, in the San Francisco Pavilion at the World's Fair in Osaka, Japan.

Completes *Taranta,* copper-nickel, Monel, and bronze, 8 × 6 × 4 feet, and installs at the Johnson Wax Co., Racine, Wisconsin.

Gives many lecture demonstrations and serves as juror for exhibitions throughout the country.

1970 Exhibits in Sculpture Annual, Whitney Museum of American Art, New York.

Completes *Mr. Ishi,* bronze sculpture, 20 × 40 × 5 feet, and installs at the Oakland Museum.

Completes *Hiro II,* copper-nickel, Monel, and bronze, 8 × 27 × 8 feet, and installs at the San Francisco Museum of Modern Art.

1971 Completes bronze sculpture, 30 feet high, and installs at the Hall of Justice, San Francisco.

PETER VOULKOS

Completes *Return to Piraeus,* copper-nickel and Monel, 30 × 20 × 16 feet, and installs at University of California Art Museum.

1972 Completes *Miss Nitro,* 70 feet long, and installs at Highland Park, Illinois.

"Voulkos and Co.," 16mm motion picture produced by University of California Extension, Berkeley, directed by Susan Fanschel, under a grant from the National Endowment for the Arts.

Begins first edition of 200 plates.

Receives honorary doctorate of fine arts from the California College of Arts and Crafts, Oakland.

1973 One-man show of ceramics at Pasadena City College.

Participates in International Ceramics Symposium and Exhibition, Banff College of Art, Banff, Canada.

1974 One-man show of ceramic plates and forms at the Quay Gallery, San Francisco.

One-man show of ceramics at Sacred Heart School, Menlo Park, California.

Exhibits in:
 Sculpture Annual, Whitney Museum of American Art, New York
 "Public Sculpture/Urban Environment," Oakland Museum.

Plate acquired by the National Collection of Fine Arts, Smithsonian Institution, Washington, D.C.

1975 One-man exhibitions of recent series of plates, "drawings," stacked forms, and pots at: Kemper Gallery, Kansas City Art Institute; Helen Drutt Gallery, Philadelphia; Fendrick Gallery, Washington, D.C.; Braunstein/Quay Gallery, New York.

Appointed to the Academy of Fellows of the American Crafts Council.

Shows ceramic sculpture at The National Collection of Fine Arts, Smithsonian Institution, Washington, D.C.

Installs *Osaka,* 40 feet long, at E. B. Crocker Art Gallery, Sacramento.

Receives commission for large outdoor sculpture for Federal Building, Honolulu, General Services Administration, US Government.

1976 Gives demonstrations at Tenth Annual Super Mud Conference, Pennsylvania State University.

Participates in seminar at World Crafts Council General Assembly, Oaxtepec, Mexico.

Produces new edition of pottery with pass-throughs and zits.

Receives grant from National Endowment for the Arts.

1977 One-man exhibition of ceramics at Contemporary Craft Association, Portland, Oregon.

Installs *Barking Sands,* bronze sculpture, 25 feet long, in Honolulu.

1978 Retrospective exhibition organized by the American Crafts Council and the Museum of Contemporary Crafts; showing at the San Francisco Museum of Modern Art; Contemporary Arts Museum, Houston; Milwaukee Art Center; and Museum of Contemporary Crafts, New York.

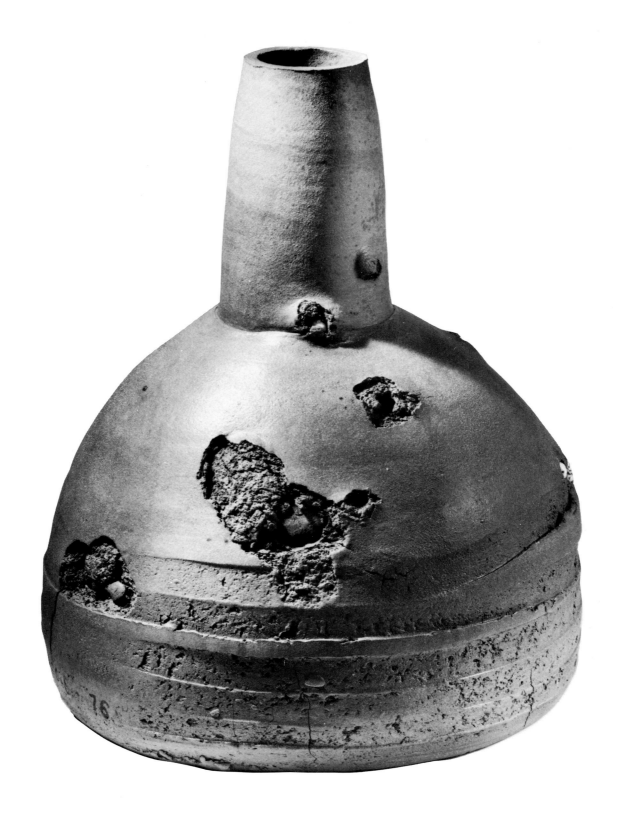

Introduction

2. (overleaf) Vase, 1977
Made in Berkeley; stoneware with "patches" of clay and/or porcelain pass-throughs; heavily grogged clay, wheel-thrown in two sections; iron wash, lightly sprayed with clear glaze; 36 inches high. (Collection of Mr. and Mrs. Joseph Nadel. Photographer: Joseph Schopplein)

Peter Voulkos is both the innovator and the medium for what has happened in the last thirty years in the creative hybridization of the crafts. In the course of his own unique development, he has opened new territories for the artists and craftsmakers, not only in this country but in the world. Using traditional pottery techniques, he created an unprecedented ceramic sculpture, joining craft and art in an inseparable unity, extending the vistas for both intentions. He was the first of the new breed of artists who cross all lines from craft to art and vice versa.

He communicated the magic of clay, its nature and possibilities, and more than that, the excitement of working it.

The first one to tell me about Voulkos with the enthusiasm of discovery was the painter Herman Cherry in 1956 on his return from a visit to Los Angeles. Cherry described "a quiet, wiry Greek who punches his pots." Of course, we had been hearing about Voulkos through regional and national shows in which he was winning the top prizes. In 1956 *Craft Horizons* ran its first major Voulkos article.

I met him at the American Crafts Council's first National Conference, at Asilomar, California, in June 1957, and for more than twenty years our friendship has been full of laughs, affinities, and insights.

In 1958, when I visited with him in Los Angeles, I stayed with him and his wife, Peggy, at their place on Silver Lake and talked into the night with Pete, who turned out never to have been quiet. He was hungry for information on what was going on in New York City, and I could tell him about my friends—de Kooning, Pollock, Kline, Rothko, the Artists Club. It was the heyday of the New York School, and Voulkos was still flirting with the idea of coming east to New York City, like so many of his generation, "to make it." We talked a long time about his struggle with form. He had by then openly claimed both sculpture and painting as the concerns of his pottery. He was now stacking the forms and then painting them to set up further tensions between form and color.

In 1959, at the American Crafts Council's Third National Conference at Lake George, New York, I took Voulkos, the Los Angeles art critic Jules Langsner, and *Craft Horizons'* managing editor, Patricia Dandignac, with me to see the great sculptor David Smith, at Bolton Landing. The meeting began a vital friendship between Pete and Dave that was to continue until Smith's death in 1965 and was to influence Voulkos profoundly as an artist. It was a great night. Dave, who worked in isolation during the day and got lonely at night, was happy for our company and in a party mood. We drank and laughed

while Dave bantered with the men, challenging and trading in good old-fashioned macho humor with Pete, flirting with the women, his drooping sad eyes in his great walrus face beaming with pleasure at our presence, breaking champagne glasses with a tricky flick of his thumb, a skill in which he took special pride and which he loved showing off, until somehow the glass cracked and blood spurted from Dave's thumb. After that we just talked until it was light. I'll never know how we made it down that mountain.

In 1960 I wrote the piece "The New Ceramic Presence," based on my knowledge of Voulkos and his work and the whole movement in clay that he generated. Pete was then in New York for his "New Talent" show in the penthouse of the Museum of Modern Art; with him was Malcolm McLain, the fine experimental potter and painter (now an equally fine poet and sculptor), a member of the original Voulkos group at the Los Angeles County Art Institute. They encouraged me to publish the article. It was the distillation of my visits and talks with Pete and with, from time to time, the more reticent John Mason, that wonderful ceramist and sculptor. But it was my communication with Pete that gave my ideas their tone and focus.

The article, published in *Craft Horizons* the following summer (see page 137) caused a furor: I was blamed for everything the bad boys of ceramics had been doing in the basement of the Art Institute. Letters of praise and damnation poured in for over two years. Everyone was all fired up about clay in those years.

The writer in me generates the need to make Voulkos a part of the written world. Writing is my way of learning about what I have experienced and intuited. How do you write a book about a close friend and an artist you admire without becoming a curatorial accountant, keeping a ledger of aesthetic debits and credits, and without submitting him to romanticized projections in your own need to make him identifiable, giving him a custom-made suit that doesn't quite fit or a custom-made suit that fits only too well, hiding the eccentric tilt of his particular body? "It's your book," says Pete. "You make books, they're yours. I make ceramics and bronzes, they're mine." Pete Voulkos, inviolable, powerful, nervy, relaxed, easy-does-it, kind, generous, totally magnetic.

In the summer of 1975, on July 24, we leave Snowbird, Utah, and the University of Utah summer workshop, where Pete has been demonstrating for the last three days, to return to Berkeley, California. Marilyn Levine, who set up the program, Rudy Autio, codemon-

strator and one of Pete's oldest and best friends, and Rudy's son Lar drive us down the canyon to the Salt Lake City airport and watch us, waving mournfully, as we walk across the sun-baked field and get on the plane.

Pete is tired from the intensity, the work, all the talking, being constantly surrounded by admiring students, or observers who want to be in the orbit of the Voulkos magnetism, who hope that being an artist is like having a contagious disease—if they stay close to him long enough, they will catch his affliction.

On the plane, I read the *Salt Lake City Tribune* and am disturbed by an Associated Press account of a steady stream of small misfit disasters ending in death—of one Woody Gillis, a victim of life, the kind of man Pete was likely to befriend and at the same time to keep his distance from, cautious, fascinated by the sheer mercilessness of life once it has picked its victim. I show him the clipping. We laugh ruefully, uneasily; a small laugh separates us from the loser.

Pete is Greek enough to accept as his personal heritage the stories of the gods picking on someone for the sheer hell of it, and if he weren't quick enough to avoid them, they would then pursue him to sure doom, allowing him to run a little while for his life. Tough and strong like his Greek-born mother and father, Voulkos does not quarrel with the dictum of the gods. He would not invite their attention without having something ready to please or amuse them. Above all, he prefers to avoid their attention altogether. He does not want to have to please or amuse. He would leave the gods alone and hope they leave him alone. It's safer. "I'm not a gambler. I'm a player." How many times was I to see what he meant, watching him play poker in his hometown, Bozeman, Montana, and in his studio at Berkeley. He played his cards close, did not take wild chances; he calculated the possibilities, knew who among the players were the gamblers, and concentrated on the game, remembering the cards, smiling, relaxed, amused, and intense. He taught me: A player plays to play. A gambler plays to lose. Peter Voulkos is not a loser. He is a player. He plays a sure game and he is a winner. He has learned to trust himself. Whether he is playing pool, poker, or pots (he has a pool table and a poker table, as well as all the pottery equipment, in the studio), he addresses himself to the matter, focusing his energies on it. His energy flows easily, consistently, and continuously when he is working or playing.

The big-boned Peter Voulkos—wide pelvis and barrel chest, wide back, powerful shoulders, and long, surprisingly thin arms, big supple

hands, large palms with slender, tapering long fingers and curving thumb. He walks on bowed legs, as if he were a cowboy, which he never was (he does not even ride a horse; he is a broncobuster of the pickup truck, considered a more masculine and practical skill in the new West), long slender feet toed inward in his pointed flamenco boots. (Pete's boots, always a subject of comment, were cast in porcelain by the California ceramist Joseph Pugliese.) Over the short, thick, strong neck looms his long jaw and prominent chin with lower dental palate pushed forward, somewhat like a Neanderthal man's; long nose hanging over the wide, grinning mouth, booming basso gravel voice gentled with western twang, hazel eyes with the clear fierce piercing look of a hawk.

A part of the Voulkos charm is this sense of primitive strength vested in an intuitive and sharp intelligence. On first meeting him, he appears somewhat giantlike, a hovering giant never quite straightening from bending over the wheel, although he stands no more than five feet eleven. At one of the workshops he gave in 1976 he was billed as "Gorilla Man," which he liked. He is in tune with such descriptions of himself. He would rather be the ape than Tarzan. One is struck by what appear easy, slow movements in which there is no waste or hesitation. The entire presence of Peter Voulkos suggests sure and total communication among all elements—heart, brain, hands, bodily strength—geared for action. Lenore Tawney, the fiber artist, pointing Voulkos out in 1957, said, "Look, look at him. You can just tell by the way he moves."

It all took place in the brief period of ten years—from the time Peter Voulkos started producing clay work in 1949, even before graduating from Montana State University, until he went to teach at the University of California at Berkeley in 1959 and turned his attention to bronze. In those years he produced a massive body of work that was to start a whole new ceramics movement in this country. He became the acknowledged leader of the revolution in clay.

His unlimited capacity for work, his large storehouse of energy and strength, was matched by his unquenchable fascination with the material, the clay, his need to experience it—everything it could do. He worked it, tested it, played cowboys and Indians with it, learned everything he could about it from books, from people, and then made it up as he went along.

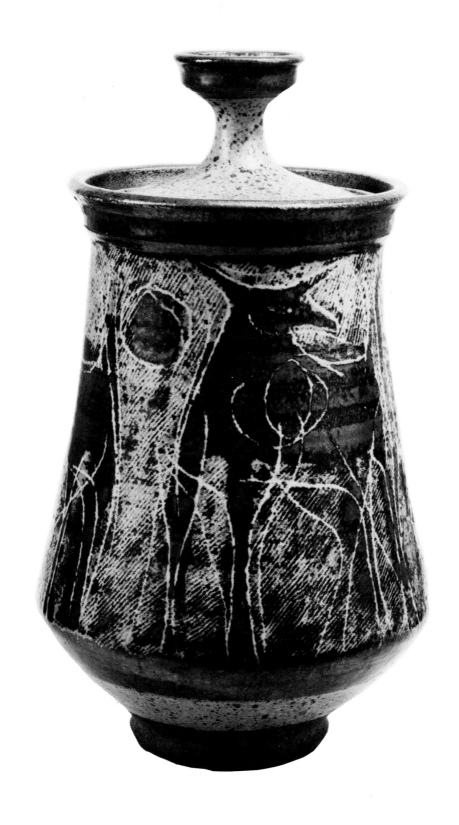

1. The Montana Years

3. (overleaf) *Covered jar, 1953*
*Made at Archie Bray Foundation; stoneware, wax resist, and sgraffito of incised
line; 17 inches high. To achieve the white lines, Voulkos covered the bone-dry
pot with a layer of wax through which he scratched his drawings and then
applied white slip, rubbing it into the lines. After bisquing, he applied a coat of
red iron slip and refired the pot to mature temperature. He calls this "my scratch-
ing period." (Collection of Museum of Contemporary Crafts, New York.
Photographer: Ferdinand Boesch)*

In 1946 Peter Voulkos was discharged from the Air Force, where he had served as a nose gunner, and went back to school under the GI Bill along with thousands of other returned veterans. The Air Force had given him vocational testing and informed him that he was not doctor or lawyer material but suggested he try engineering or some manual skill, like art. He went home to Bozeman, Montana, and registered at Montana State University, specializing in commercial art. Voulkos, a night person all his life, says half-jokingly, "I heard that artists don't have to get up in the morning." Actually, he had excelled in his art and shop classes at Gallatin County High School. Along with his generation, swelling the population of the colleges and universities at the time, he had returned from the war with an expanded view on life, feeling lucky to be alive and full of curiosity about the creative disciplines. At Montana State University he studied painting with Robert De Weese, an abstract painter who became his close friend and under whose influence he became totally involved in painting. He gave up commercial art and design (despite the fact that he won the school's poster contest with a prize of two dollars, the check for which he still carries in his wallet).

Voulkos decided to become a painter. "I had never been in a museum in my life. The only master paintings I knew were the ones De Weese showed me in reproductions in books he or the university library happened to have." Clay did not cross his vision until his senior year. So involved had he been with the painting that he tried to avoid the two-credit clay course the art department required. He managed to do so until he was told that he would not be allowed to graduate without taking it. A protesting Voulkos reluctantly appeared in Frances Senska's class. Just out of the Wacs, having received her ceramics training at the School of the Art Institute of Chicago, Frances Senska, a shy and eager teacher, was a bit apprehensive as she faced the class that included the recalcitrant Voulkos. She need not have worried. From the moment Peter Voulkos touched the clay, it was love. No one could keep him out of the "mudroom." He became friends with the night watchman, who would look the other way when Pete crawled through the basement windows after hours to get back into the building to work all night. There was no equipment to speak of and everyone started from scratch, which included digging clay out of the nearby mudbanks.

There are few potters who have used native clays and earth glazes to the extent Voulkos did. He says, "I didn't realize at the time you could buy a bag of clay, so I spent my weekends digging it up and processing it. At MSU they gave you twenty-five pounds of clay for the

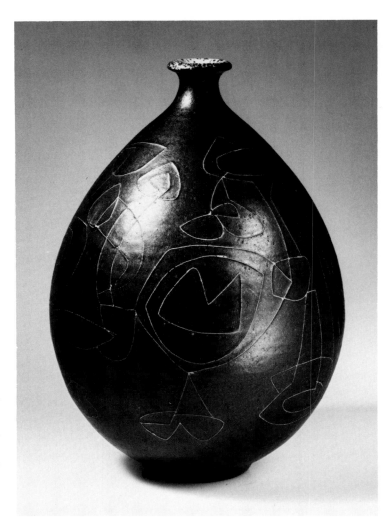

4. Bottle, 1953
Made in Montana; stoneware, wheel-thrown;
local native slip with saturated iron on
bisqued-fired pot is waxed. Drawing is
sgraffitoed into wax and inlaid with white slip
which appears raised after firing; 20 inches
high. (Collection of Prieto Gallery, Mills
College. Photographer: Joseph Schopplein)

quarter, so that didn't go very far. My clay was as primitive as you can get. After digging it up, I would put it in garbage cans with water and then screen it through window screens to get the rocks out. It was a red-iron earthenware clay from Bear Canyon up in the hills. I also dug up a slip glaze at Trail Creek, a canyon outside of Bozeman. We tested the slip and fired it so that it would mature at the same time as the clay."

Describing those days and that particular class, Frances Senska says:

Pete has always had infallible taste. Where it came from, I don't know. But what he did was always right—just the thing that seemed to work. And then of course he could always carry things through. He was a leader. It was an unusually good class—half a dozen people who were really working. It was

a wonderful experience, the sort of experience a lot of people don't get in teaching.

Pete took to everything like a duck to water. At school the advertising people wanted him in advertising; the graphics people wanted him in printmaking. Even the home economics department wanted him. He took a family life course, social problems of the family, and wrote a first-rate paper. He didn't always come to class, but when he got around to it, he did superbly.

Pete liked to work at night when it was quiet. He made a coffee cup for the night watchman and always had coffee for him when he sneaked in so the watchman wouldn't throw him out. The administration would get very mad —they'd say you can't have people in the building after hours, and so forth. But I defended him; those are his hours; he got into that habit of reversing time very early.

His decision to focus on clay may have been partly because it was something sort of new in those days. We built some kilns and got it going. Ceramics hadn't been done around here. Nobody knew anything about it. I think that was part of the appeal. Everybody likes to be on the ground floor, investigating, finding out. Then there were a lot of very good people. Rudy Autio and his gifted wife, Leila, were in that class and brought their new baby along in a basket, as was the custom in those postwar university years with newly returned veterans going to school along with their wives and babies. There were several other people who were very good, so there was competition, but they also built each other up, because they were very fond of each other. We were a very small group and we did everything together.

Everything Pete does is based on knowing it from all angles; from there he goes off on his own. A lot of people don't get anywhere that way, but Pete did because he'd work long and he'd hit something that he didn't know and, frankly, I didn't know much more. But he'd come and talk it over; we'd figure out what it was and get suggestions. When he needed something he came and got it.

Then he and Rudy thought they'd like to do enamels. Well, we didn't know anything about enamels; they weren't being done. Kenneth Bates hadn't written his book yet, and nothing was going on. We didn't have any enamels but we read whatever we could find about them and made some out of ground glass and coloring oxides—some very nice things. Everything went together.

Rudy and Pete worked on the same things to a certain extent. Rudy never was a potter—he was always a sculptor. But they would do things and bounce them off each other. It lifted them both up along the way. Then for several years, two or three years anyway, after Pete went down to L.A. to teach—by that time Rudy was teaching at the University of Montana at Missoula—Pete came up to teach at the Archie Bray Foundation in Helena in the summer and then they'd be together.

Being built like a gorilla is a big help working with clay because you have all this power. You have to be steady. Pete has a big advantage there; he can keep his hands absolutely still and the clay has to come to him.

If Pete's doing a pot, he does what that pot needs. If he's doing a painting, he does what that painting needs. If he's doing a print, he does what that print needs. As a student he had one silk screen with thirty-two runs, because that's what it needed. He enjoyed the process in everything.

Pete ran through a half-dozen careers in clay—just went through a great many different possibilities. He'd see something and he would take that and exhaust that possibility and go on to something else.

THE MONTANA YEARS

It's fascinating to me to see little things that you've picked up from someone, or that someone has picked up from you, move around through a sort of cycle. Sometimes, when you watch Pete throw, you can see Marguerite Wildenhain. I learned certain things from her, Pete learned certain things from her. Pete holds his hands just the same way I do, even though I'm making little things and he's making big things.

After graduation from Montana State University in 1951 Voulkos decided to go on for his master's degree in ceramics, specializing in stoneware. He had already demonstrated his mastery at the wheel, had already entered his pot in the Syracuse Ceramic National Exhibition in 1949, winning one of the top awards in the most important national competitive show at the time, attracting the attention of potters through-

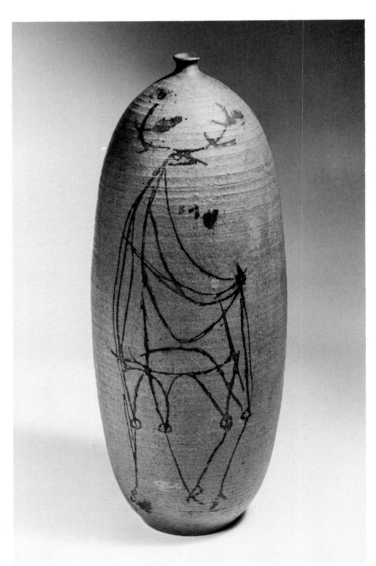

5. Deer bottle, 1949
Made when Voulkos was an undergraduate at Montana State University; wheel-thrown, with local low-fired clay and slip glazes; wax resist with raised line decoration; 17 inches high. To achieve the line, Voulkos covered the bisque pot with "Trail Creek" glaze, applied a coat of wax over it, and scratched his drawing through this to the bisque. Into the lines he brushed a highly refractory solution of iron, cobalt, and chrome. In firing, the glaze recedes around the clay ridges and the line comes out raised, emphasizing the inlaid pattern. The innovative application of this painstaking technique was characteristic of Voulkos's earlier work. This piece, shown at the fifteenth annual Ceramic National sponsored by the Everson Museum of Art, Syracuse, and the Onondaga Pottery Company, was one of his group of three that won first prize and brought Voulkos his first national attention. (Collection of Margaret Voulkos. Photographer: Joseph Schopplein)

PETER VOULKOS

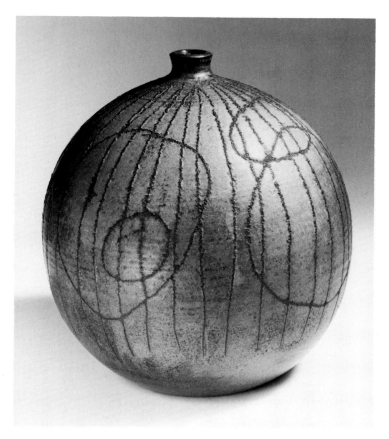

6. Bottle, 1949
Made when Voulkos was an undergraduate at Montana State University; wheel-thrown with local low-fired clay and slip glazes; wax resist and raised line decoration; 10 inches high. Voulkos used a heavy iron-chrome engobe. Lines are scratched through the wax emulsion and slip brushed into them. In firing, the glaze shrinks around the clay ridges, much like melting snow, to emphasize the inlaid pattern. This technique was frequently used in Voulkos's early work. (Collection of Margaret Voulkos. Photographer: Joseph Schopplein)

out the country. He was also producing a variety of bowls, jars and casseroles, plates and mugs, as a production potter and was beginning to sell his work. He went to the California College of Arts and Crafts in Oakland, one of the few art schools in the West with a ceramics facility at that time. At CCAC he sharpened his technique, doing his MFA thesis on lids. While at the school he married fellow student Margaret Cone, from whom he was divorced in 1964. Their daughter, Pier, now in her twenties, is also an artist.

Voulkos returned to Bozeman in 1952. When he had been there the previous summer on vacation he had met the Helena brickmaker Archie Bray, Senior. Frances Senska recalls: "Pete wanted to work at ceramics full time. We were looking to find a studio for him and heard about the brickyard. A couple of artists in Helena, Peter Malloy and Branson Stevenson, had talked Archie Bray, who collected paintings, into the idea that he should do something for living artists by building a pottery in the brickyard, so Pete and Rudy went up to see him and they hit it off right then." Archie Bray agreed to let Pete and Rudy use his equipment to build the pottery, and to make and teach pottery, and in return they worked in the factory making and salt-glazing bricks.

THE MONTANA YEARS

Together Pete and Rudy built the pot shop. Those were exciting years as the two friends searched out the clay. Pete continued to perfect his wheel work, while Rudy worked mostly with slabs and other approaches to the forms that interested him.

Among their visitors that winter of 1952 were Japan's Shoji Hamada and England's Bernard Leach, close friends and collaborators, coming through together on their first pottery scanning trip across the United States. Voulkos drove Hamada through the surrounding mountains and hills that cold Montana winter so that Hamada could do watercolors of the scenery. When the paint froze on the paper, Hamada was enchanted with the resulting effect, and Voulkos was delighted with Hamada's spirit and enjoyment of fortuitous aesthetic accident.

In the meantime, Voulkos was submittting work to all competitions, and winning the prizes. These included the Wichita Decorative Arts Annual, one of the most important national shows at the time, as well as regional shows in the Northwest and California. At his one-man show at the Pomona State Fair (held on the invitation of Richard Petterson) in the summer of 1952, everyone agreed his wheel work was extraordinary, his glazes rich, his surface decoration inventive and masterful (wax-resist brushwork and raised and inlaid line)—that this Voulkos fellow, whose name kept appearing as the one taking prizes, actually deserved those prizes. His thrown work already had that sense of speed, clarity of form, and sureness of touch that marks all his later work.

Young people from all over the country, having heard of Peter Voulkos, began to show up at Archie Bray's brickyard. They worked alongside one another in the easy give-and-take camaraderie of the workshop, the spirit for which Voulkos was to become as famous as he was for his pots. His energies and capacity for work were contagious and exhilarating.

Voulkos still considered painting to be his primary art and he continued to paint, but he decided to make his living as a production potter. When Pete first told his mother he was going to be a potter, she said, "What! Make pots and pans! I thought you gonna be an artist." She dreamed of an artist among her sons. To her it was the highest of Greek aspirations and the most noble of all callings.

In the summer of 1953 Voulkos went to Black Mountain College, near Asheville, North Carolina; at this experimental college directed by Josef Albers, art was at the center of the curriculum. Voulkos had been invited to teach at its ceramics institute by Karen Karnes and David Weinrib, its resident potters, who had gone to head the center

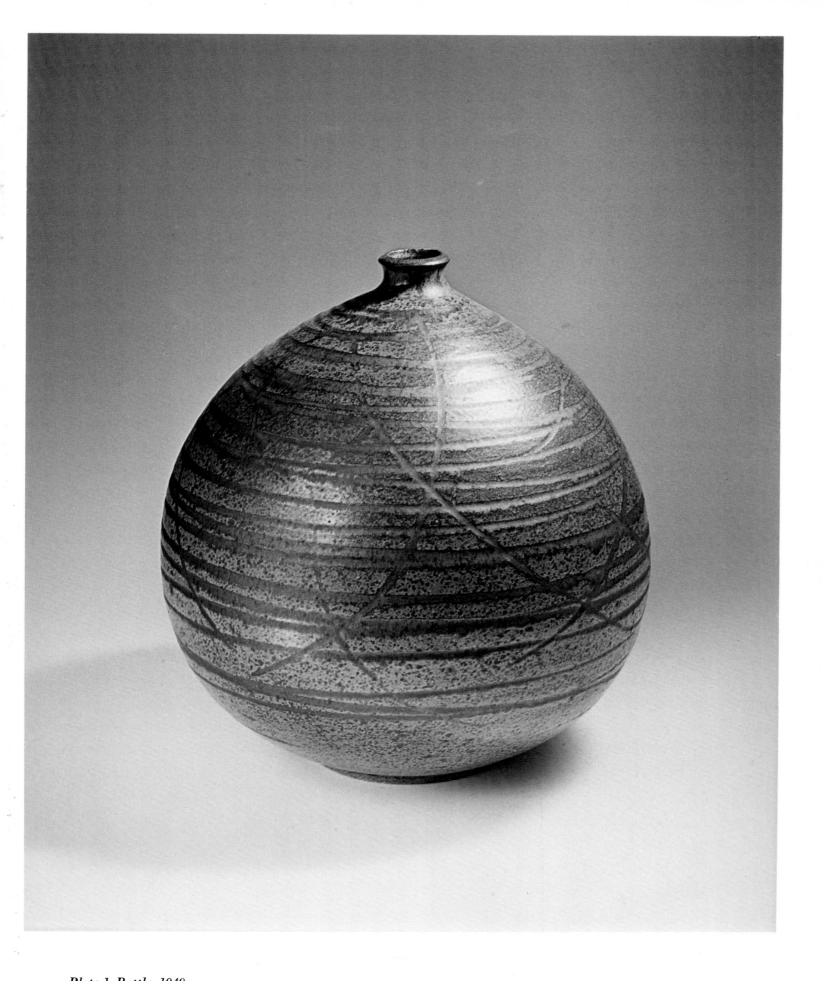

Plate 1. Bottle, 1949
Made while Voulkos was a student at Montana State University; low-fire local clay and glazes from Bozeman area; wax resist incised line, with heavy iron-bearing engobes and oxides. (Collection of Margaret Voulkos. Photographer: Joseph Schopplein)

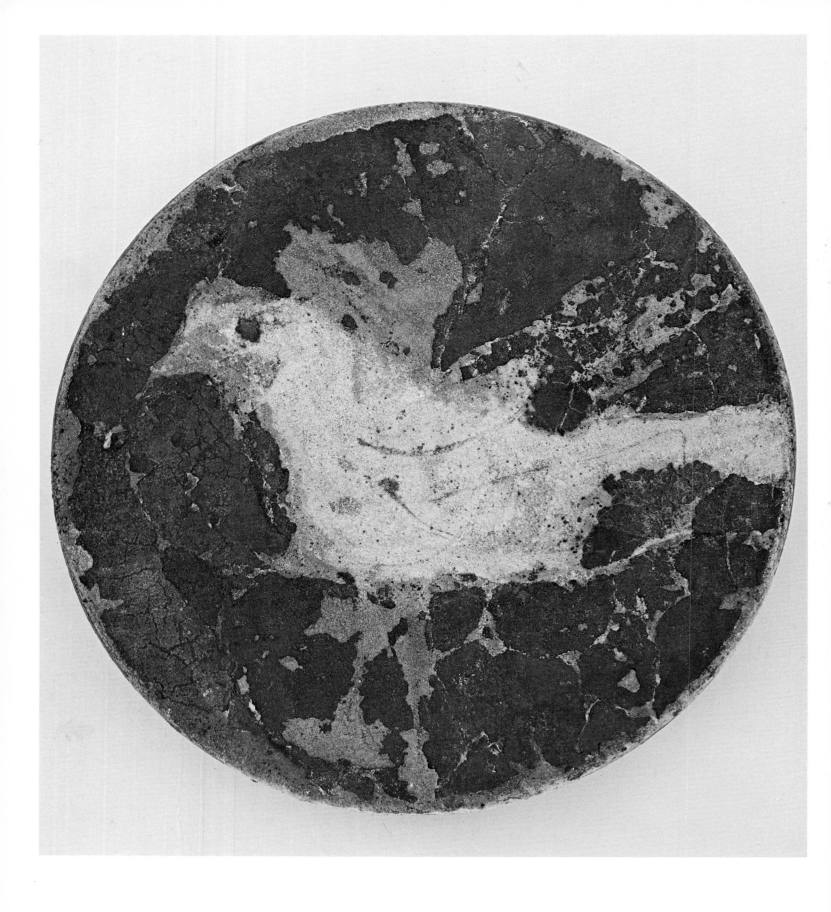

Plate 2. Plate, 1957
Made in Los Angeles; stoneware, iron inlay; white sand slip, sgraffito, and rusted metal fragments glued on surface; 11¾ inches in diameter. (Collection of Fred Marer. Photographer: Frank J. Thomas)

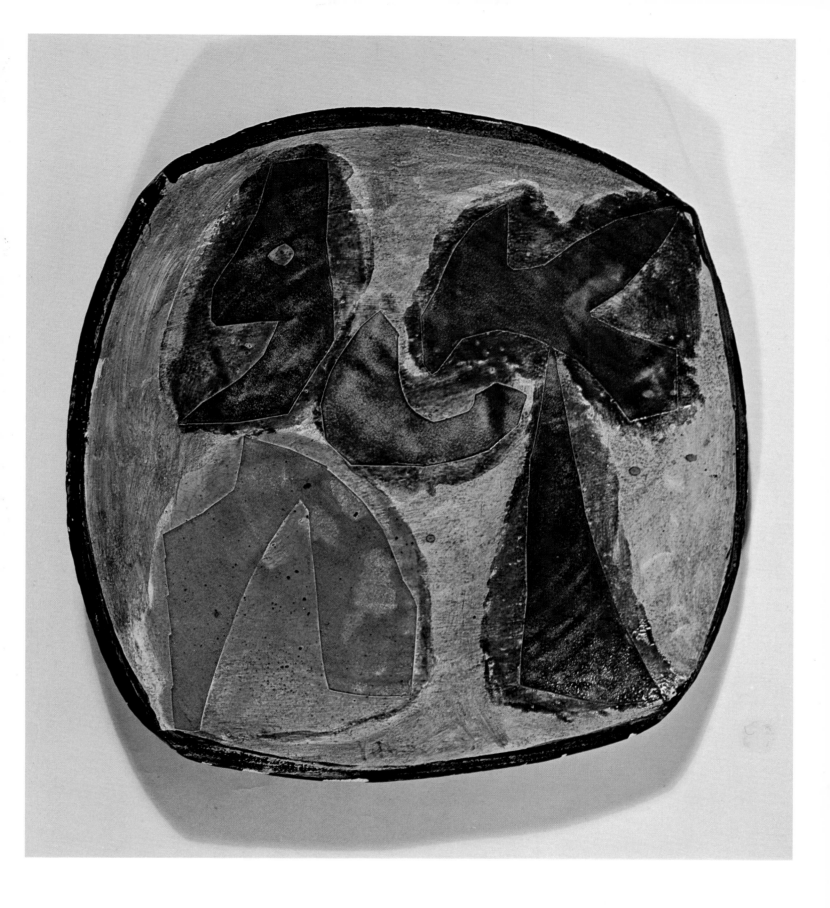

Plate 3. Plate, 1958
*Made in Los Angeles; low-fire, wheel-thrown, stencil cutouts and buildup of white
slip with applied color glazes; 17 inches in diameter. (Collection of Gerald Nord-
land. Photographer: Frank J. Thomas)*

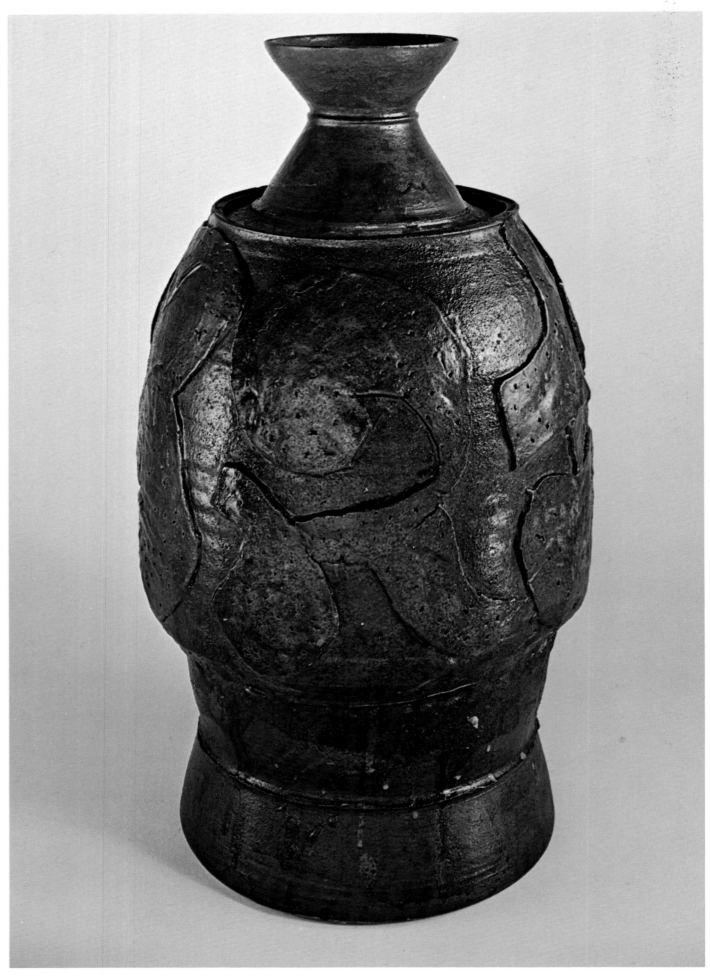

Plate 4. Jar, 1956
*Made in Los Angeles; stoneware, wheel-thrown, slab cutouts slip-welded to surface
as relief pattern; iron slip and thin natural glaze; 37½ inches high. (Collection
of Peter Voulkos. Photographer: J. P. Oren)*

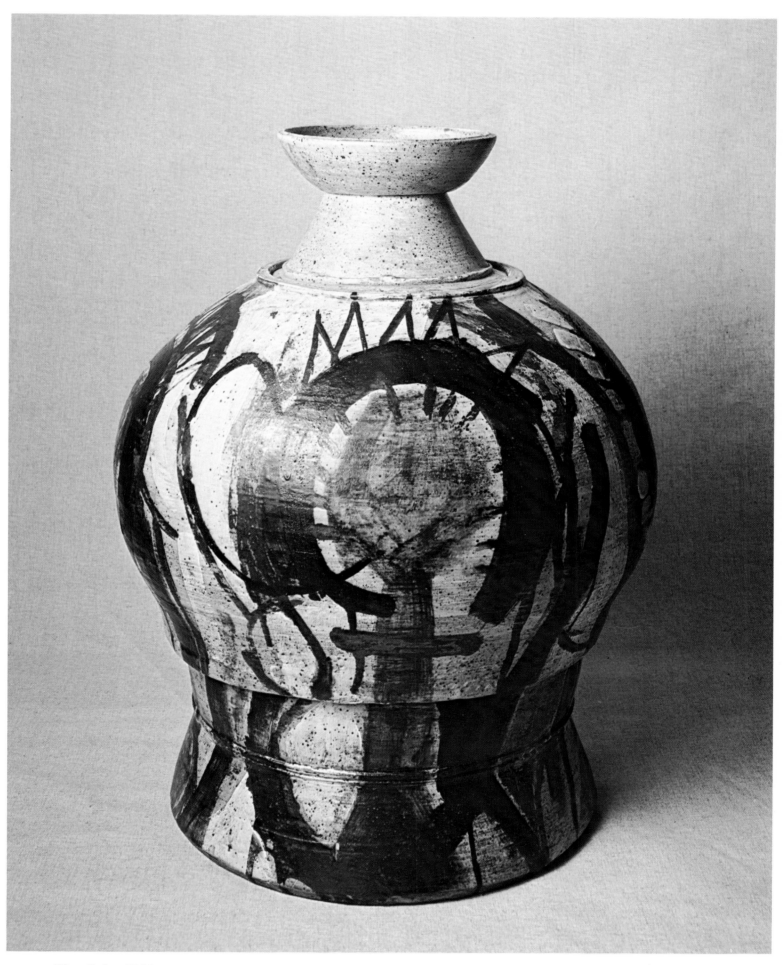

Plate 5. Jar, 1956
Made at Los Angeles County Art Institute; stoneware, brush-painted white, iron, and cobalt slips and glazes; 26 inches high. This piece was a prizewinner in the nineteenth Ceramic National exhibition. (Collection of Everson Museum of Art, Syracuse, New York. Photographer: Main Street/Lorenz)

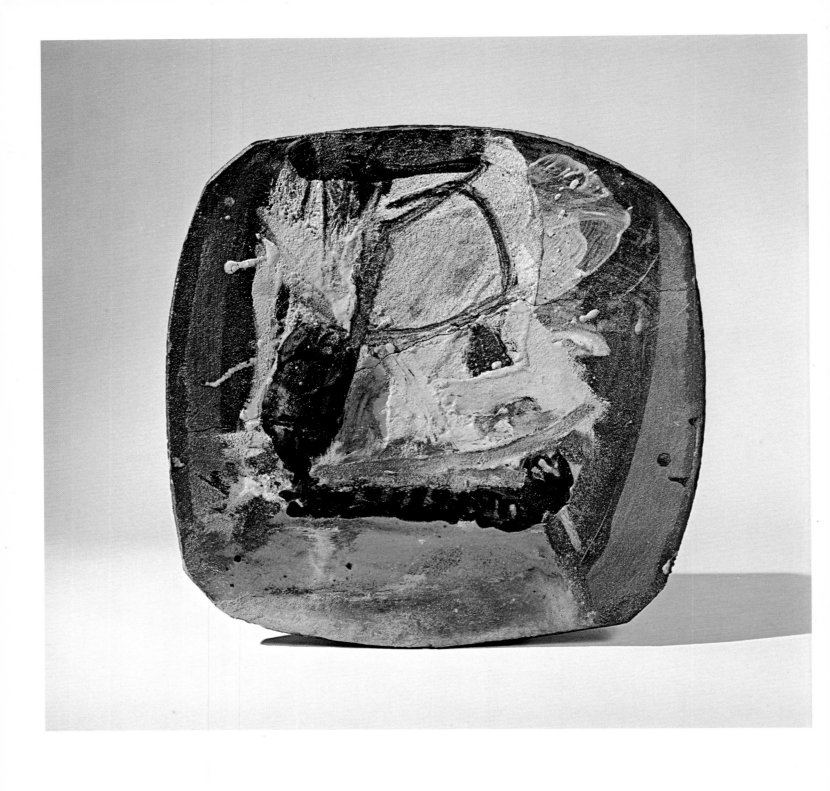

Plate 6. Square plate, 1959
*Made in Los Angeles; stoneware, wheel-thrown and cut, carved foot; white sand slip
painted with iron and cobalt slips, orange, blue, black, white epoxies; 18 inches in
diameter. These plates are closely related to Voulkos's painting on canvas. Voulkos
was the first to introduce the use of epoxy paints to achieve bright color in ceramics.
(Collection of Peter Voulkos. Photographer: J. P. Oren)*

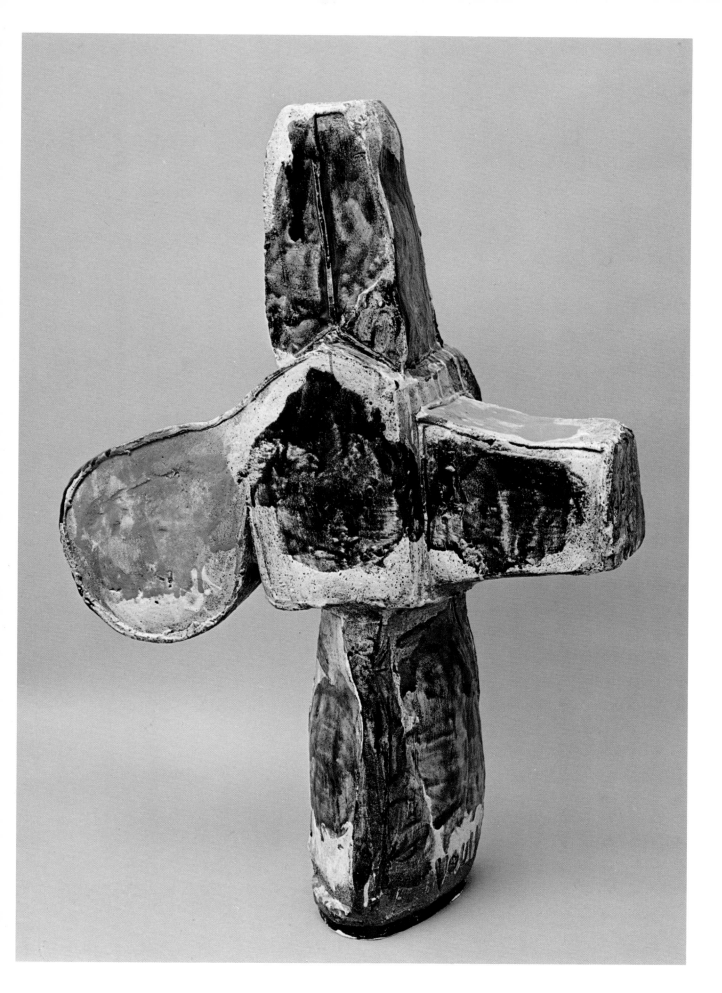

Plate 7. Sculpture, Cross, 1959
Made in Berkeley; stoneware, white slip with low-fire glaze (color is all glaze)
applied before second low firing; 34 inches high. (Collection of Museum of Con-
temporary Crafts, New York)

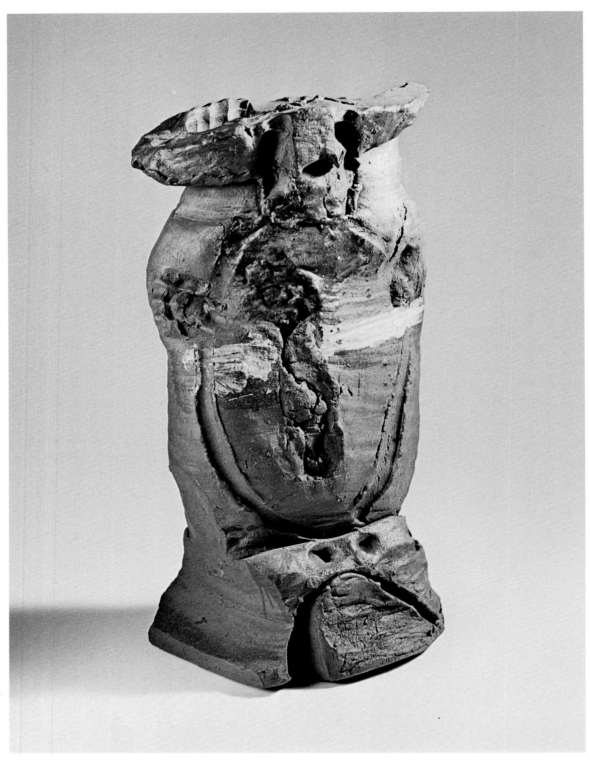

Plate 8. Sculptured pot, 1962
Made at Teachers' College, Columbia University; wheel-thrown and carved, slab foot, gouged and manipulated; heavy iron body "o'd on iron with Fe 203"; white slip stripe and turquoise glaze; 24 inches high. (Collection of Margaret Voulkos. Photographer: Joseph Schopplein)

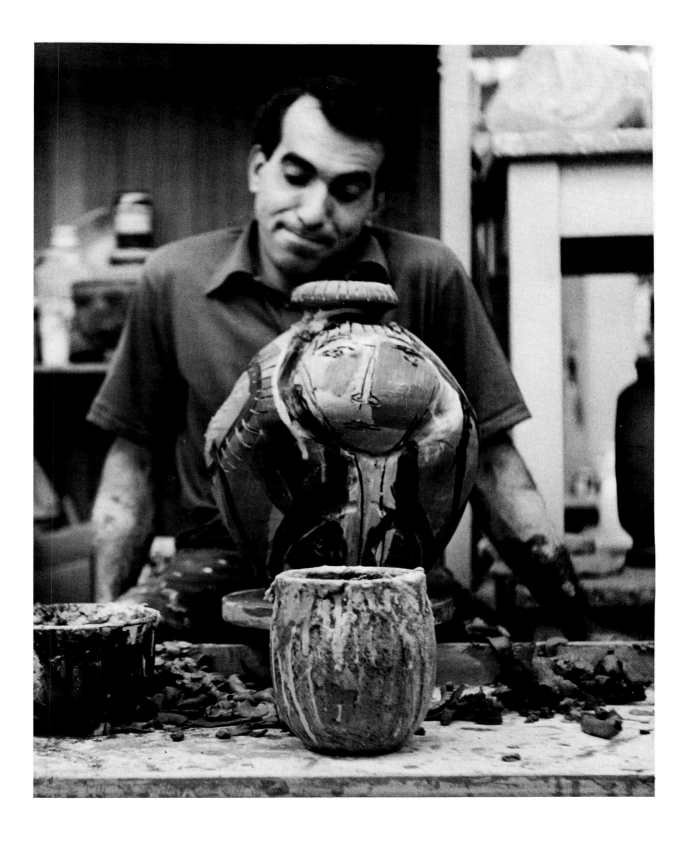

7. Voulkos at the wheel in 1956

after graduation from Alfred University in upper New York State. Daniel Rhodes from Alfred and Warren MacKenzie from Minneapolis were also teaching ceramics there that summer. The kiln and pot shop had been built by another potter from Alfred, Robert Turner, who had come there in 1951. Those three weeks at Black Mountain were to change Voulkos's life. He had already been stirred by reproductions of the ceramics of Picasso, Miró, and Artigas, by the Zen pottery of the Japanese and Koreans. Now, in an atmosphere of high experimentation, he met artists in every field exploring the new art that was to remake American culture. He became friends with the composers John Cage and Stefan Wolpe, with David Tudor the pianist, Merce Cunningham the dancer, painters Jack Tworkov, Esteban Vicente, Robert Rauschenberg, the poet-potter M. C. Richards, the poet Charles Olson. (Olson, struck by Voulkos's dark coloring, reserve, and prodigious strength, created the fantasy of Pete as the personification of the American West. Nothing could dissuade him from the conviction that Voulkos was American Indian, not even learning, at the end of Voulkos's stay, that he was of Greek origin; Olson promptly amended his vision to include some Greek in the Indian.)

Voulkos was, as he describes himself, somewhat of a "farm boy," but the weeks he spent at Black Mountain were to release his adventurous spirit and fierce energies. As Rudy Autio said, "He came back to Helena. But he was never the same again. It must have been about the most important thing that had happened to him up to that time."

M. C. Richards, returning to New York that summer, invited Pete to come along. They drove up to New York together, arriving in blistering hot weather that August, and stayed with M. C. and David Tudor in their three-room flat on Second Avenue (with bathtub in the kitchen), in the heart of New York's Lower East Side. There Voulkos visited with Cage in his Monroe Street apartment, meeting other experimentalists of the time. At the famous Cedar Street Bar he met Franz Kline, a meeting that was to influence Voulkos for the rest of his life, as was his encounter with Willem de Kooning. New York was a seething hive of creative activity. Jackson Pollock, who had come from Wyoming, Voulkos's part of the West, was in his prime and three years away from death; the painters Mark Rothko, Clyfford Still, Philip Guston, Conrad Marca-Relli, Robert Motherwell; the sculptors Reuben Nakian and David Smith; fellow Greeks, painters Aristedes Chaldis and Theodoros Stamos (who bought Voulkos's work); they were all on hand that summer in New York City. Dylan Thomas had conquered New York and was to return in the fall. Harold Rosenberg had written his manifesto for action painting, and New York was

ringing with discussions of what was taking place. The leading art magazine of its time, *Art News*, and its editor Tom Hess reflected the excitement of the work of the "New York School," work which was called "action painting" or "abstract expressionism."

Aside from the visits to the museums in the Bay Area while at the CCAC, where the collections still were mainly regional, and his experience at Black Mountain, Voulkos had not seen contemporary American art firsthand, nor indeed any major contemporary works. Now he experienced the excitement of accessibility—of artists being physically close to one another, being able to exchange views and discuss their work together as a natural part of the working day. On Tenth Street he saw artists going in and out of each other's studios, meeting at night at the Cedar Street Bar, meeting at least once a week at the Artists Club—in daily touch with energies that ignite one another. New York was to remain a source of attraction for him for many years to come.

He returned to Helena that fall and continued his work at Archie Bray's, making production pottery—cups, saucers, plates, bottles, casseroles—and expanding his clientele all over the country. As he said, "If I were still at it now, I would be doing very well financially. We developed a good trade." In the meantime he had continued also to make pieces for national exhibitions that increased his visibility, and to paint.

In those years the only way potters in the United States could find out about their craft was to travel to where it was happening. There

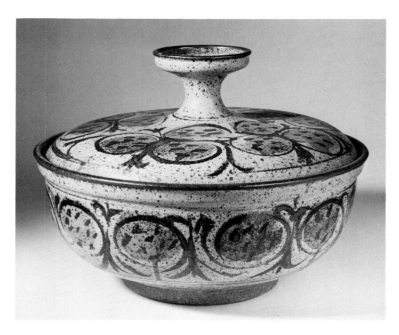

8. Soup tureen and lid, 1952
Made at Archie Bray Foundation; stoneware, wheel-thrown; floral motif, brushed with iron and cobalt slip on white slip; clear glaze; 20 inches in diameter. (Collection of Efrosine Voulkos. Photographer: Joseph Schopplein)

THE MONTANA YEARS

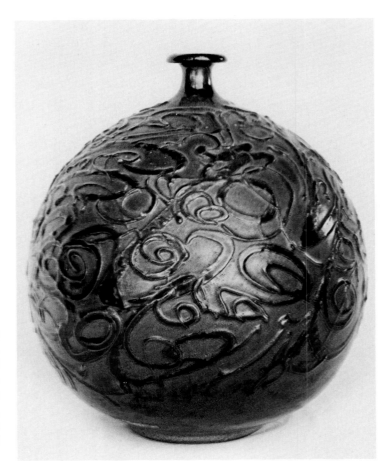

9. Bottle, 1954
Made at Archie Bray Foundation; stoneware,
wheel-thrown with slip trail decoration;
20¾ inches high. With a syringe, the artist
trailed white slip in layers — ⅛ inch thick —
over the bisqued pot, which had been coated
with red iron slip. A glaze of saturated iron
was applied. In the firing the saturated iron
over the red iron slip turned red crystalline,
while the meandering raised pattern
turned black. (Collection of
Mr. and Mrs. Millard Sheets)

were few books. Potters began to hear that among the places it was happening was Archie Bray's. In 1953 Pete and Rudy had built the biggest kiln around. Archie Bray, who was a ceramics engineer and a graduate of Ohio State, had laid out the kiln—a down draft with red construction brick on the outside and firebrick on the inside. Aside from being one of the largest kilns in the country for studio pottery, is was also one of the few high-fire ones. "It was a big kiln, and you had to crawl into it. You really could stack it," Voulkos recalls. Pete and Rudy Autio held workshops and ceramists began to come from throughout the West.

Marguerite Wildenhain, the great Bauhaus potter who had emigrated before the war and established her studio in California, spent five weeks working and teaching there, and Voulkos worked with her; eight years later she was to cancel her subscription to the magazine *Craft Horizons* when it showed the new work of Voulkos and the group that formed around him. Carlton Ball, traveling throughout the country visiting potteries, working and learning, stayed there about

six weeks. Eight years later he, too, was to protest bitterly the Voulkos mode in clay.

Among those passing through were Jim and Nan McKinnell. As students at the University of Colorado at Boulder, they had known Paul Soldner, who now asked them for advice. Soldner, who had received his BFA in art education on the GI Bill, had decided that he wanted to study ceramics but, in order to be funded by the GI Bill, he had to find an institution that would give him an MFA degree in the subject. The McKinnells asked Pete Voulkos's advice and quoted him in a letter to their friend: "If he wants a PhD, let him go to Ohio State University; if he wants to teach, let him go to Cranbrook; if he wants to go into industry, let him go to Alfred; if he wants a vacation, tell him to go to the University of Hawaii or to Switzerland; if he wants a quickie, he should go to the College of Arts and Crafts in Oakland; if he wants to learn to pot, he should go to Marguerite Wildenhain." Then the McKinnells added a PS to their letter: "We think Pete is great and he is going to teach at Otis Art Institute in L.A. next fall." Soldner says: "It was just like Pete not to suggest himself. Anyway, I was lucky that just as I was ready to study and to get the next degree under the GI Bill, that's when Pete went to Otis, which offered the MFA I needed." It did not occur to Pete to suggest himself. There is more reticence and shyness in Voulkos than his open and gregarious manner would suggest.

At this time, Millard Sheets, the director of the Otis Art Institute in Los Angeles (soon to become the Los Angeles County Art Institute) invited Voulkos to head its new ceramics department—so brand-new that when Voulkos arrived in the fall of 1954, the department was nothing but an empty basement; again, the whole thing had to be built from scratch.

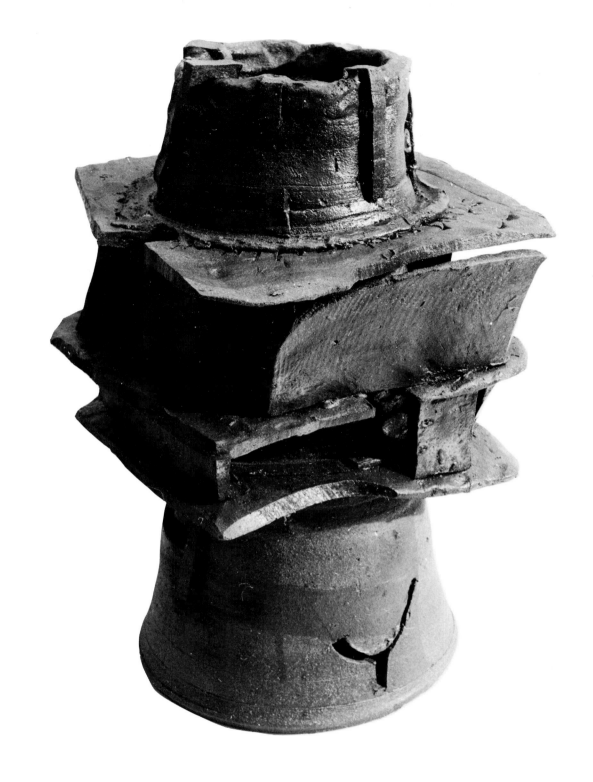

2. Los Angeles: The Clay Revolution

10. (overleaf) Pot, 1956
Made in Los Angeles; stoneware, wheel-thrown and slab construction with slabs
boldly attached to the central cylinder; slashed cutout on foot. Red iron slip
was applied directly to the raw clay, which was then lightly glazed. Neck was
thrown separately and slip-welded to slab; 20 inches high. (Collection of
John Mason)

"The biggest thing that ever happened to me," Voulkos says, "was moving to Los Angeles. Then I became aware of everything. Everything started falling into place. I began to go to all the shows, all the openings at galleries and museums—painting shows and sculpture shows I had never been to before, and I really got turned on to painting like never before—work by New York painters especially."

In 1954, Los Angeles was the marketplace, dominated by the new postwar money looking for cultural respectability and recognition. La Cienega Boulevard began to mushroom with galleries and with curiosity, daring, and hunger for the new vision and the new touch. Los Angeles, moreover, was the place to which you went to make your ideas become realities. It was the sunny mecca for people from all over the country, for seekers of divergent dreams—to find stardom in Hollywood, or to become champion of the surf riders or queen of the strippers or to join an evangelist's cult or a guru's ashram. It was crass, competitive, ravenous, roaring, and mobilized—the West Coast equivalent of New York in its human variety, its determination to get what it wanted at whatever price, its hospitality to art.

San Francisco, with its tradition for culture, its old West Coast money—Athens of the West—was more comfortable, more complacent, more decadent, its money more conservative, more oriented to Europe. San Francisco money was going to opera houses, French impressionists, African and Oceanic primitive art—blue-chip stuff. Voulkos, walking into the Los Angeles of 1954, was like a boy in a candy store. He was not a visitor, as he had been the year before in New York. He had a job to do, a reputation that had preceded him, he was part of it. And he proceeded to do what he had to do.

He arrived in August 1954 with his wife, Peggy, and their young daughter, Pier.

The next month Paul Soldner arrived. "I was his first student and the only one for about two months. It was great. There was nothing there and we had to build it. We did it all together. He accepted me completely as a peer, as a friend, not as a student. The minute Pete got to L.A. he hit the galleries. He was hungry for everything that was going on and he drank it in. We went to the galleries all the time. We built everything—the wheels, the kilns, the tables and shelves, everything. And it's still there. Actually it was the best thing that ever happened. We not only learned to set up a pottery, but we helped plan the department. That's how I got into the pottery-wheel-building business, and seriously into teaching."

Voulkos and Soldner first built two kick wheels for themselves so they could start work immediately, then built motorized wheels with

LOS ANGELES: THE CLAY REVOLUTION

pipe and plywood, and, with the help of ceramics engineer Mike Kalan, a kiln of forty cubic feet—four feet wide, two feet deep, and five feet high, an updraft kiln with four perimeter burners that could fire at 2,300 degrees in five to eight hours. ("You can fire any kiln in eight hours or less providing you have the right combination of fuel and air. But I remember they used to fire twenty-four to thirty-six hours, too," says Voulkos.)

The ceramists in the area also pitched in—Vivika and Otto Heino at USC, Richard Petterson at Scripps College, and, particularly, Albert and Louisa King, who had a pottery kiln near the Watts section. Voulkos visited them often, learning from these mature and excellent potters both craft and life-style. They did highly controlled slip-cast high-fire porcelain—copper reds and celadons. Voulkos recalls:

The Kings could reproduce any Chinese glaze you ever heard about, much less saw. Their firings were highly controlled and predicated on the weather—they fired according to the kind of day it was. Those firings were very tricky to do—very complicated. There was a lot of technology involved, especially in the calculation of the glazes.

I used to go out and see them quite a bit. They had a huge avocado tree that was just out of sight, with thousands of avocados, and every year they'd pick it and make avocado butter out of it. It was the biggest avocado tree I ever saw in my life. At the time, I didn't even know what an avocado was. To me it looked like something you should throw away.

Within two months the shop was usable. Since Pete did not yet have a studio of his own, he began to work in the school's communal pot shop as he had at Archie Bray's. In order to give Voulkos the chance to organize and build its ceramics program, the institute had not yet advertised it, so for the first quarter Voulkos and his colleague-student Soldner had the run of the place.

Voulkos ran the pot shop as a freewheeling place. Students from outside the department and nonstudents began to drop in and work with greater frequency until they became (unofficially) part of the regular crew. Billy Al Bengston, now a painter, and Ken Price, both registered students at Los Angeles City College, joined Pete. John Mason from Chouinard, the painter Malcolm McLain, who had returned West after a period in New York, Michael Frimkess, Jerry Rothman, and Henry Takemoto were among the most outstanding participants of those early days. Mostly they worked in what Fred Marer calls "a twenty-four-hours-a-day, seven-days-a-week atmosphere."

Voulkos describes his method of teaching: "We'd all go to the class, and then the first thing we'd do is go off in three cars, driving

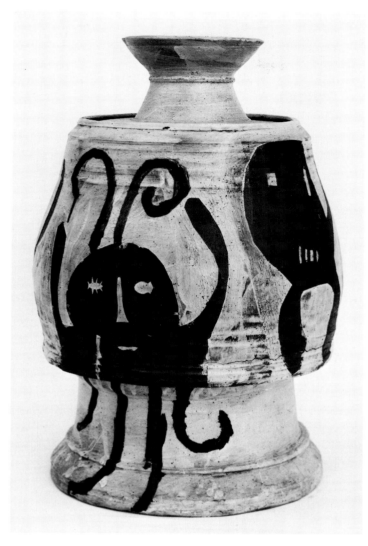

11. Jar, 1956
*Made in Los Angeles; stoneware, paper
cutout stencil over red iron slip, brushed with
white and black iron slips; 20 inches high. See
page 109 for more details on the technique.
(Collection of Fred Marer. Photographer:
Frank J. Thomas)*

around town, going to see whatever there was to see in the galleries, drinking coffee and talking. We'd look at a new building going up or a show at a museum. Then we'd talk some more. Then we'd go to work. My purpose was for the students to become aware not only of everything around them but of themselves, to find themselves, to get to the point where they felt they were the complete center of the universe and everything worked around them. Then they could go ahead and work. Everybody gets involved in new materials, old materials. My point was to make them aware just of themselves."

Voulkos in those years was as involved in finding himself as he was with helping his student-colleagues. They all gave to and supported each other in this search. The presence that precipitated the identity crisis was New York action painting. The influence of Clyfford Still and Mark Rothko, who had been teaching since the late forties

LOS ANGELES: THE CLAY REVOLUTION

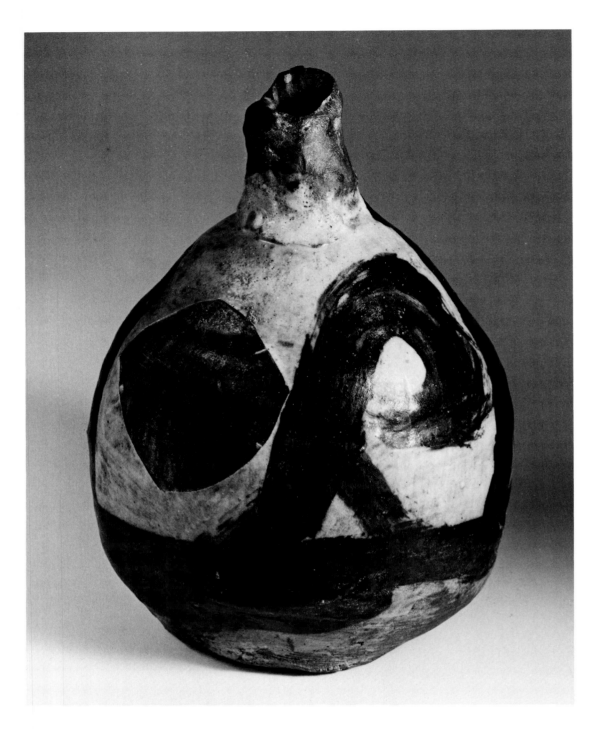

12. Vase, 1956
Made in Los Angeles; stoneware, wheel-thrown; wax resist and brushwork; paper cutout stencil masks round pattern on bisqued pot coated with red iron slip; several layers of white slip are brushed over entire surface before stencil is removed to reveal sharp-edged inset pattern; 20 inches high. Black iron slip brushwork over white slip contrasts with stencil pattern. (Collection of Margaret Voulkos. Photographer: Joseph Schopplein)

PETER VOULKOS

on the West Coast, was decisive and prepared the way for the shock of recognition that came with the exhibitions of Pollock, de Kooning, and Gorky in Los Angeles.

Soldner recalls the mood of those days:

All the elements we needed were in evidence. We were feeling the Oriental influence, Zen, we were swept up in the beatnik period. We were part of that, but we didn't know it until later. We were all involved in jazz and the movies. We did everything with Pete. He gave us the sense of caring. People misinterpret his casualness and ease. He knows exactly what he's doing. He is in absolute touch with the material, with himself. It's like watching a dancer. The precision looks easy, effortless. Pete didn't have his own studio at that time and he worked in the classroom alongside his students. People began dropping in. They did not enroll. They just worked. It was dynamic. It never happened before. It never happened again like that. He didn't lecture, he didn't teach, he just worked. We all realized there was something very exciting happening. It was a new school, new teachers, new students, many of them more mature than before because of the GI Bill. It was an explosion peculiar to the time, and the energy was down in that cellar at Otis in the ceramics studio.

The influence of Voulkos's personality on his students and others was strong. "We caught his macho style and relished putting on the act for each other. When we went to a party we didn't dance. We sat on the sidelines, smoked cigars, and drank whiskey," says Soldner.

John Mason gives an analytical and measured summation of the period:

In fifty-four I'd been in and out of school for five years and I felt I'd about reached my saturation point. It was a time when everybody was into pottery on the West Coast; everybody was throwing pots. I'd seen a show of Pete's in San Francisco which impressed me; it was obvious that he was ahead of almost anyone I knew. The people who were attracted to him over the years and he certainly attracted a lot of people, took him as a model and as a great person to be around.

Voulkos's interest, although he was really an excellent potter, was in painting on surfaces. McLain was also interested in painting on surfaces, making surfaces and painting on them. It was a fairly simple approach and it followed a lot of possibilities; its strongest obvious influence was the painting going on at that time in this country. But there were also a lot of influences out of Japanese brushwork as well. So it was kind of a crossover. The glazes were fairly simple; it was mostly working with the brush and some oxides.

In a sense we were at that moment producing a lot of pottery that was almost like production pottery except that it didn't follow the kind of channels pottery would take if it was to be a line of ware. It did follow the tradition of the wheel and did follow the container-vessel situation. But the real purpose was working on these surfaces and what then might come of that.

The thing that fascinates me about this period is that it had been preceded by a time when there was not enough technical information to con-

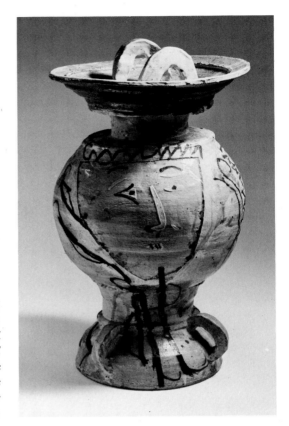

13. Covered jar, 1956
Made in Los Angeles; stoneware, wheel-thrown and slab
construction; several layers of white slip applied over stencil
placed on primary coating of white slip, leaving sharply edged
indented pattern when stencil is removed; slabs and black
iron brushwork complete face and rest of decoration; 17 inches
high. (Collection of Margaret Voulkos. Photographer:
Joseph Schopplein)

tinue the craft in a vital way after it had been bypassed by the industrial revolution and industrial products and procedures had taken over the craft tradition. So here was a period of rediscovery, of learning all this information in order to reestablish the handcraft. And yet at the moment when it was possible to reestablish it, the people who were really involved in it didn't want to reestablish it as straight craft. They wanted to take it somewhere else outside that straight-line continuity of the craft tradition. And it wasn't just one individual—it was a common feeling.

At that time, there were lots of funny little support systems. There were associations of potters, which I think exist everywhere. There were exhibitions or sales. There were communal activities, and at every seminar or demonstration or whatever, there was always talk about the future of pottery, of the craftsman, the artist, and there was always a desire to do something greater, more profound, more adventurous, more creative.

It was more than just the simple homage to abstract expressionist painting. I think it also had a good deal to do with feelings of doubt about pottery, with reevaluating the whole history of ceramics and with reexamining attitudes about the use of clay. In other words, we were exploring the techniques to take them someplace where the previous tradition would not normally have supported them. There was a feeling that it was time to change; it was kind of a consensus. Among the people who really believed that was Peter; he had come out of a production situation at Archie Bray's to Otis, an art school. He was very conscious of the fact that he was teaching in an art school and of wanting to do something within that environment. There were other people around who were advocating doing something in the other

PETER VOULKOS

media. You've seen what happened in the weaving and glass fields. You can see the same parallel concerns. There were a lot of forces that were really shaping this thing, that were feeding into it, and there was a community of ideas. Although there was a lot of common talk about "doing something adventuresome," the minute it began to happen, the people who had been promoting it suddenly became very resistant to what was going on. They felt very threatened by it.

The first months at Otis, once the equipment got going, were still primarily within the old ongoing activity of throwing a pot, painting it and firing it, and there was a good deal of exploration in the possibilities of how to paint on a pot or what techniques you might use. But Pete really wanted a change. So he spent the summer of 1955 in Montana, and he came back with some combination forms he had made, thrown things that he had assembled. They still looked very potlike; they had pot glazes on them, and the way they were linked together made them look like pot assemblages, really. But Pete made the move—the first at that time. I think the fact that there was a real move triggered a lot of other activities. Soldner then really got interested in doing tall thrown pieces. He wanted to see how tall, how big, he could make things. He got into a whole series of very elongated forms. I got into a series

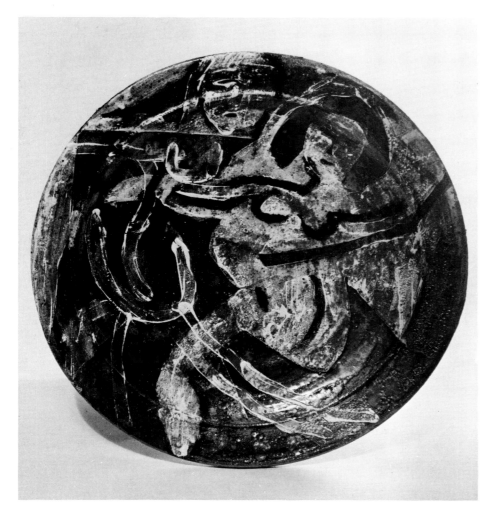

14. Plate, 1957
Made in Los Angeles; stoneware, stenciled and brushpainted with multicolored slips and oxides; 18 inches in diameter. (Collection of Fred Marer. Photographer: Frank J. Thomas)

LOS ANGELES: THE CLAY REVOLUTION

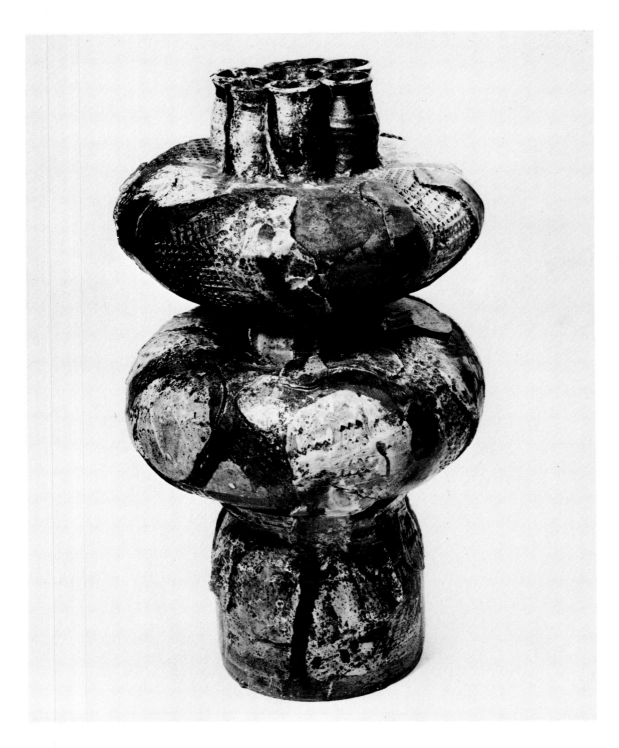

15. Branch vase, 1956
Made in Los Angeles; stoneware, wheel-thrown in three sections and seven spouts; cutout slabs applied to form thin relief patterns on surface covered with white slip brushed with red iron slip; 33 inches high. One of Voulkos's early assembled forms, this was first shown in October 1956 at the Museum of Contemporary Crafts at its opening show, "Craftmanship in a Changing World." (Collection unknown)

PETER VOULKOS

of plastic transformations of pots, thrown and then shaped, changed, altered. They were pots, but they were shaped—they were shaped from the inside and shaped from the outside, done in a very plastic state. Pete went on to continue his assemblage. By fifty-six, fifty-seven, those areas were pretty well defined. The basic technique that Voulkos used in all his clay structure after that was set.

Voulkos began seeking out his forms, exploring the possibility of each form. A show of Fritz Wotruba's sculpture at the Los Angeles County Museum gave him the clue to stacking and cantilevering volumes as a method of assembling individual forms, as a way of floating the solid energy of his continuing emergence of forms. He would work on five or six forms at a time, piling them all over the floor until he would start stacking them. Visitors could hardly walk through the basement as new forms were constantly produced.

Paul Soldner describes the day Voulkos first broke with the symmetry of the bottle.

Some really beautiful girls came over from the Chouinard Art Institute and asked Pete to throw a big pot for them. He threw the pot and they were impressed. Then we sat down and had coffee. I remember he kept looking at the pot. Although the girls were beautiful, Pete just wasn't paying much attention to them, or certainly not as much as he ordinarily would have. After they left, he went over and cut the top off the pot. Then he threw four or five spouts and stuck them around the rim. That didn't seem to work, because it still had the old bottle lip. So he pared that off. The pot was still soft. So he recentered it on the wheel and gouged three huge definitions— the top third, the center third, and the bottom third. In one afternoon, he made the jump from one kind of thinking to another—but it was one that he had been looking for for a long time.

Those were the decisive events that took Voulkos from the Archie Bray classicism to the Los Angeles anything-goes adventurous spirit. The pot, called *Love Is a Many Splendored Thing* (since lost), was included in his first exhibition at an art gallery—at the Felix Landau Gallery, in Los Angeles, in 1956—the show that won him both the admiration and the protest of the clay world as well as the attention of painters and sculptors.

Peter Voulkos's New York show at Bonnier's in December 1956 was of the same body of work and merited the following review by this writer in *Craft Horizons*:

Peter Voulkos, the potter, reveals a restlessness with the confines of his craft. He has pushed it as far as he could in the direction of modern painting and sculpture, retaining only the central form of a basic hollow container on which he then proceeds to build. Spiny protuberances, complementing amazing surface textures of thin slabs beat on with a mallet; form piled on form

LOS ANGELES: THE CLAY REVOLUTION

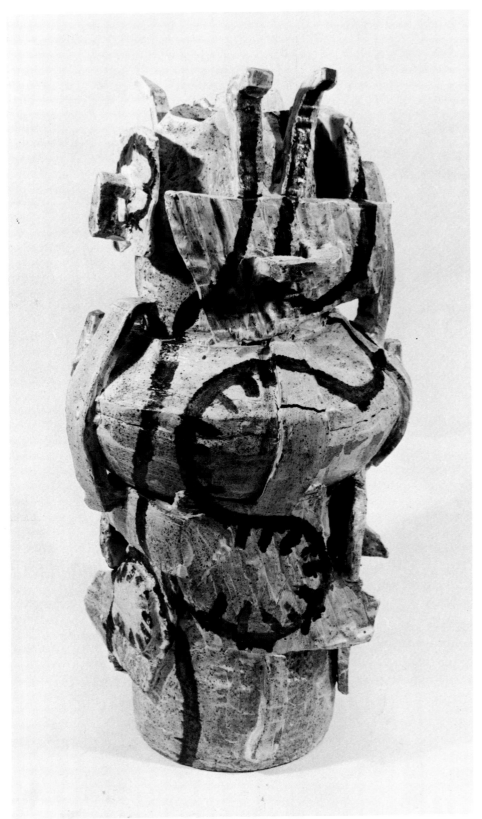

16. Pot, 1956
Made in Los Angeles; stoneware, wheel-thrown in three parts; slabs applied and slip-welded as dimensional elements of the construction. The surface of the entire construction was covered with white slip before rusty brown (red iron) slip was brushed as a color element to set up tensions between form and surface; 40 inches high. Along with the Rocking Pot *(Figure 19), this piece represents a major breakthrough in the evolution of Voulkos's pottery sculpture. It was shown in his exhibition at the Felix Landau Gallery in Los Angeles and at Bonnier's in New York. (Collection of S. A. Rosenfeld. Photographer: Oppi Untracht)*

PETER VOULKOS

or cut through to allow the insertion of narrow slab constructions; the surface and texture of the pot used as a canvas-in-the-round for painting are the features of some of the large and most compelling works. The influences of Picasso, Japanese raku pottery, and the American "action" school of art are there along with Peter Voulkos himself, who emerges as a truly magnetic experimentalist. This fine and accomplished potter, searching his craft for new solutions more related to the explorations taking place in modern art today utilizes these elements: The new consciousness of spontaneity as a force, and the deliberate effort to achieve it; the charm of "accident"; the violation of precedent (this does not mean a disrespect for it) in order to disturb old ideas and stimulate new ones; the new freedom of the artist to express his particular personality and psyche with directness and depth. Voulkos has ventured courageously into a risky area for potters. But Peter Voulkos the potter and Peter Voulkos the painter and Peter Voulkos the sculptor all make a fascinating pot and a controversial one.

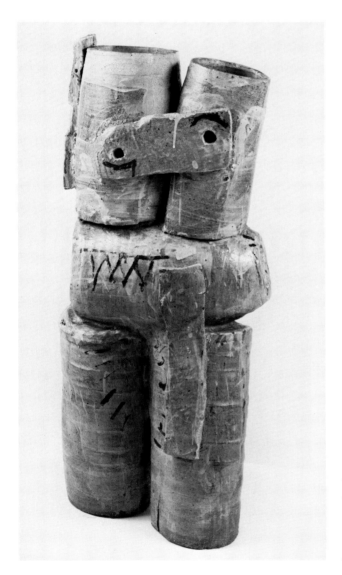

17. Pot, 1956
Made in Los Angeles; stoneware, made in five cylindrical parts with slab strips joining elements. White slip, brushed red iron slip markings, partially glazed; 42 inches high. One of a series of figurative pieces. (Collection of Museum of Contemporary Crafts, New York. Photographer: Bobby Hanson)

LOS ANGELES: THE CLAY REVOLUTION

The basement of the Otis Art Institute became a mecca, a magnet, and a forum for discussions, clowning, Indian wrestling, laughter, parties, on a firm and unremitting ground of continuous hard work.

The standing joke was to compete for the distinction of making the ugliest teapot of the day. "Dump and Deathware," they called it, as opposed to the classical "Life and Lift." The place was jammed with work and with people dropping in and out. Voulkos says, "We used to have contests to see who could throw the fastest teapot. We tried to make a teapot in two minutes complete—throw it on the wheel, make a lid, a spout, real fast. We were always trying to beat the two-minute mark. Had some of the weirdest-looking teapots you ever saw, some of them fantastically good. You couldn't start fooling around with it. You had to go by sheer instinct. You just had to know it was going to fit right. We started contests all the time. We had some pretty funky teapots."

The Los Angeles clay movement, with Voulkos its acknowledged leader, became the counterpart to the New York movement in painting, and its most direct and vigorous response, its natural extension in a material to which expressive action was intrinsic.

In 1956 Otis Chandler gave the Otis Art Institute to Los Angeles County and it became the Los Angeles County Art Institute. Nonclay artists, painters in particular, hung around the institute, including Leonard Edmondsen, Richards Ruben, Emerson Woelfer. It was Ruben, especially, who, with Voulkos, struggled with the new sensibility, and the two became close friends. (Ruben left Los Angeles to come to New York in the early sixties, shortly after Voulkos left for Berkeley.) Among the nonartists who came and sat on packing crates, watching the work, listening to the arguments, participating in them, was Fred Marer, the modest teacher-mathematician who taught at nearby Los Angeles City College. He acted as spokesman, enthusiast, confidant, sponsor, patron (although he was a man of very modest means), friend, partisan, and supplier of the coffee, which he bought at sales, a dozen pounds at a time for forty-three cents a pound, and brewed "hobo style" in the can it came in, throwing out the can when it started to leak. No one thought to make a coffeepot.

The Los Angeles years, from 1954 to 1959, were the most exciting, intense, obsessive, and productive years of Voulkos's career, and sparked a clay movement that was to spread throughout the country and continue in its varying modes of experimentation and stylistic diversity to this day. The participants were the first generation of American ceramists to make their break from European and Oriental traditions. Voulkos absorbed all influences like a chameleon. At times

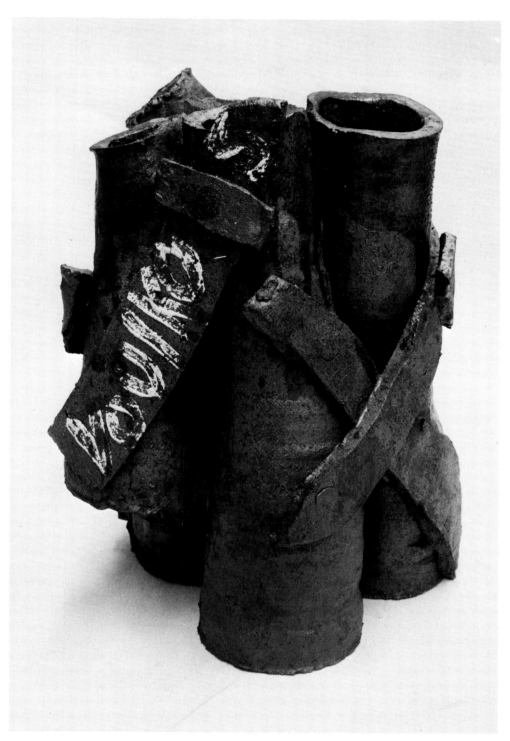

18. Multiform Vase, 1956
Made in Los Angeles; stoneware, shapes wheel-thrown and paddled for eccentric tilt; slip-welded and joined by slabs with ceramic "nails," pressed in as if they had been hammered; black iron and white slips; approximately 20 inches high.
Wit is often the essence of the Voulkos aesthetic. (Collection unknown)

LOS ANGELES: THE CLAY REVOLUTION

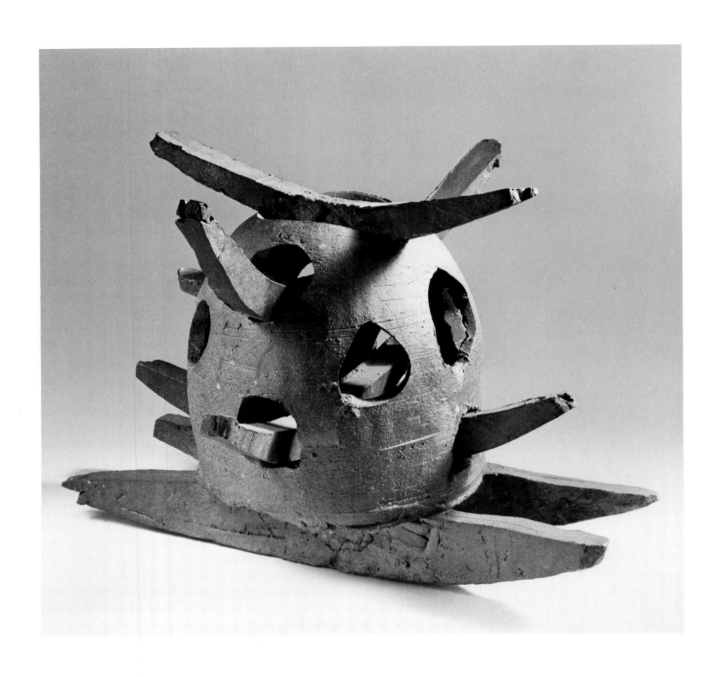

19. Rocking Pot, *1956*
Made in Los Angeles; stoneware, wheel-thrown and slab construction with a thin colemanite wash; 14 inches high. This was one of Voulkos's earliest outright sculptures. The pottery technique is evident, while the pottery function is subverted to the formal invention. "I claim this as a Pot," says Voulkos. (Collection of Peter Voulkos. Photographer: Joseph Schopplein)

PETER VOULKOS

he was Picasso using his line; at times cutting and pasting like Matisse, making collages like Marca-Relli, using Kline's brush and sweep, de Kooning's fragmentation and explosions of form and color, the crudeness and spontaneity of Zen pottery, the flamboyance of the Italians, the formal control of the Scandinavians. He tried everything, searching for what he needed. All this time Voulkos also painted, still considering painting his first love.

Voulkos's struggle to build massive volumes of clay forms went on for several years. It was not until 1958 that he began to achieve the scale he searched for, beginning with the five-foot-eight-inch-high *Soleares.*

Among the factors that made the work on this scale possible was the new $75,000 building the Los Angeles County Art Institute constructed to house the ceramics department. Voulkos, a lover of machinery and equipment, always scrounging around industrial supply and Army surplus warehouses, keenly alert to the possibilities of every nut and bolt, installed there a secondhand giant dough mixer, which bakers used to mix hundreds of pounds of yeasty bread dough. It now could be used to mix speedily dry powdered clay with water in the massive quantities that Voulkos and his students needed daily. (In 1956, Voulkos, Soldner, Mason, and McLain together used over fifteen tons of clay. Some of Voulkos's sculptures alone used as much as two tons.) "Clay is about one-third water, so we decided we were paying a lot for water—especially since we ordered two tons at a time. So we went to see how they make clay at this place where we bought our clay and found out they were using old dough mixers. We went and got one from a used bakery equipment warehouse and made our own clay. Been using horizontal dough mixers ever since."

The new building also had three kilns. These enabled Voulkos to become even more prolific, experimental, and to maintain the constantly accelerating rhythm of his spontaneity and invention. He worked continually and obsessively, within the community and camaraderie of the circle of friends, students, colleagues, well-wishers, kibitzers, and observers who worked absorbedly and intensely alongside him. Work was the fever of those years. An incredible amount of work was produced in this short period—no more than five years—and it was then Voulkos achieved his international fame.

Though the facilities at the institute were excellent and Voulkos was open and gregarious in his working methods, he still needed more space and privacy to pursue his growing obsession with monumental scale and the technical and aesthetic problems that would have to be solved in the clay medium before he could achieve that scale. In 1956,

LOS ANGELES: THE CLAY REVOLUTION

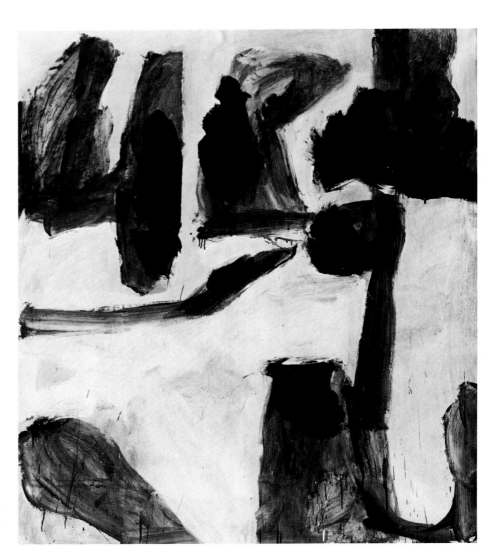

20. Painting,
Blue Remington, *1961*
Vinyl and lacquer, blue,
black, white; 79 inches high
by 68 inches wide. (Collec-
tion of Pauline Annon)

he rented a large one-story warehouse on Glendale Boulevard around the corner from his house. John Mason shared the space. Together they built a studio out of which came the largest ceramic sculptures to be made in this country. The two men, contrasts in personality, could supplement and fortify each other's already impressive skills. Each had a unique point of view but shared the abstract expressionist zest.

Mason, who had joined Voulkos at Otis soon after his arrival in 1954, had first met him at Chouinard Art Institute when Pete went there to check out the facilities as he sought to build the Otis ceramics department. Mason was instantly attracted to the Voulkos energy, to what he recognized as a vigorous and open reconnaissance into all possibilities. As Mason says, "As a result of his many interests and curiosity, I became aware of those things myself." Mason, taciturn, or-

PETER VOULKOS

ganized, tenacious, and fiercely independent, was a contrast to Pete with his open, warm, gregarious, easygoing personality. They were able to work independently, respecting each other's approaches. Mason, moreover, having worked as a production potter for the California ceramics firm of Vernon Kilns, could contribute valuable know-how in industrial ceramics technology. Of all the gifted ceramists who were attracted by the Voulkos magnet, Mason was the one who could most easily hold his own. Several of the others had to get away from Voulkos's powerful influence in order to define their own identities. As Pete himself says, "John is and always was his own man."

By then the Voulkos method, which was also his style, was established. He used the wheel as the tool for spinning out the shapes he wanted and then combined them in complex and massive assemblage. Mason, on the other hand, was involved with direct plastic manipulation and transformation of thrown shapes, as well as with making architectural wall tiles and murals.

Together with ceramics engineer Mike Kalan they built the Glendale Boulevard kiln, one of the largest updraft reduction kilns in a private studio at the time—120 cubic feet, six feet high by four feet deep, with a five-foot-wide firing chamber. They worked together

21. Pot, 1957
Made in Los Angeles; stoneware, made from wheelthrown parts paddled and combined; tooled surface brushed with white slip and washed with thin, rutile glaze; 20 inches high. This pot was shown at the World's Fair in Brussels in 1958. (Collection of James Melchert)

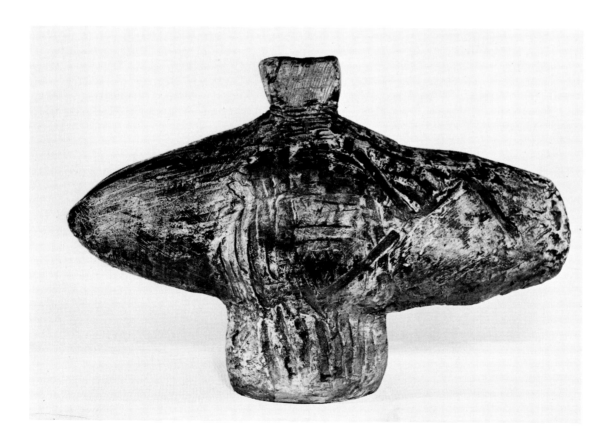

LOS ANGELES: THE CLAY REVOLUTION

on technical problems, helping each other in the arduous physical labor in which they were mutually involved—lifting, moving, hauling the pieces that were unprecedented for their size. Mason says, "It was impossible for one person to load one of those big pieces in the kiln and very often it took more than two people. Certainly that sort of sharing and helping and concern was there. We were in some ways very similar and in other ways quite different, and we made an effort to keep a kind of attitude that made it possible for two people to work in that small place. When you think of the kind of scale we were working on, it was amazing."

Voulkos worked there until 1961 (commuting from Berkeley after he began teaching there in the fall of 1959). Mason kept the studio until 1970, when it was torn down.

While in Los Angeles, Voulkos, who had always loved music and played saxophone for his high school band, became a guitarist and composer. He says that it was through the guitar and his intensive three-year study of it that he learned about form. He found music a necessary element during the work process and always had records playing in his classroom and in the studio. After a night's work he would go to the jazz joints in Los Angeles with his group.

Soon he and Arthur Ames, enamelist and fellow instructor, were going almost daily to the shop across the street from the Los Angeles County Art Institute to buy records. It was Ames who introduced Voulkos to the music of the great Spanish classical guitarist Andrés Segovia. One of Pete's students, Kayla Selzer, soon sent him to the music teacher Theodore Norman, with whom he then took guitar lessons every Thursday, for more than three years.

He plunged into the study of the instrument with the same obsessive energy he gave to clay from his first encounter with that medium. He practiced five hours a day, was writing twelve-tone guitar compositions and using bop rhythms. For years Voulkos was never seen without his guitar; wherever he went—and he was already frequently on the road, demonstrating and lecturing all over the country—he took along his small yellow drawstring bag containing his spatula, blade, sponge, shoes—and his guitar. He was extraordinarily gifted and became almost as popular a musician/performer as he was a ceramist/teacher/performer. He brought to the guitar the same touch that he brought to the clay. It was in that touch, the rhythms, the vibration of the strings, that he could continue the search for form that absorbed him in the spin and touch of the turning clay. But the music did not

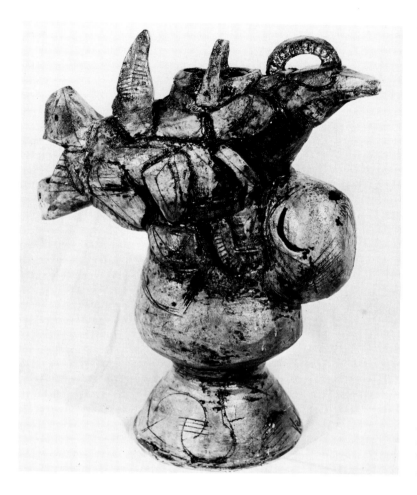

22. Chicken Pot, *1957*
Made in Los Angeles; stoneware, wheel-thrown and slab construction, sgraffito with light blue and black low-fire glazes; 32 inches high. (Collection unknown)

hold him. Instead Voulkos went to Berkeley and turned his attention to bronze. Today he says of his composition books, "It's like a foreign language. I can't even read them." Yet, unconsciously, he was to transfer his experience in music—his sense of musical form—to his bronze forms and rhythms. He was amazed not long ago to recognize the visual similarities between his musical notation and his bronze sculptures.

As the fervor and the population in the basement pot shop at the Los Angeles County Art Institute grew, as Voulkos's reputation grew, as unorthodox methods, working hours, and the number of unprecedented pieces increased, so did the administrative pressures, professional jealousies, and competitive power needs of the Los Angeles County Art Institute. The school, as all schools in those years, was doing well, but the basement was threatening to take over. Millard Sheets was not in sympathy with the Voulkos stride, much less with his stance. Aside from the fact that Sheets had not bargained for what he got, he did not approve of the work that was coming out of the

LOS ANGELES: THE CLAY REVOLUTION

ceramics department. He was essentially in sympathy only with the classical pottery tradition. "One day the faculty members at Otis all got together in a restaurant for a luncheon meeting. Picasso's name came up," Soldner relates. "Millard Sheets said Picasso had no business monkeying with clay. Pete was quiet. He said absolutely nothing. When he got back to school he headed straight for the library, got a pile of pictures of Picasso's plates and put them up all around the walls. That was his answer." It did not escape Sheets's attention. Sheets, moreover, who juried the student ceramics show in 1958, rejected more than half the submissions and told them to get out of their ivory tower. Instead they got into one, opening a gallery called "The Ivory Tower," and held exhibitions of student work from the Voulkos group. And when Sheets came across a distorted pot by Billy Al Bengston that added insult to aesthetic injury with the inscription "Fuck You" exquisitely sgraffitoed and brushed on the surface, he took it as a personal affront. Finally, when the ceiling of the new building just above the kiln was charred, things came to a head. Sheets fired Pete in May 1959. In June, the Art and Design Departments of the University of California at Berkeley jointly appointed Voulkos assistant professor of ceramics. (The joint appointment, unprecedented at the university, continued until 1976 when the Design Department was phased out and Voulkos became a full professor in the Art Department.)

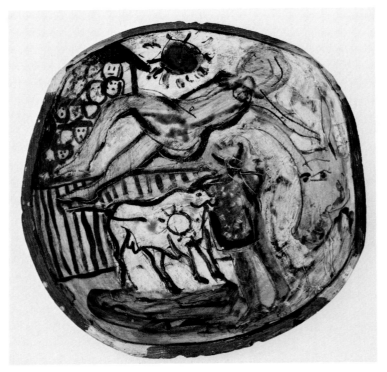

23. Plate, Bullfight, *1957*
Made in Los Angeles; low-fired with multi-colored glazes; 18 inches in diameter. This is one of Voulkos's rare figurative drawings, made during a period when he was strongly influenced by Picasso and the bullfight theme. (Collection of Fred Marer. Photographer: Frank J. Thomas)

PETER VOULKOS

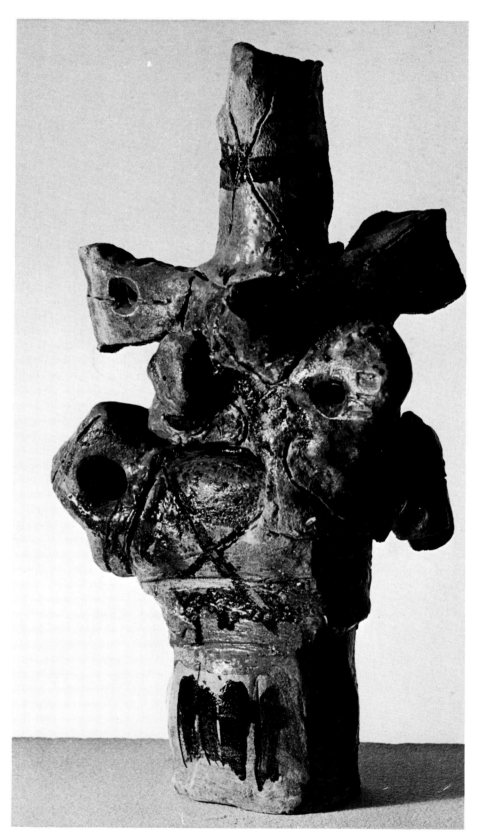

24. Vase, 1959
Made in Los Angeles; wheel-
thrown and slab construc-
tion, squeezed, paddled;
sgraffito; white slip with
areas of celadon glaze and
brushed black glaze; 20
inches high. This piece won
a prize at the International
Ceramic Exposition in Os-
tend, Belgium. (Collection of
Fred Marer. Photographer:
Guy Mognaz)

LOS ANGELES: THE CLAY REVOLUTION

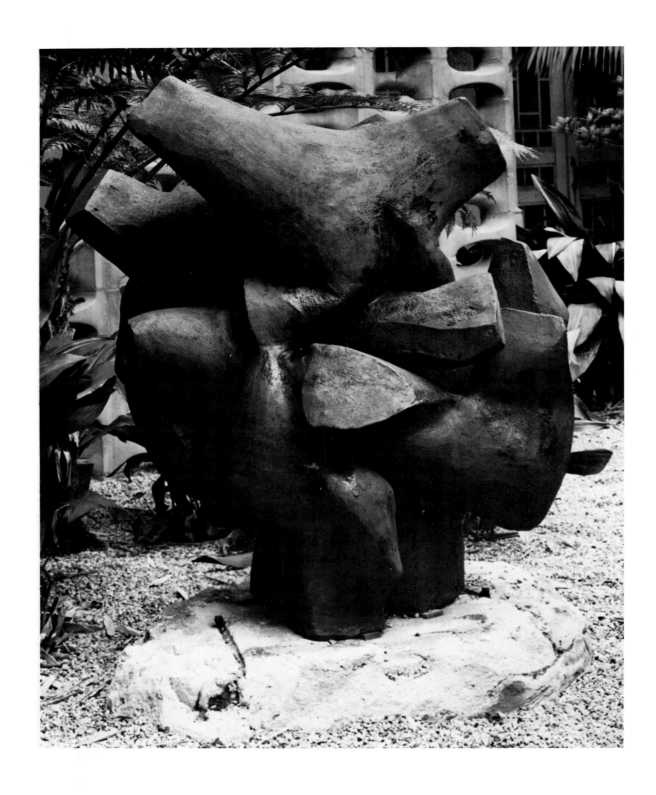

25. Sculpture, Black Butte-Divide, 1958
Made in Los Angeles; stoneware, wheel-thrown and paddled construction; black iron slip and thin natural glaze; 47½ inches high. (Collection of Norton Simon Museum of Art, Pasadena, California)

PETER VOULKOS

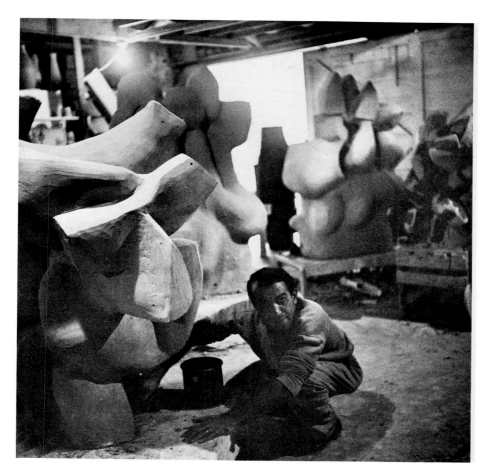

26. *Voulkos in the studio, 1958, with* Black Butte-Divide (*left*), Rondena (*center*), *and* Black Bulerias (*right*)

By the time Voulkos finally left Los Angeles in 1961, the original Otis group had scattered, each struggling to find his own form and escape the orbit of Voulkos's influence. Kenny Price, one of the most gifted of the circle, had gone all the way to Alfred, perhaps because of Voulkos's own rejection of that school's academic emphasis on traditional pottery. Price was intent on learning the glaze technology that Voulkos minimized at the institute, subordinating it to the priorities of spontaneous expression and individual search. He was to emerge with a highly personal and mysterious aesthetic that was to make him as legendary as Voulkos but for exactly the opposite reasons. He became solitary, seeing few people, working on intimate, small forms—a cup series, with exquisitely articulated forms and glazes, shown by galleries and museums internationally and prized by collectors. Now living in Taos, New Mexico, he is working on a miniature scale, creating a curio shop of souvenirs from his own life. As he completes each miniature, working in his vast new studio, a former supermarket, he packs and stores it for the day when the curio shop will be complete and will be shown in toto.

LOS ANGELES: THE CLAY REVOLUTION

27. Vase, 1959
Made in Montana; stoneware, wheel-thrown
and paddled in four sections; sgraffito and
slashes; painted with black iron, white, and
cobalt slips; 23 inches high. (Collection of
Minnesota Museum of Art, St. Paul)

By 1962 the clay revolution had reached every university art department in the country and its momentum had affected other media, particularly glass, with the work of Harvey Littleton at the University of Wisconsin at Madison. True, there were pockets of strong resistance, but the face of modern American ceramics was never the same again.

In 1958 and 1959 Voulkos produced more than sixteen ceramic sculptures (not counting the ones that blew up in the kiln), of which the smallest, *Burnt Smog*, is just under three feet high and the largest, *Sitting Bull*, is five feet nine inches high. Of this series, the five-foot-five-inch-high *Black Bulerias* won the Rodin Prize at the first Paris Biennale in 1959. The seventeenth is the eight-foot-high *Gallas Rock*,

PETER VOULKOS

Plate 9. (opposite) Sculpture, Gallas Rock, 1959–1961
Made in Los Angeles; stoneware, over 100 thrown and slab elements, slip welded;
iron slip and glazed; two separate parts fit over each other; 96 inches high. (Collec-
tion of Frederick S. Wight Galleries, University of California, Los Angeles.
Photographer: Frank J. Thomas)

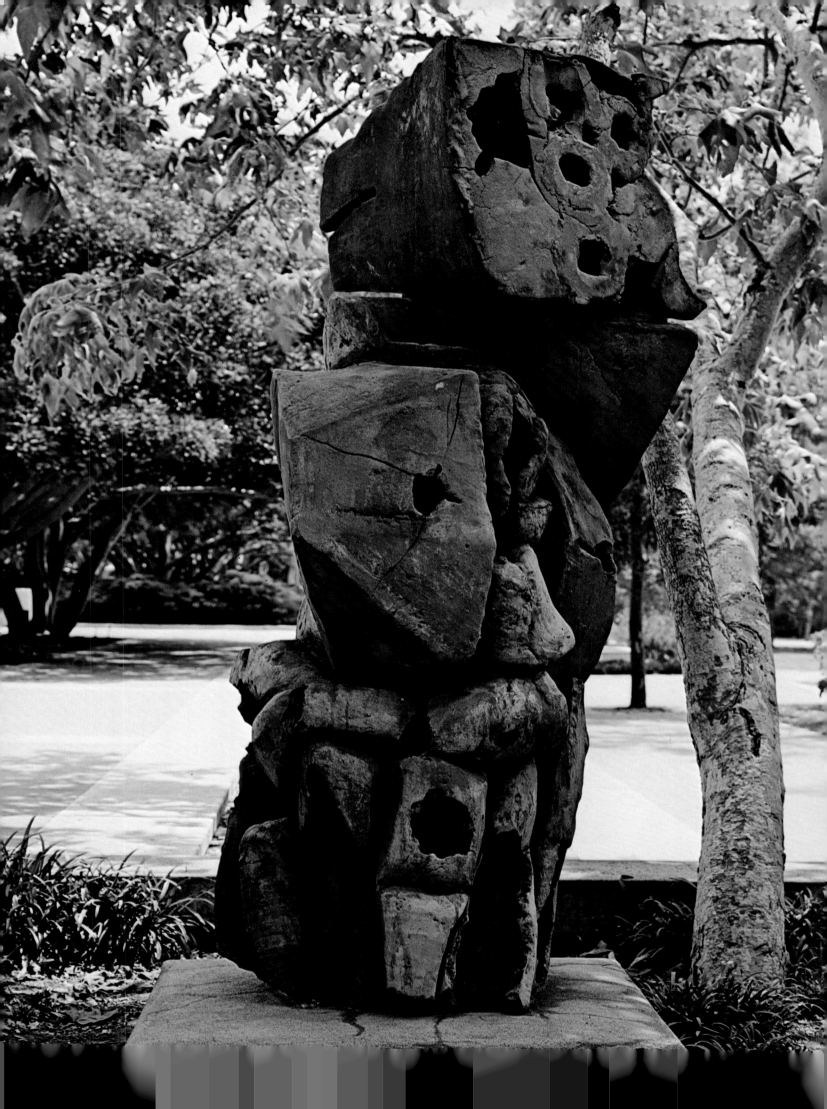

Plate 10. Pot sculpture,
Red River, *1960*
Made in Berkeley; stoneware,
wheel-thrown and slab construc-
tion, paddled and scratched;
white and black iron slips, red
and orange low-fire glaze at
low temperature; 37 inches
high. (Collection of Whitney
Museum of American Art, New
York. Photographer:
Bobby Hanson)

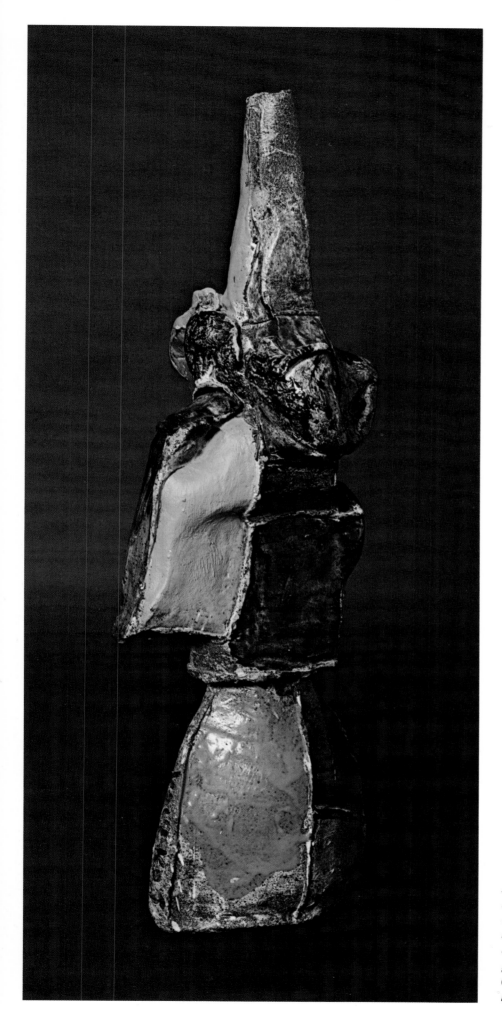

Plate 11. Pot sculpture, USA 41, 1960
Stoneware, wheel-thrown and slab
construction, paddled and manipu-
lated; orange, red, green epoxy paints,
cobalt, white, and iron slips, and light
glaze; 36 inches high. (Collection of
Corcoran Gallery of Art, Washing-
ton, D.C.)

Plate 13. Plate, 1963
Made in Berkeley; stoneware and porcelain, wheel-thrown parts and porcelain slabs; ticktacktoe sgraffito; cobalt, white, and gray slips with thin coat of clear glaze; 16 inches in diameter. (Collection of Fred Marer. Photographer: Frank J. Thomas)

Plate 12. (opposite) *Sculpture, Rondena, 1958*
Made in Los Angeles; stoneware, wheel-thrown elements paddled and constructed; brushed cobalt, iron, and white slips and epoxy paint; 66 inches high. (Collection of Mr. and Mrs. Stanley K. Sheinbaum. Photographer: Frank J. Thomas)

Plate 14. Sculptured vase, 1963
Made in Berkeley; stoneware, wheel-thrown, carved, and slab construction; blue and white slips with epoxy red paint; 11 inches high. (Collection of Gerald Nordland. Photographer: Frank J. Thomas)

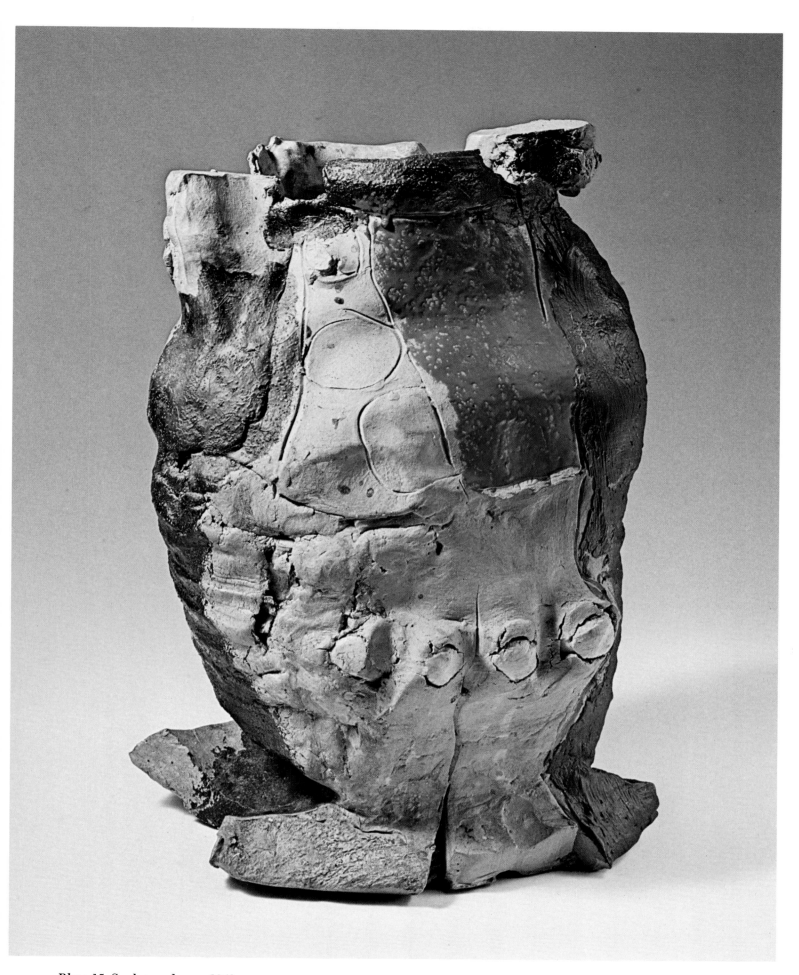

Plate 15. Sculptured vase, 1963
*Made in Berkeley; stoneware with porcelain pass-throughs, wheel-thrown and slab
construction; sgraffito; cobalt and white slips, lightly glazed, epoxy black and red
paint; 13½ inches high. (Collection of Mr. and Mrs. Matthew Ashe. Photographer:
Joseph Schopplein)*

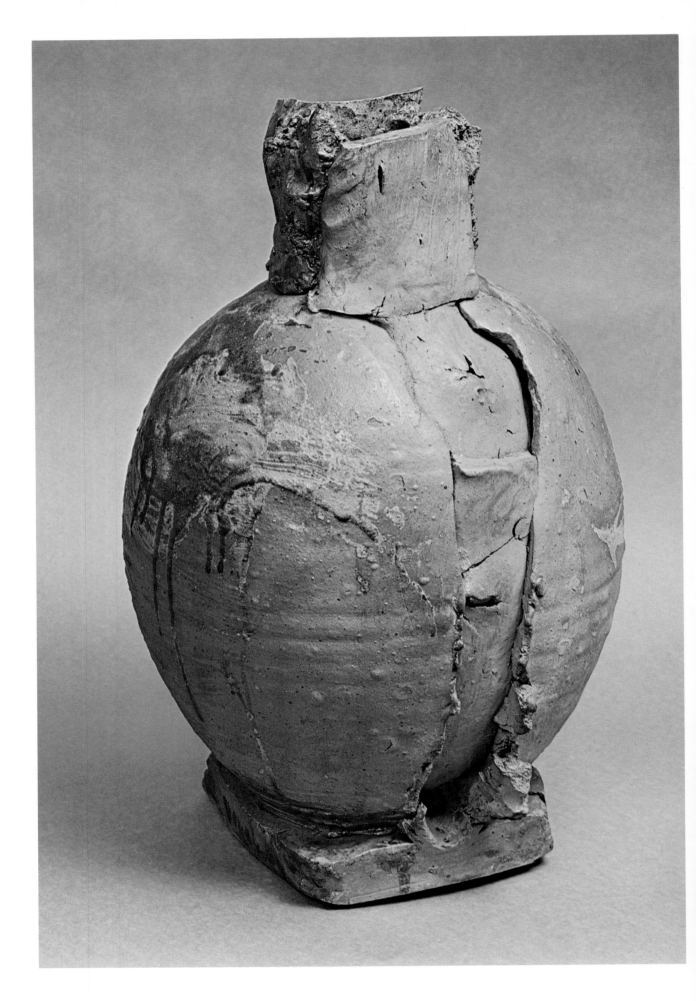

Plate 16. Vase, 1961
Made at Greenwich House, New York; stoneware, wheel-thrown with slab foot;
copper glaze and colemanite; 24 inches high. (Collection of Josephine Blumenfeld.
Photographer: Bobby Hanson)

28. *Sculpture,* Black Bulerias, *1958*
Made in Los Angeles; wheel-thrown and paddled shapes; covered with black iron
slip, brushed in places with white sand slip; 65 inches high. This sculpture won
the Rodin Museum Prize at the first Paris Biennale in 1959. (Collection of Mr. and
Mrs. Philip Gersh. Photographer: Frank J. Thomas)

LOS ANGELES: THE CLAY REVOLUTION

*29. Sculpture, 5000 Feet,
1958
Made in Los Angeles; stone-
ware, many wheel-thrown
and paddled elements as-
sembled and joined; covered
with black iron slip wash
and glazed; 41 inches high.
It was given the Los Angeles
County Museum of Art
purchase award in 1958 by
the sole juror, sculptor
David Smith. (Collection of
Los Angeles County Museum
of Art)*

PETER VOULKOS

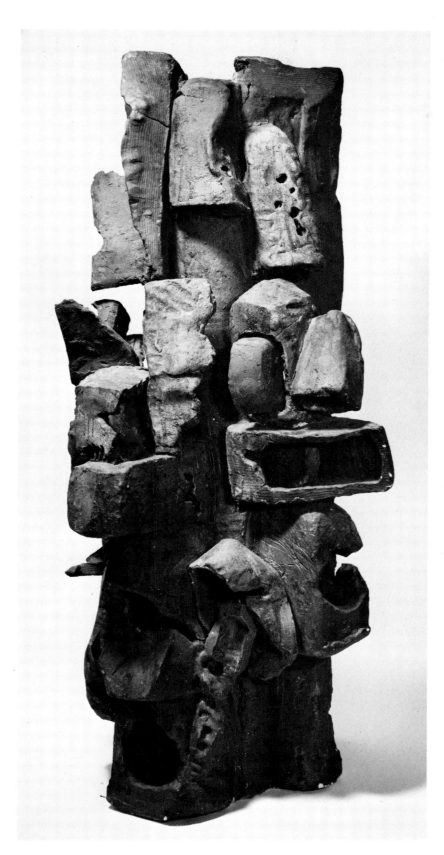

30. Sculpture,
Camelback Mountain, *1959*
Made in Los Angeles; stoneware,
wheel-thrown and paddled shapes,
with slab elements, assembled
and slip welded to a central
cylindrical core; covered with
black iron slip and thin coat of
natural glaze; 48 inches high. This
piece was made just after Sevillanos.
(Collection of Stephen D. Paine.
Photographer: Barney Burstein)

LOS ANGELES: THE CLAY REVOLUTION

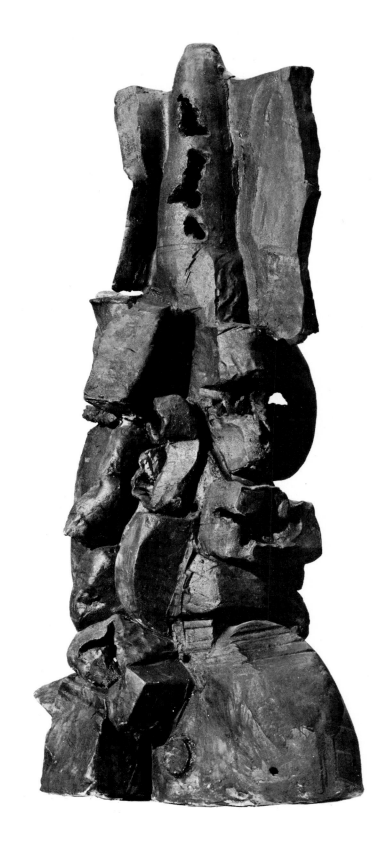

31. Sculpture, Sevillanos, 1959
Made in Los Angeles; stone-ware, wheel-thrown, paddled and slab construction; iron slip and thin natural glaze; 57 inches high. All pieces have been assembled and joined around a central cylinder. The eruptions of the clay surface articulate the character of the clay and Voulkos's own spontaneous handling. He has broken away from bulbous, mono-lithic construction and explores the spirit of open assemblage. (Collection of San Francisco Museum of Modern Art)

PETER VOULKOS

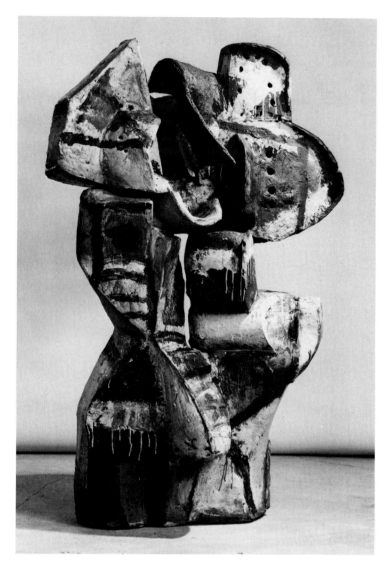

32. Sculpture, 1960
Made in Los Angeles; wheel-thrown, paddled
and slab construction; painted with white,
cobalt, red, and black iron slips; 68 inches
high. (Collection of Ruth Braunstein. Photog-
rapher: Joseph Schopplein)

for which he received the commission in 1959 and which he com-
pleted in 1961; it was produced during his transition from Los Angeles
to Berkeley, and from clay to bronze.

Voulkos describes his work of this period: "I was trying to learn
to throw big hunks of clay—one hundred pounds or so to make a two-
foot cylinder with a thick bottom. The basis of those sculptures is the
core cylinder inside with other cylinders going in different directions
to take the weight of the slabs. There is a lot of construction inside—
stacked cylinders to support a lot of weight—sometimes several cylin-
ders at the bottom. Outside and inside grew together, building on
themselves. I was working in such a way that I had to relate to every-
thing at the same time. The sculpture is building on itself. At the same
time, you try to keep the spontaneity. You can't sit there and think

LOS ANGELES: THE CLAY REVOLUTION

about it for long. You don't have that kind of time with clay. Clay is too fast; it moves fast and dries fast. That's one reason I turned to metal. So I could sit there and look at it a few days. Clay—I like to work real fast on it. It's not that you *have* to do it like that. You could cover it with plastic sheets and keep it for months. When I made *Gallas Rock*—it took me over two months to actually make it—it was a tough piece—it wasn't coming that easy and I kept going back into it. After a while, I felt I was contriving and losing its point. I almost gave up on *Gallas Rock*. Energy—you can't contrive energy."

In attempting to reach a monumentality never before achieved in modern Western ceramics, Voulkos struggled against the intimacy of his material; his venturesome spirit hungered for a scale that would not be inhibited by the material or the confinements of the base. While still in Los Angeles he had begun his investigations of the possibilities of bronze casting. A visit to the studio of sculptor Jack Zajac, who was experimenting with lost-wax casting, further pointed Voulkos toward bronze. At Berkeley, he would meet other artists who were to be decisive in helping him reach his goal. An additional factor in the shift of direction was the fact that at Berkeley, once again, the ceramics department had to be built from scratch. And at the same time Voulkos was setting up his own new studio on Shattuck Avenue in Oakland. All conditions pointed to change.

3. Berkeley and Bronze

33. (overleaf) Untitled, *1968–1972*
Thirty feet high, San Francisco Hall of Justice commission. (Photographer:
Roger Gass)

Early in 1960, just after he had settled in at Berkeley, Voulkos had his first one-man show of the large ceramic sculpture in New York at the Museum of Modern Art, as one in their series of New Talent shows. Organized by Peter Selz, then curator of painting and sculpture at the Modern, it showed six major pieces; five of these had been completed in 1959 and one in 1958; the tallest was sixty-five inches high and the smallest no less than forty-eight inches. Six paintings done in 1958 were also exhibited. Despite the fact that New York was at the height of its power in the art world, with the abstract expressionist movement at its peak, the show went largely ignored. Except for the discerning critic Dore Ashton, who wrote with enthusiasm about Voulkos for both the *New York Times* and *Craft Horizons*, the New York art world failed to recognize the major statement of Voulkos's massive works—probably because they were in clay and New York was snobbish about the modesty of the material. At that time, if it wasn't bronze, marble, or welded steel, it wasn't considered important. New York failed to understand that clay was the one material through which the energies of abstract expressionism could be expressed three-dimensionally. The contrast between the East and West Coasts in their perceptions of an artist and their attitudes toward craft was certainly made clear in the case of Peter Voulkos. The exhibition of the same body of work in California, at the Pasadena Museum just one year earlier, had united West Coast craft and art worlds in acclamation of Voulkos as a new amalgam of artist and craftsman, and of his craft as indispensable to both groups. In New York the craft world welcomed him as their craftsman–hero, flocking to his demonstrations at Greenwich House and Columbia University, but the larger segment of the art world remained aloof, in the traditional posture of disdain for "craft" connections. If ever Voulkos dreamed of coming to New York, that show was to dispel the notion. In the chummy, clubby atmosphere of the New York art world of the late fifties and early sixties, it was assumed that if you had any real talent you would bring it to New York, work, and brave it out with the rest of the boys who had come there from all parts of the country and the world. Voulkos was, therefore, an outsider, and it was years before he was taken into the professional and social ranks of the New York art world.

By then, Voulkos no longer cared. He had established himself in Berkeley, in a studio of a size that would never have been possible in New York, turning out bronze sculptures unprecedented for their scale and daring technology. Once again, students and nonstudents came from all over to work with him at the university and at his studio. Voulkos's magnetism and prodigious work energies are such that wher-

BERKELEY AND BRONZE

ever he established himself, the world literally beat a path to his door. Jim Melchert, a professor of English in Chicago who had come to study with Voulkos at his summer workshop in Helena at Archie Bray's, ultimately followed him to Berkeley, quitting his job and moving his family—his wife and three small children. Melchert, now a full professor in the art department at Berkeley (presently on leave to direct the Visual Arts Board of the National Endowment for the Arts), describes Voulkos the teacher:

One thing that always amazed me was that Pete could walk through a room without looking around—he just walked through—and if you asked him a question in the next room, you'd find out that he'd seen everything that was in there. He didn't miss a thing. He'd never tell you he liked something when he didn't. You could tell how he felt, though, by the way his cigarette hung from his lips. Pete always gave us this challenge; he set a standard and it was up to you to come up to it or to challenge it. I remember hearing stories about how Kenny Price or somebody down in L.A. had done something that turned Pete's head around and we used to talk about how we'd love to come up with a piece that would do that, and I think how much he encouraged his students to do that to him. There was a responsibility to challenge him and, if you didn't, you weren't going to do much good there.

By the time Voulkos returned to Berkeley from New York after his show at the Modern, he was ready to take on the challenge of bronze, eager to reach further for the scale that so intrigued him. He had gone as far as he could with clay at the time and, for the next few years, he would work the clay largely during the many demonstrations and workshops he continued to give throughout the country. From 1959 until 1964, Voulkos continued to return to New York City each summer to do workshops at Greenwich House and Teachers' College, Columbia University, producing a variety of small plates, bowls, and vases with frenetic surfaces and bold color—his response to both the finer grain of East Coast clay and his continuing fascination with East Coast abstract expressionist painting.

When Voulkos discovered the plasticity of lost-wax casting, the drama and challenge of the process and its physical demands on him, the excitement of mastering its machinery, materials, and tools, the possibilities for achieving monumentality, he became intensely absorbed in bronze casting, building foundries both in his own studio and at the university.

In the fall of 1960, Donald Haskin, an experienced art foundryman, and sculptor Harold Persico Paris joined the faculty of the university's art department. With Voulkos they started the "Garbanzo Works" in a small rented corner of the Engineering Alloy Foundry in

Berkeley. The trio built their own furnace with a crucible of 190-pound capacity. They spent the first year experimenting with wax formulas, molds, and burn-out materials. They cast everything that could be cast into molds and burned out—chairs, tree branches, rope, paper napkins, anything and everything—and they learned. The foundry and its fiery moment of the white-hot pour became the center of a new bronze culture, no less than a cult. Many gifted artists and students came around to watch the bronze pour and participate in the

34. Painting,
Blue Slider, *1961*
Vinyl and lacquer, blue,
black, white; 90 x 72 inches.
(Collection of Manuel Neri)

BERKELEY AND BRONZE

35. Sculpture, 1959
Made in Berkeley; stoneware, wheel-
thrown and slab construction with sgraffito;
white and black magnetite slips; 40 inches
high. (Collection of Jack Lenor Larsen.
Photographer: Bobby Hanson)

PETER VOULKOS

party, which was part of the work atmosphere Voulkos inspired. By the fall of 1962, 10,000 pounds of bronze were cast into sculpture at the Garbanzo Works, which ceramist Joseph Pugliese, one of the participants, called "the most cooperative, most confused, most productive, and most slapstick, do-it-yourself foundry operation on record." For artists working as their own technicians, they achieved amazing and courageous technical innovations. There was nothing they were not willing to try, ultimately opening freedoms and solutions to forms in bronze they would not otherwise have known. Harold Paris said, "A self-respecting foundryman would have laughed at some of the

36. Feather River, *1960*
Made in Berkeley; stoneware, wheel-thrown in four sections and slab construction; low-fire orange, red, and clear glazes painted on stoneware bisque, then refired; 32 inches high. (Collection of Mr. and Mrs. Ray Kaufman)

BERKELEY AND BRONZE

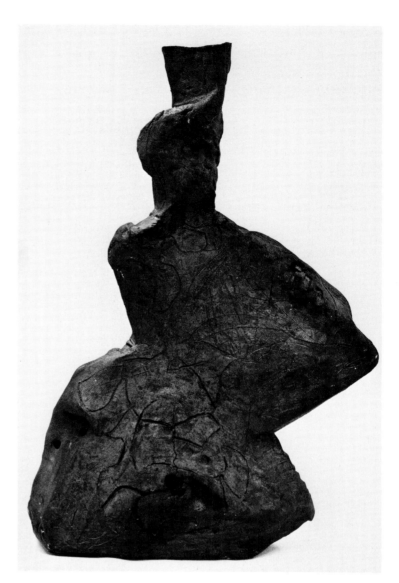

37. Snake River, 1959
Made in Berkeley; stoneware, wheel-thrown
and slab construction; sgraffito; black iron
slip, light glaze; 40 inches high. The wandering
scratches and finger marks enrich the surface
of the form, which reveals its pottery origin.
(Collection of Joseph Monsen)

things we attempted, but we were interested in making sculpture, not in self-respect."

Once he was no longer limited by the monolithic nature of clay, Voulkos began to cantilever forms out into space. Casting convoluted, crag-shaped, ruffled, and directly manipulated wax forms, he then assembled them by welding in open see-through constructions that reached into space horizontally. He tried to find alternative solutions to the base, first mounting several of his early pieces on platforms and wheels, and then basing pieces directly on the ground.

In 1961, the trio was joined by the sculptor Julius Schmidt, who had come from the Cranbrook Academy of Art, where he operated the foundry. By this time some fifty artists and students had become in-

PETER VOULKOS

volved with many of the foundry operations being carried on in various studios as well as on the Berkeley campus itself. They all worked together, sharing everything—the heavy labor, the materials, molds, bronze ingots, pickup trucks to move sculptures, mistakes and disasters, as well as triumphs, knowledge, and experience. Voulkos moved his studio to Shattuck Avenue, sharing the space with the painter Matt Glavin and the ceramist Joseph Pugliese. When city authorities accused them of violating the fire safety codes, Voulkos found an enormous warehouse on Third Street in the industrial section of Berkeley, adjacent to the tracks of the Southern Pacific. His new space, approximately 10,000 square feet with twenty-foot ceilings, allowed him to do the gigantic bronzes toward which he had been striving during the past two years. The scale of that space was natural to him. In it he made some of the largest pieces of sculpture to be totally fabricated in the sculptor's studio in our time—casting all parts himself in his

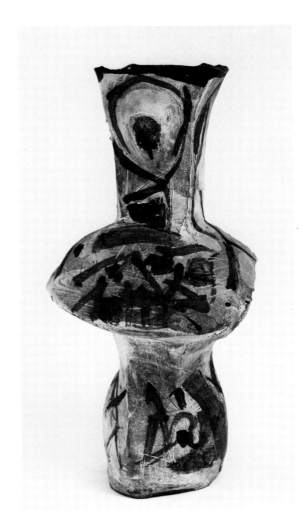

38. Vase, 1959
Made in Berkeley; stoneware, wheel-thrown and ribbed forms; covered lightly with white slip, brushed with cobalt, red iron and white slips; thin coating of clear glaze; 21 inches high. (Collection of Fred Marer. Photographer: Frank J. Thomas)

BERKELEY AND BRONZE

39. Studio, Berkeley, 1977
In process: plates and pots in background; cast bronze sculpture commissioned for the Federal Building in Hawaii in foreground.

foundry—as well as some of the most sophisticated and innovative clay forms made in pure pottery techniques.

The warehouse was now equipped with a casting furnace, a crucible with a capacity of five hundred pounds, electric cranes, forklift truck, burn-out kilns, ceramic kilns, and potters' wheels, not to speak of a professional pool table and a poker table used for Voulkos's famous Saturday-night poker games and pool-ins. In addition, Voulkos built a wooden house at one end of the warehouse, to live in. The house within the house, like a two-story womb, continues to coddle the constant visitors, colleagues, students, in its unique and warm environment. It is dominated by a thirty-inch color TV always on in an open living–dining room–kitchen with professional restaurant equipment,

PETER VOULKOS

including a cast-iron Garland stove, two huge steel refrigerators, and three butcher's chopping tables and steel counters. Large couches and upholstered chairs in the sitting area are under an amazing indoor skylight that miraculously catches light from windows in the studio above it and outside it. Under the sitting-room skylight is mounted Happy, the Big Horned Elk, a gift to Voulkos from an admirer. Pete has fantasies of Happy falling down on him one day while he is napping on the couch during an earthquake and stabbing him to death; the big newspaper headlines would read *Artist Gored in Studio by Elk.*

The first floor contains the studio of his companion, the ceramist Ann Adair Stockton, plus two bathrooms, a guest bedroom. Upstairs are the master bedroom, a large guest bedroom, and a room for Ann's pet alligator.

Just as they did at Archie Bray's and then at the Los Angeles County Art Institute, people followed Voulkos to Berkeley, and within a short period a community of artists mushroomed around the warehouses around Third Street; they worked with him and he with them, learned from him and he from them, sparking the contagion of energy shared by artists accessible to each other. Among them, the painter Jimmy Suzuki, the sculptor Tania Kowalsky, and above all, the ce-

40. During the assembly of the bronze, 70 feet long, now in Highland Park, Illinois. (Photographer: Roger Gass)

BERKELEY AND BRONZE

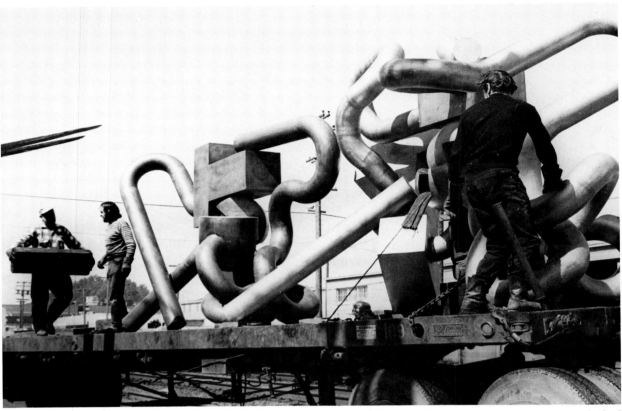

41. *Loading bronze segments of* Dunlop *and* Pirelli, *each 13 feet long, on a flatbed truck for shipping to East Coast in 1967. The sculptures were assembled at installation sites in Albany and Boston.* (Dunlop *in collection of State of New York, Albany Mall, Albany, and* Pirelli *in collection of Stephen D. Paine, Boston*)

ramist, friend, and assistant Vaea. It was and is a focal point for artists coming to the West Coast.

Voulkos, rarely a solitary worker, thrives when working with his "boys." An excellent organizer, he formed a regular crew known as "Voulkos and Company," which became the largest and the most prolific group producing the sculpture of an individual artist. By 1965, Voulkos had determined his basic vocabulary in cast-bronze sculpture—the cylinder, the elbow, the dome, the flat sheet, the rectangular cube. He manufactured his basic forms, stockpiling them until it was time to assemble them into completed works. Then "Voulkos and Company" would compose the elements with the artist directing—much like a symphony conductor—making instantaneous decisions, putting together and tearing apart, putting together again, until he got what he wanted. Then he would take it apart again to set it up again, sometimes recomposing entirely at the installation site. Ed Primus describes Voulkos's installation of his first show of bronze in 1961 at the Primus-Stuart Gallery in Los Angeles:

PETER VOULKOS

He came down from Berkeley with hundreds of cast sections packed and mounted on a flatbed truck and drove it right up to the back entrance of the gallery. He arrived, of course, the day before the show was to open, along with his crew of three or four guys. We all worked all night long putting the stuff together. It was a really hot night. And the welding torches went all night. The police and fire departments would show up from time to time because neighbors kept seeing flames. Pete would say put it here or put it there and then, when he'd make up his mind, he'd weld. He actually composed the sculpture and put it together on the spot, right here, at the gallery. He brought a twenty-four-thousand-pound forklift right into the gallery. There's still a dark oil spot on the floor of the gallery from the oil. Then, if the sculpture didn't sell, he'd take it apart. You can see parts of sculptures he's taken apart all over his studio.

So adept did Voulkos and his crew become that his sculpture commission installed in the spring of 1977 at the new federal building in Hawaii was assembled and constructed within one month from elements previously fabricated in the studio. The camaraderie and loyalty among the young artists and artisans in "Voulkos and Company" was and is unique. In 1964, they even played concerts for friends as a jazz group, with Voulkos as the guitarist.

Third Street was a magnet for young artists from all over the country during the sixties. They came to Voulkos eager to work for him and with him, perhaps most of all, to learn *how* to live and to work, to catch the magic through exposure. And Voulkos, a natural Greek patriarch, took them in, turning what could have been chaos

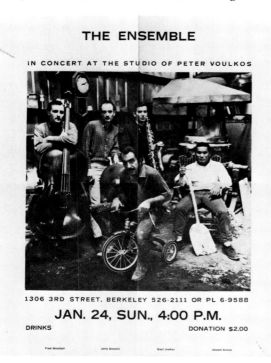

THE ENSEMBLE

IN CONCERT AT THE STUDIO OF PETER VOULKOS

1306 3RD STREET, BERKELEY 526-2111 OR PL 6-9588

JAN. 24, SUN., 4:00 P.M.

DRINKS DONATION $2.00

42. An announcement of the Voulkos group in 1964

BERKELEY AND BRONZE

into fertile environment for the production of sculpture. It was like a commune, with Papa Voulkos and his extended family of young potters, sculptors, painters, photographers, printmakers, musicians, poets—and railroad men from the Southern Pacific, who discovered the Voulkos menage did not start moving before one in the afternoon and continued until four or five in the morning, getting livelier as it went along.

The source of Peter Voulkos's loyalties to his group, his perception of himself as *paterfamilias*, goes back to his own family and upbringing as a first-generation American—the son of immigrant Greeks alone in a town of the new West, the family fiercely loyal to each other, protective and supportive.

In 1975 Pete invited me to go with him, Ann, and their sixteen-month-old son, Aris, or Harry, named for Pete's father, on his annual visit to his mother in his hometown, Bozeman, and also to see the new twenty-four-inch color TV set he had bought for her; meet his younger brother, Emanuel; watch them play pool at the Crystal Bar, the perennial hangout, and poker at the Poker Arcade; hear country music at the cowboy bars; and learn to flip pancakes with style and authority at the renowned Burger Inn. Also, it would be my chance to see Yellowstone.

We never made it to Yellowstone. One afternoon, shivering in the cold August rain, we dutifully bundled into the rented Dodge and started out from Bozeman, looking dubiously at the fog-enclosed mountains. By the time we had driven five miles to the old railroad hotel, once the elegant stopping place for millionaires touring the country at the turn of the century, now an antiques museum, we were ready to seize on this cultural alternative, and we settled on the bar stools of the still-glorious saloon with its splendid sweep of pure mahogany bar and wall of elaborately etched mirror and watched ourselves drinking Bloody Marys. Pete had wanted to check out Chet Huntley's ski resort development but the drive in this weather would get us back too late for Mama Voulkos's Greek dinner. She had been cooking for two days in honor of her son's visit.

We got back in good time for a welcoming feast of beef and onion stew, stuffed vine leaves and peppers. Emanuel was also there, with his two sons, Duryea and Danny, both of them artists like their Uncle Pete. Emanuel had taken over the now famous Burger Inn, started by Pete when he was still in high school. It is a rare authentic small diner, one of the finest short-order eating places west of the Missouri. People come from miles around to eat there, enjoying both the quality

43. Peter Voulkos, 1926

of the food and the warm, bombastic wit of its proprietor, Manny, as he is called, surely the hero of Bozeman (along with his brother Pete). Fishing is the Bozeman passion, and Manny is known throughout the state as a great fisherman. The morning of our arrival in Bozeman, as we were sitting around the bar of the Holiday Inn, a constant stream of friends who heard Pete was in town dropped in. One enthusiastic visitor identified himself as Bill Altunis. "I had to meet you, Pete. I heard about you from Manny but I didn't realize you were so famous. I went camping up in British Columbia last year and we came on a real isolated section of the woods near the water and we thought it looked good for fishing. Then we sighted another camper who didn't seem to look too friendly-like on our preparations to stay. Pretty soon I noticed he had a canvas on an easel and I walked over to him and said, 'Say, do you know Pete Voulkos?' The scowl on his face broke up into the biggest smile you ever did see. Sure, he knew Pete down in California and sure, he loved him and thought he was the greatest artist since Michelangelo. So we were real buddies after that. And it was fine fishing."

BERKELEY AND BRONZE

Pete's mother, Efrosine, a small, strong-boned woman, came from the Aegean island of Lesbos to Bozeman for her prearranged marriage to Harry Voulkos, a chef at the Bozeman Hotel. Harry had arrived the year before, in 1921, from the mountains of Thrace, having fought and fled the Turks after World War I. He came first to New York, then to San Francisco, and then to Bozeman, where he had a cousin. Harry, a large, powerful man, soon took over the restaurant at the hotel and started two others in the town. Bozeman, settled in 1860 just before the Civil War, was lush farming and cattle country, still with a cowboy tradition and wild Saturday nights in the cowboy bars, where it was not unusual for a killing or so to take place during Pete's growing-up years.

Harry and Efrosine had five children—Mary, the eldest, then John, Pete, Manny, and Margaret. It was not easy for non-English-speaking Greeks to live in Bozeman, but Harry was a handsome, intelligent, affable man, and was, besides, the best cook in town.

44. The eye and the hand of Voulkos, at his studio pool table, 1972

PETER VOULKOS

Efrosine, on the other hand, always stoic and strong, from hardy peasant stock, had the enduring quality of the pioneer woman. She was loved by neighbors and townspeople. During the Depression, in 1930, Harry lost his restaurant and was compelled to take a job as chef in a restaurant in the neighboring town of Whitehall, coming home on Sundays whenever he could. It was up to Efrosine to raise the family, and this she did with a strong hand. Pete was the rebel, preferring to spend his time at the pool hall or fishing in the nearby mountain streams rather than go to school. He still laughs at the memory of his mother marching down to the pool hall to yank him out.

The family struggled to survive, and the boys always did odd jobs to contribute income. Pete worked for many years in Jimmy Lambros's dry-cleaning store, before taking the job at the Burger Inn and eventually buying it. When the flare-up of an old war wound forced Harry to give up his job at Whitehall, the Burger Inn became the family business, supporting the entire tribe.

Young Pete, who had already shown exceptional skill in his high school woodworking shop, became the family carpenter and fix-it man, having set up shop in the basement of their two-story frame house on Main Street.

In 1941, after graduation from high school, Pete left Bozeman to take a job as moldmaker at the Grey Iron Casting Company in Portland, Oregon, casting and welding fittings for Liberty Ships. Here he worked for two years, before joining the Air Force, learning skills that were to be valuable to him in a life he was not to envision until much later.

In 1966 the city of San Francisco awarded Peter Voulkos the much sought-after $45,000 commission for a sculpture for the lawn of the Hall of Justice building, in a competition of some fifty entries. Among the jurors who chose his maquette was Arnaldo Pomodoro, the Italian sculptor and visiting professor at Stanford University, who subsequently became good friends with Voulkos.

Under Pomodoro's persuasion, Voulkos went to Italy in the spring of 1967, his first trip abroad since his Air Force days in the Pacific during World War II, and his first trip to Europe. There, during a five-week period, he met some artists who gave further confirmation to the direction he was already embarked on in both clay and bronze. He spent considerable time in Rome with Arnaldo Pomodoro, who maintains one of the largest and most completely equipped studios for the production of sculpture and jewelry on the continent, with sizable crews of apprentices and craftsmen. Among other Italian

BERKELEY AND BRONZE

69

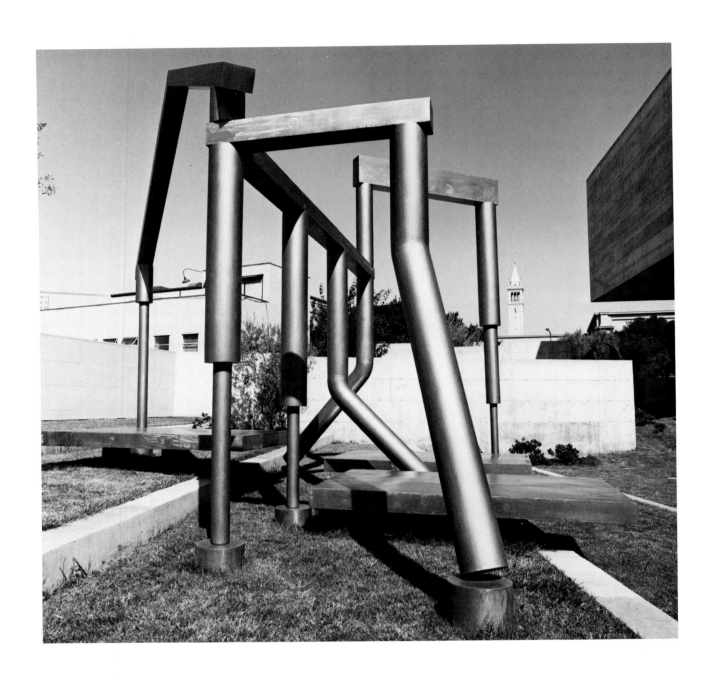

45. Bronze (Monel) sculpture, Return to Piraeus, *1970–1971
Made in Berkeley; 16 feet high by 30 feet wide by 20 feet deep. (Collection of
University of California Art Museum, Berkeley. Photographer: Roger Gass)*

PETER VOULKOS

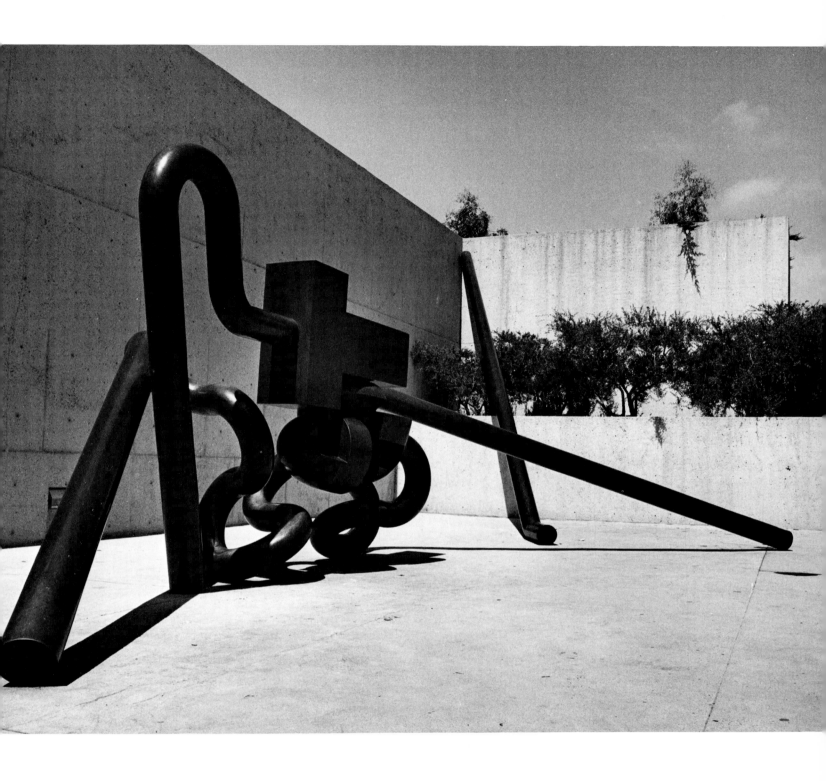

46. Mr. Ishi, *1970*
Cast bronze sculpture; about 40 feet long; installed at the Oakland Museum.
(Photographer: Roger Gass)

BERKELEY AND BRONZE

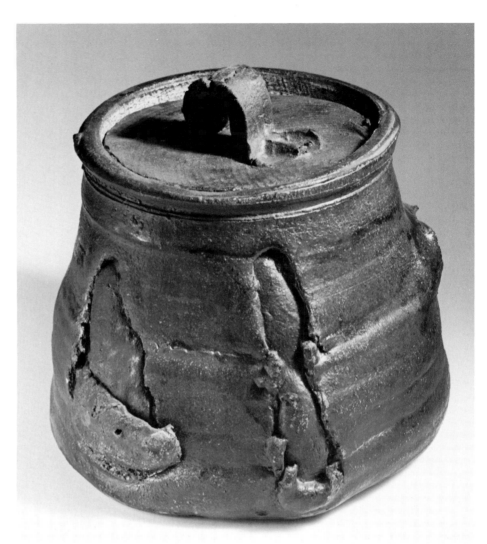

47. *Covered jar, 1968 Made in Berkeley; stoneware, wheel-thown with passthroughs; black iron slip, thin clear glaze; 12 inches high. (Collection of Peter Voulkos. Photographer: Joseph Schopplein)*

artists, he felt a particular kinship with Alberto Burri and his collages of burned and torn fragments and with Lucio Fontana, who slashed his canvases as he had his clay plaques years before.

When Voulkos returned to Berkeley late in the spring of 1967, he entered a rich work phase that resulted in the completion of two major bronzes, *Pirelli* and *Hiro II*, the beginning of his San Francisco Hall of Justice piece, and a return to working in ceramics in his own studio, rather than just in demonstrations. He began to develop further the erupted and slashed surface as a signature of his aesthetic in the clay. This series of ceramics culminated in his show in 1968 at San Francisco's Quay Gallery, with fourteen bottles two to three feet high and five nineteen-inch plates. All works were black, covered with a rich iron oxide slip and lightly glazed. Voulkos was now focusing on the form, surface, and substance of the clay itself, simplifying the color,

PETER VOULKOS

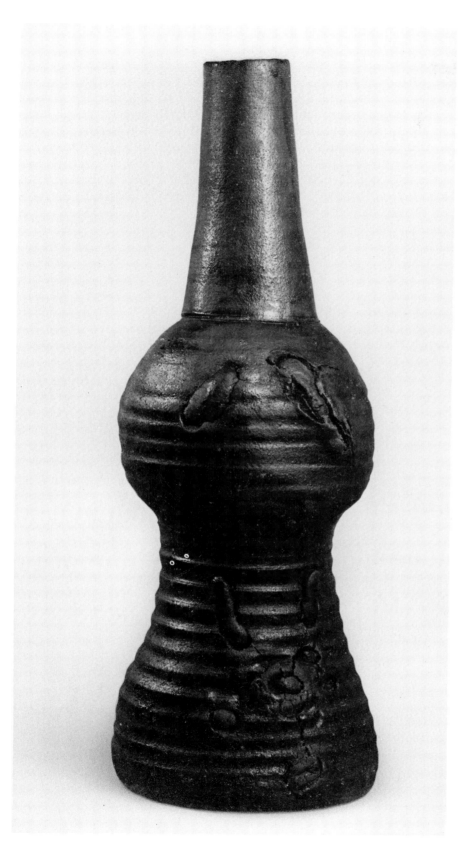

48. Vase, Anaqua, 1968
Made in Berkeley; stoneware,
wheel-thrown with pass-throughs;
red iron slip thinly sprayed with
clear glaze; 36 inches high. (Collec-
tion of Mr. and Mrs. Julius Blank)

BERKELEY AND BRONZE

as he has continued to do in subsequent work. Of it Jim Melchert wrote (in *Craft Horizons*, September/October, 1968):

The group is composed of the most haptic pottery I've seen in a long time; it wouldn't surprise me if the pots had been made in the dark. The glazes, mostly dull black, function as a skin that registers the activity of the body underneath. As the major forms swell and shift, the surface tension is kept taut, interrupted here and there by slashes and perforations. Sometimes the wall splits open under the pressure of a secondary form pushing through. . . . They're purely hand products. There's a casualness about them, even an abandon, that's transparent to the spirit behind them. To me, the beauties in the group are the plates. They seem the most transparent and consequently the toughest. One thing about a Voulkos pot is that even when he misses, you know he's been there. The conception is so individual and dependent on him, that each pot works as a complete system in itself. It's not pottery that anyone else could take further.

John Mason, commenting on Pete's return to clay, said: "I think what Pete is doing in clay now is really an extension of where he left off, because there were big periods when he really didn't do much in clay. I think he's gone back to where he left off and has built on that and I think that's what he has always done. That's his way of working; he's very consistent."

His remarkable life-style and work methods (documented in a film by Susan Fanschel, a former student of Voulkos) reached a peak from 1970 to 1971 with the production and installation of two heroic sculptures—*Mr. Ishi* at the Oakland Museum and the commissioned piece for the San Francisco Hall of Justice. The furor that preceded installation at the Hall of Justice caused by the San Francisco police officers' "official opposition" to the sculpture, which they described as "an abomination," brought the enthusiastic attention of otherwise apathetic San Franciscans to this magnificent, intricate, thirty-foot high monument that stands downtown, a triumph of the Voulkos vision. The City Art Commission stuck to their guns, and the complicated installation—which involved engineers making wind and stress calculations and the digging of a ten-foot-square, five-foot-deep foundation—was completed in the fall of 1971.

The sculpture, composed of serpentine cylinders undulating around cubes and hemispheres through five platforms at varying levels, mounted on bronze poles, has the effect of a musical composition—monumental bronze stanzas of music vertically stacked one on top of the other, aspiring skyward, with one chord at the base level catapulting out into space. Contrapuntal in form, the composition is charged with a lyric force that is unique in modern sculpture.

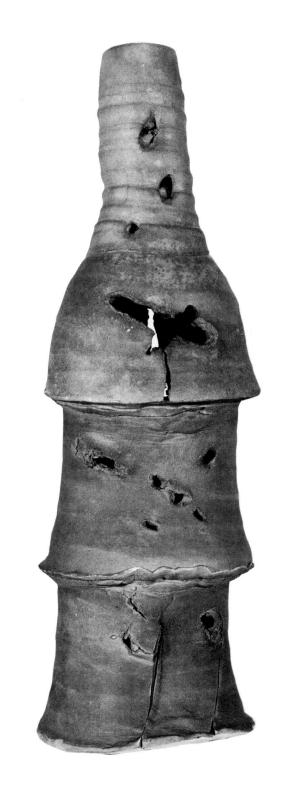

4. The Demonstration

49. (*overleaf*) *Vase, 1973*
Made in Berkeley; stoneware, wheel-thrown in four sections, with pass-throughs, slashes; thinly sprayed with clear glaze; 40 inches high. (Collection of Dr. Seymour Rubenfeld, Washington, D.C.)

To watch Peter Voulkos bear down on a mound of clay and draw up the walls of the spinning cylinder is to watch power, the physical manifestations of power—great strength, total balance, absolute control, coordination between the body of the man, the clay, and the feel of the clay in his hands—between the rhythms of the moving man and that of the moving clay—a situation of freedom and ease for the artist and his clay. Ease, meaning a sense of natural action, nothing forced, nothing contrived, following in rhythm what seems inevitable between the man and the clay. There is real intimacy between Voulkos and his clay. There is no waste motion. There is a sense of unfailing precision and grace in that powerful hulking body.

Often as I have watched him bear down on the clay, holding it with his powerful and strangely delicate hands, bringing it up and out, I have been reminded of that unforgettable moment when the baby is brought from the womb. It is total, hard work, intense and arduous and natural.

Voulkos loves to work at physical tasks, whether it is building a new studio, which he is currently absorbed in doing, or becoming totally involved in the machinery and materials. "I love machines," he says. "They perform miracles. They make me feel like a dolt." When I visited with him in the summer of 1975, it was his ritual daily to check on the progress of the conversion of the old Oakland train station not far from his studio into a Chinese restaurant. There we watched "his boys"—Dave, Scott, Leon—all artists and ex-students, earning money at construction jobs to enable them to afford their art. We watch a small crane digging a sewage trough. "I need that machine," Pete says. His Berkeley studio is located in the industrial area surrounded by steel foundries, lumber companies, tool and dye manufacturers. The air is filled with the chug-chug of machinery, the hiss of big boilers, the clang of metals, and the tripping thrum of air hammer, the buzz of saws.

"Hear the air compressors going from the big boiler! That's power. Look at the size of those castings!" We are passing one of the foundries in his 1973 Chevy pickup truck on our way to The Macaroni Factory, a former macaroni manufacturing plant in Oakland that Voulkos purchased in 1972 and converted into a series of twelve studios for artists. He is at present supervising the remodeling of the third and largest of the buildings he bought; his own new studio—20,000 square feet with thirty-foot ceilings—will be located in this one. Called *The Dome* for the domed ceiling in Voulkos's space, the huge building embraces the unique community of sixteen artists with as many living-work spaces,

THE DEMONSTRATION

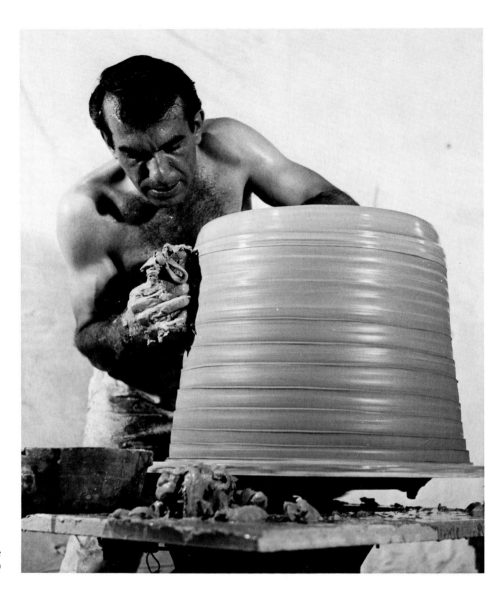

50. *In Glendale Avenue studio, Los Angeles, 1959*

the smallest of which is two thousand square feet. Voulkos is as keen an innovator of life-style as he is of craft and art.

During his many demonstrations throughout the country, Voulkos creates his pieces while an audience watches, much like a fine jazz musician creates music while he is playing before his audience. He is so secure in his craft that he is able to trust his spontaneity, trademark of the Voulkos oeuvre, as a precise reflex of knowledge, experience, and timing. He does not plan his pieces in advance or draw on paper. At the Tenth Annual Super Mud, at Pennsylvania State University in 1976, where he demonstrated before some two thousand potters and students of clay, he told his audience, "The quicker I work, the better I work. If I start thinking and planning, I start contriving and design-

PETER VOULKOS

78

ing. I work mostly by gut feeling. The thing about clay is, it's an intimate material and fast moving." Voulkos's involvement is with process, with the handling and with the fast-moving dialogue that takes place between the man and the moving clay in his hands. His art begins where pottery finishes.

Voulkos is suspicious of the intellectual approach to art and believes, rather, in creative un-culture. He holds with the credo of sculptor David Smith, with whom he enjoyed a friendship based on their common love of tools and machinery as a source of creative power: "Creative art has a better chance of developing from coarseness and courage than from culture. . . . I would much rather have a man who has no ideals in art, but who has a tremendous drive about it, with the fire to make it. The drawing that comes from the serious hand can be unwieldy, uneducated, unstyled, and still be great simply by the superextension of whatever conviction the artist's hand projects and being so strong that it eclipses . . . the qualities critically expected."

Voulkos is not subjectively confessional or revealing of himself in his work. His process of work, the interaction of work and energy mutually begetting each other, is the self-revealing subject of his work. Voulkos wants students to see the *use* of technique—to understand where technique can lead, rather than to focus their attention on the technique itself.

"If you work hard, you'll be all right, my mother used to say,"

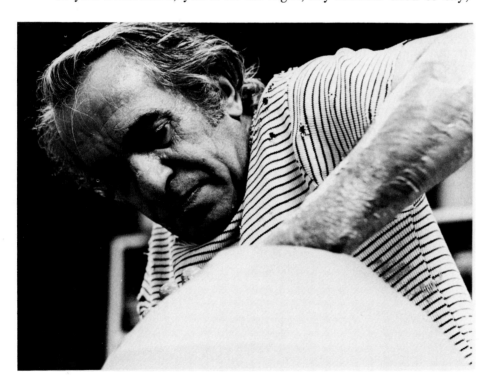

51. *Voulkos at the wheel, 1976. (Photographer: Ryusei Arita)*

THE DEMONSTRATION

says Voulkos to his audience at a demonstration as he walks around, usually in a small, poorly lit classroom in the basement of the ceramics department, where ceramics and sculpture are so frequently located in American universities. There is standing room only—some of the audience have driven two hundred miles to see the giant Voulkos. The spectators hesitate, not sure of what they are hearing and watching.

The man before them, in a horizontally striped shirt with holes (his good-luck shirt) and vertically striped pants caked and blotched with dried clay, has taken clay-stained flamenco boots out of the yellow drawstring bag that holds his tools—a small ragged sponge, blade, wooden spatula, rib, wire, potter's knife, paring knife. He walks around slowly in front of his audience, eyeing the wheel, eyeing the clay, eyeing the audience, muttering remarks about his mother and her wisdoms, stooping and groaning in front of his audience to change his shoes. Suddenly the audience starts to laugh and Voulkos figures he's on. He wets the plaster disc wheel bat. The eyebrows go up, the grin widens, and he picks up from the table a large mound of clay, about fifty pounds—a usual amount for Voulkos. He slaps the clay down on the wheel bat with a resounding thud, plop. He pauses for a moment glowering at the clay, his powerful shoulders hunched, his knees slightly bent, his feet firmly planted, toed in, the stance emphasized by the pointy boots. Then, with his foot on the pedal of the motorized wheel and his hands on the clay, he begins.

To center fifty pounds of clay requires enormous skill and strength. It is characteristic of Voulkos's offhand, self-mocking, "non-technique" technique, to say, "I'm off center. But the clay is on." Voulkos, who is intensely conscious of his Greek heritage, knows the gods considered Socrates to be the wisest because he began by admitting his ignorance and fallibility. Some people say Voulkos's clay is crooked but he is centered.

The left hand and entire body weight bear down on the center, the right hand holding the outer spinning mass, the right shoulder pulling up, the whole man in intuitive rhythm with the centrifugal force of the wheel, the density of the moving clay, the walls coming up in his hands. He is tilted to one side, balancing with his knees, as he bends over the wheel, and clay and water spatter as it spins. Rudy Autio's description of a Voulkos demonstration in Pomona, California, in 1954, is still accurate: "Pete strains to push it into shape and after a few minutes begins to sweat from the effort. Soon the mass magically grows to 20, to 25 inches, straightens out and is shaped again with the top of the whirling cylinder in his armpit. Up it goes to 30

PETER VOULKOS

52. Vase, 1964
Made at Montana State University; low-fired bisque,
wheel-thrown and carved construction with pass-
throughs, sgraffito, and cuts; 30 inches high. (Collection
of Montana State University. Photographer: Joseph
Schopplein)

inches, sometimes 35; the lip is shaped, cut and smoothed deftly, and
the pot is thrown."

Today the cylinder can go up to over forty inches, the plate drawn
out to over twenty-four. He stands throughout the throwing, his entire
body moving, hovering over the turning clay, his slender fingers and
long curved thumb delicately and consistently touching the soft, spin-
ning cylinder. Takes his foot off the treadle and stops to look at the
form. Puts his unlit cigar in his mouth; takes his cutting wire and, as a
student holds the pot, passes the wire under the pot, cutting it from
the disc, and then with one fast motion, picks up the large form,
heavier somehow now, perhaps because of all the dark air inside, and
swings it over, his knees bending under the weight, to rest it on the
long table on the side. The table serves as a counter for the ten or

THE DEMONSTRATION

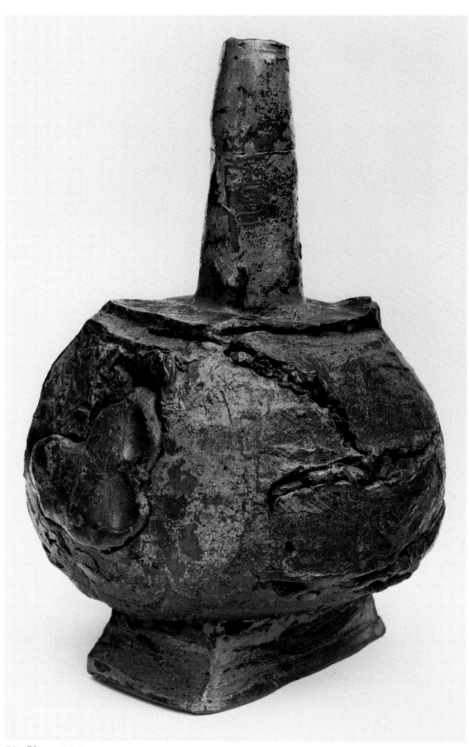

53. Vase, 1961
Made at Teachers' College, Columbia University; stoneware, wheel-thrown and
carved construction, slashed, manipulated; pass-throughs are filled with a clay
body that fires darker; painted with cobalt and red iron slips and glazed with a thin
wash of colemanite; 18 inches high. (Collection of Pauline Annon. Photographer:
Frank J. Thomas)

PETER VOULKOS

twelve large cylinders and plates, as well as the numerous small bowls ("ice buckets") and cups he will throw over a two-day period. He stands for a moment, grimaces, grins, takes the unlit cigar out of his mouth, sets it down, lights a cigarette and looks for the cup of "tea" (Johnny Walker Red Label) that he sips throughout the "demo." Holds rib against the turning wheel as leftover clay skin from the bottom of the last clay form peels off to the floor in curls. Wets his hands, rubs the wheel bat clean with water, picks up another mound of clay and slaps it on the disc to begin again. The whole process has taken about twenty minutes so far. Wets his hands, pats the clay. Wipes hands on pants, and puts them on hips, regarding the mound. "Let's see now," he says in his gravelly bass, "I gotta figure out the sequences here. I gotta throw a shape." Voulkos does not explain as he goes along. He teaches by what Paul Soldner calls "osmotic education." He works openly, and with such clarity and directness that his observers learn by watching. This has always been the Voulkos method. He makes light of what he is doing, but we are aware that we are watching a master. Now we see him turning an enormous plate that starts as a cylinder and, with a lightning turn of the rib, starts arching outward, miraculously growing in diameter, holding its shape and growing. Voulkos stops. He figures he has made the piece go as far as it can and perhaps farther. He will cut off the disc and let it dry to leather hardness. But first he shapes the rim with the flat side of his rib and then with his wet palm, smoothing, touching. He is serious when he says, in answer to a question, "Clay body? It don't matter too much. Clay's like anything else. If you treat it right, it'll treat you right. But if you watch me for a while and pick up on it, it's information."

Spins another plate. It collapses. The audience groans. Voulkos laughs, "That's okay. I got some more." Pinches and ruffles the edges of the sagging plate and sets it on the floor. "It's like my mother used to say, don't pick at it, it won't get well." Everyone howls with laughter. Easy come, easy go. After some three hours of constant throwing of clay and "bull," bantering with his audience and students, smoking cigars, cigarettes, and sipping his "tea," Voulkos will leave, followed by a mesmerized group in the thrall of the master. He will talk, drink, eat with them, see their work, and return to his forms around midnight to see how they are drying—too fast? not fast enough? has anything collapsed? All's well. The group will follow him, doing everything with him. He can now go out with his group for a few more drinks and predawn eggs before turning in for the real work tomorrow. If there is a Greek artist in the community where Voulkos is demonstrating, he will consider it a matter of honor, and tacit commitment

THE DEMONSTRATION

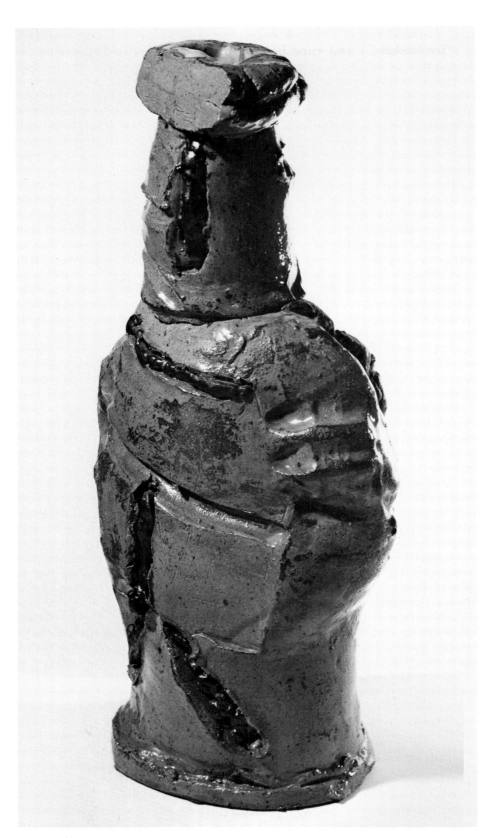

54. Sculptured vase, 1961 Made at Teachers' College, Columbia University; wheel-thrown, carved, slashed with pass-throughs of darker clay; cobalt slips, celadon and copper glazes; 18¾ inches high. (Collection of Mr. and Mrs. Monte Factor. Photographer: Frank J. Thomas)

PETER VOULKOS

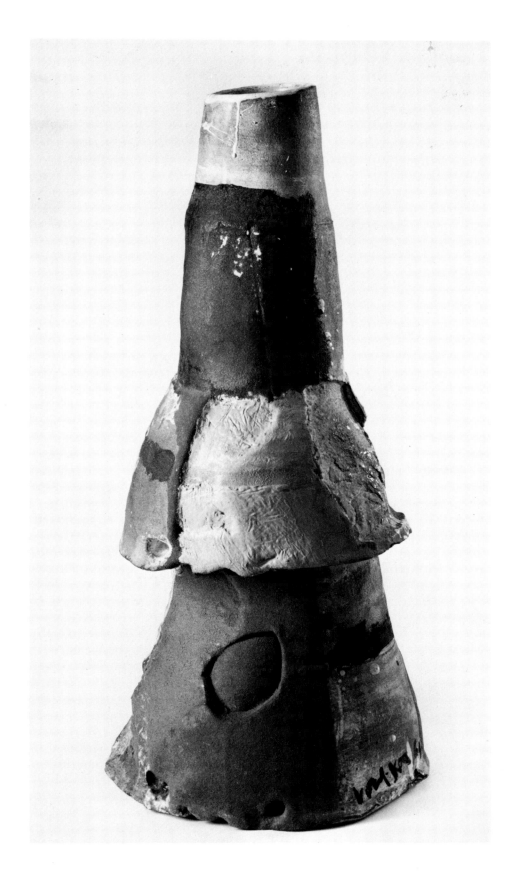

55. Vase, 1964
Made in Berkeley; stoneware,
wheel-thrown and slab construction
with pass-throughs; white slip,
glaze, and red, green, black, and
yellow epoxy paint; 27¾ inches
high. (Collection of Joseph Monsen.
Photographer: Dudley, Hardin &
Yang, Inc.)

THE DEMONSTRATION

of all Greek artists in brotherhood, to give a party for Voulkos, the most famous Greek vase maker of all time, the one modern Greek who has kept his pact with the Greek past, who gave it continuity and engendered new life and new energy within the components of basic classical forms and traditional techniques. The food will be Greek and abundant—dolma, shish kebab, feta with olives, pilaf, pastry with spinach, baklava. Tomorrow, with the forms in their leather-hard stage, he will trim and form, slash and rupture, compose and assemble. And answer accumulating questions.

On glazes: "Lost my glaze book. Stole most of it to start with. I buy it now at the glaze store and put it on real thin, barely fogged on with a spray. I pick up a gallon and it goes for thirty or forty pieces—a cone 04 glaze and I fire it to cone 5, reduction firing, which is how I do my plates now. It's not how many glazes you use. It's how you use what you've got. At Berkeley we have three of the crappiest glazes in the world. We don't like to get good glazes. You can get turned on in the wrong way. We got an awful looking semishiny glaze and a matte glaze. Then we have the basic black. I tell my students, if you can make anything good out of that you can have an A grade. I don't like pretty glazes; they're misleading. I don't have too much of a glaze vocabulary. Also the firing is pretty minimal. If it comes out of the fire, it's good if it turns you on. I even shun raku a little because it's a process you can get an immediate result from. It always looks good." Voulkos, the non-technique master, expresses distrust of an easy, aesthetically seductive method, with fast and always satisfying results. "You have to understand it and once you understand it, you build on it. I don't like to use glazes. They cover up the detail. When the clay comes out of the fire, I like for it to look like when it went in. I like for the clay to pick up on my fingerprints. I like to put my own marks on it."

On firing: "I don't fire above cone 5 anymore. When you fire to 10, you lose detail. The higher you go, the more the clay shrinks and you lose detail. What's this big mystique around firing methods? So in the early days I used to fire to stoneware. What's so great about firing to cone 10? What the hell difference does it make! Making a thing of it is like describing a painting by saying it was painted on linen with pine stretchers."

On scale: "My scale comes out of art history. It comes out of what I see—art. I always liked the large things. Take New York skyscrapers. Those are more awesome to me than the mountains. You take a mountain for granted. But a skyscraper just blows my mind. You can put a little thing in the middle of a mountain and it shows up. But make it work in the middle of New York—that's something else. Man-made

is a different trip—like even those spaces between buildings in New York—they're fantastic. I always wanted to work large. Now, though, my concept of scale has changed. Kenny Price used to try to make things large, but he didn't particularly enjoy it. So he got smaller and smaller until he got to a minute size—six, eight inches. He's comfortable in that scale. But those pieces have a tremendous bigness about them, those little mountains, those eggs. Giacometti made little things, but look at the bigness of them. He is fantastic. He makes a small figure and it takes in all the space. It's uncanny."

On the difference between working clay and metal: "Clay is a very intimate material. It's a very fast-moving material, immediately responsive to the touch and it's silent. When I want to work slower and I want more resistance and more noise, I turn to the metal. It's a different trip. Trying to expand the possibility of pottery and the form of pottery—sometimes it gets too tough and I get too tight on it, so it's nice to swing back to something else, to bronze. I started as a painter, and pottery provided another form in which to work. So you have the form of painting, the form of sculpture, the form of pottery, and these forms all feed back into one another. The painting helps the sculpture, the sculpture helps the painting, the pottery helps the sculpture, and so on. They are all interrelated, although they all demand different disciplines and different kinds of thinking. I think that working in the form of pottery is very demanding. It's a very restrictive thing. You can't second-guess it. The minute you touch a piece of clay it responds. It's like music—you have to know the structure of music and how to make sound before you can come up with anything."

What got you on to this? "Bad toilet training."

What do you feel about the last piece you made? "Best thing I ever did."

How do you know it's happening—that the piece you're working on is going to come off? "Usually you don't know it's happened until after it's done."

What tools do you recommend? "You find your own tools, like you find your own way of working."

How would you define a good pot? "It's a simple matter to pick out a pot's poor qualities but it's impossible to analyze a good pot."

Why do you still consider yourself a potter? "Usually, the last thing on my mind is why I am a potter."

He likes to start with soft clay, increasing the necessity for control and the risk of collapse. "I've got to keep it complicated. I take a lot of chances. And if it's wet, it acts this way. That's why I like to work in wet, soft clay. I get into a head trip on it. I just throw the shit

THE DEMONSTRATION

on the wheel and see how it comes out and see if I can control it. The point is, I like to handle materials that I can't quite control. I like to get a great big ball of clay in my hands. I like the feel of it. If it gets too small, I can't get around it. When I can control it too much, then I start contriving. When I'm teaching and I see the student get to a certain point, I say take a bigger piece of clay. See what that feels like, and struggle along a little further. So I get up to one hundred pounds or so. When you're working that and you try going back to five pounds, it's kind of difficult. It's harder for me to throw a little cup than to throw a thing fifty pounds—to make a little cup work, to really come out. I keep trying—I make little cups all the time. I haven't made very many good cups. It's hard to relate to that. Just even material-wise, to use that small amount of material."

Twenty-four hours later, plates, open cylinders, closed cones, a variety of smaller bowls and cups sit on the counter, having dried to the leather-hard state for the Voulkos treatment of surface, edge, lip, and foot.

He picks up a large cylinder, swings it over to the wheel and regards it with a Voulkos grin that sits somewhere between a comic grimace and a serious scowl. He is deeply concerned, yet at the same time he is consciously performing. For Voulkos is a wonderful showman, as the popularity of his demonstrations indicates. He gives an average of ten lecture demonstrations a year throughout the country in addition to his regular teaching at Berkeley and work in the studio on his sculpture commissions.

The demonstration as a teaching device was popularized by Voulkos. You learn by watching and then by doing. His movements are compelling. He "lives" into the work. It is a nonverbal, communicable quality that is unique to him.

It is Voulkos's conviction that *making* is as physical as it is intellectual, that a community of artists sharing common concerns creates energy, and energy is contagious. It is the Voulkos attitude of sharing with student-colleagues, inspiring the serious commitment of each shop member that has illuminated student-teacher relationships and spread throughout the university system and professional schools, making the clay shop the friendliest, the most productive, the most popular of the studio courses in art departments. Even at present, when enrollment in every other discipline of art in the universities has declined, the enrollment in clay continues to rise.

He picks up the knife and, with blade horizontal, he plunges it into the one-inch clay wall of the fifteen-inch-diameter, thirty-inch-

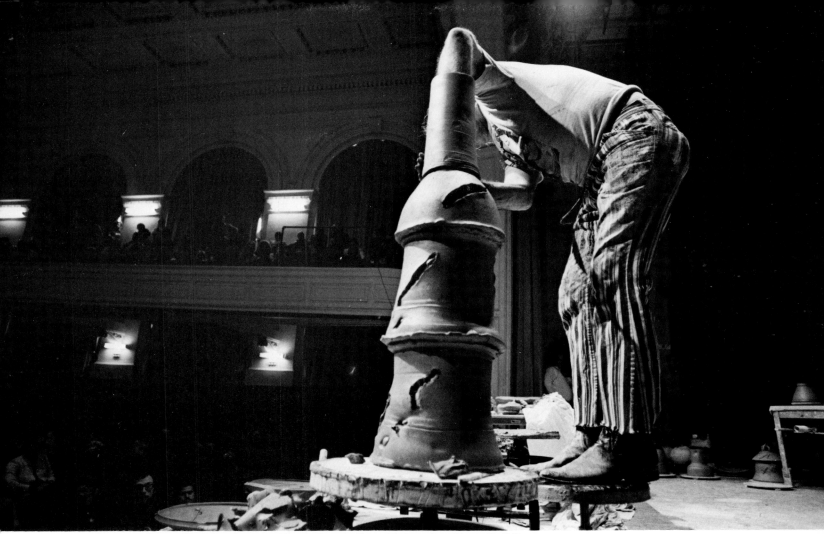

56. *Demo at Super Mud Conference, Pennsylvania State University, 1976. Building a stacked pot over four feet tall, Voulkos mounts stool to reach inside as he attaches neck. (Photographer: Stu Chernoff)*

high cylinder. The audience gasps. Swiftly he brings it down about five inches, peeling out a one-inch-wide clay noodle as he goes, leaving clearly ragged edges along the gash he calls a "zit." Turns the pot slowly and makes another ragged gash on the other side with the flat blade and then still another. Takes a small ball of clay and flattens it with wet palms, dips it quickly in an orange plastic pail of water and presses from inside against one gash, pushing it so that the clay ball bulges through the increasingly cracked lips. Steps back, lighting a cigarette, sips "tea," and says wryly, "That's known as a patched pot."

Inserts thumb from inside pressing out holes in various parts of the cylinder, plugging some of them from the inside with balls of wet porcelain mixture, as contrast to the regular clay body he is using. The holes have crater-like edges, swelling over the smooth small plugs. Of the holes he says, "We call those our basic pass-throughs. The look depends on the dryness of the clay. If you punch through from the

THE DEMONSTRATION

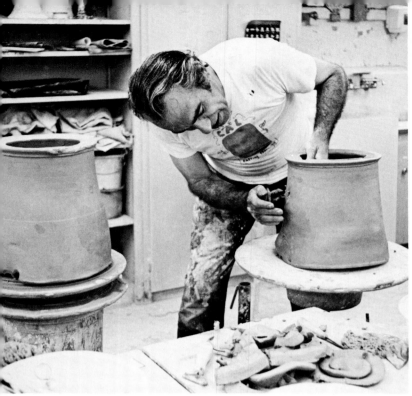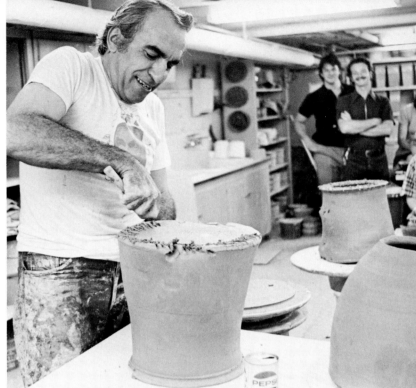

57 a-d. Turning, scoring, stacking, lifting. (Photographers: Edythe Brownstein, a, b, c; Ryusei Arita, d)

back it'll give you the dry look. Then you go on the quality of the zits. They tear differently depending on the dryness."

It looks so *easy* as he rips and fills.

How do you know when it's dry enough? "I taste it." Laughter. He likes that too. Then serious: "Experience. The look, the feel. You get to know what you're looking for and then you keep trying to get it. Don't matter what you do with it as long as you use it. This is as much a valid use of clay as any. Long as it turns you on. Like I said, I like to keep it complicated."

Picks up the knife and makes both horizontal and vertical slashes at different points on the cylinder, turning it slowly by hand, stepping back to look, whistling, singing, bantering with the audience. "As long as you're working at something, as long as you're working at something. Anything. Who says it has to be art. I can get off on plumbing. Anybody know how to build a shit chute? That's for toilets. Shit chutes. I can get off on that."

He wets the top rim of the cylinder with his little ragged sponge and quickly crosshatches around the rim with his knife, scoring the clay. Turns to the other cylinders waiting on the table, chooses one and does the same, wetting and scoring its top rim. Lays knife down and picks up cutting wire, and while a student holds down the cylinder, Voulkos slices it off its bottom. He takes the open cylinder, turns it over and joins the two scored and wet lips, welding them with their slip—"the juice," as Voulkos calls it. He smooths the joint with his wet

PETER VOULKOS

90

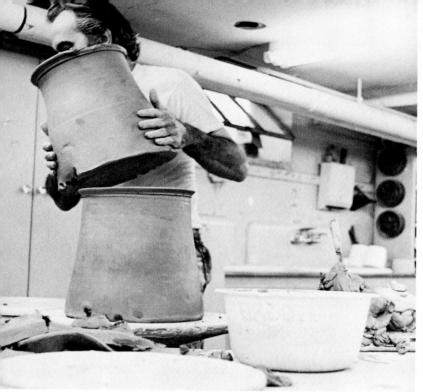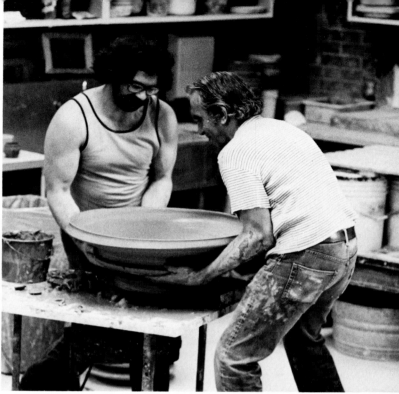

palm, gets up on a stool to reach inside, pressing and smoothing the joint. He hunches over the form, some four feet high, pushing and feeling. He takes his knife and begins a long slash from the top of the second form down through the joint to the first form and through several plugged eruptions, joining the elements in the stroke, line-tracing the events of that clay surface, drawing the path for the eye's journey, underscoring the graffiti embedded beneath the surface. He continues to create his "pass-throughs" by pushing holes out from inside: some he plugs; some he tears out more clay from and makes them larger; some he "patches," also making more "zits" and slashes. Before he is through he may have added two more forms of different cylindrical sizes by the same welding with slip method—"See, I gotta put more art on top"—and enriched the clay in its form by revealing its essential character as it develops and acts in his touch. The dialogue is strictly between clay and Voulkos, about clay and Voulkos. Voulkos tells the clay about itself and the clay tells him about Voulkos. It is a silent and intense confrontation recorded in all its detail in the clay. The total form may be anywhere from three to eight feet tall. And before the day is through he will have made at least three or four of these stacked pieces. He talks to himself as well as to those watching him. Chewing on his unlit cigar, he mutters as he puts a form to one side, "Let the molecules settle." "Son of a bitch, made this too big. It'll probably collapse now." Sipping his "tea," wetting hands, pushing his forms gently and firmly, constantly caressing surfaces with

THE DEMONSTRATION

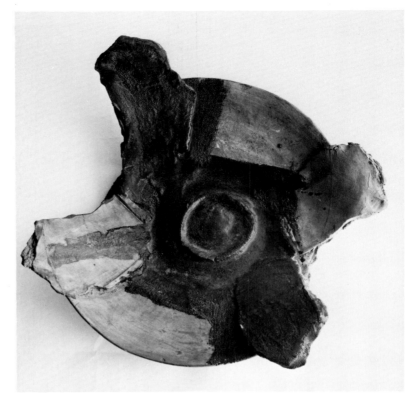

58. *Plate*, 1963
Made in Berkeley; stoneware, wheel-thrown and slab construction; white and black iron slips, green and black epoxy paint mixed with sand; 18 inches in diameter. (Collection of Dr. and Mrs. Judd Marmor)

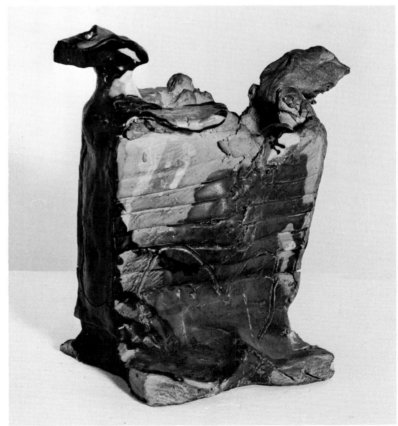

59. *Vase*, 1963
Made in Berkeley; stoneware, wheel-thrown and carved construction with sgraffito, white slip, black and red epoxy paints; 12 inches high. One of the distinguishing features of this piece is that the base was constructed of parts of two cylinders. (Collection of Wanda Hansen. Photographer: Joseph Schopplein)

PETER VOULKOS

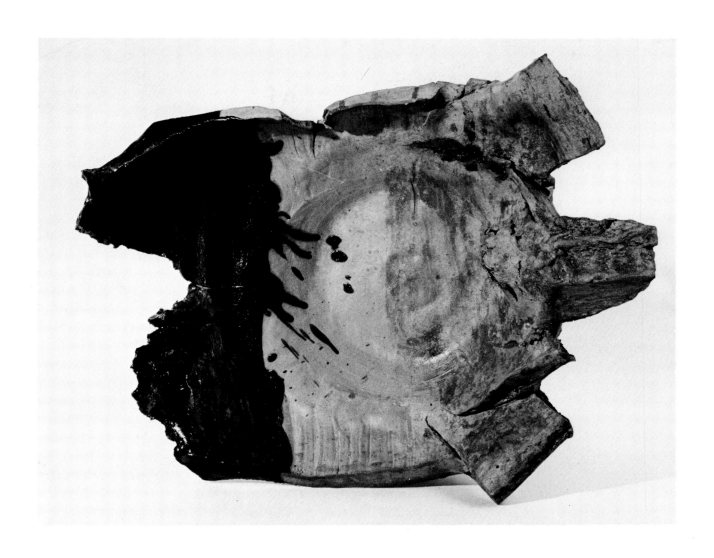

60. Turtle bowl, 1963
Made in Berkeley; stoneware, wheel-thrown and slab construction; colemanite
wash and turquoise glaze; 18¼ inches in diameter. (Collection of Baltimore
Museum of Art)

THE DEMONSTRATION

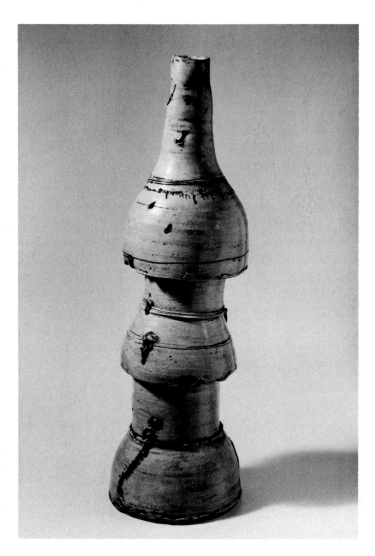

61. Vase, 1973
Made in Berkeley; wheel-thrown in four sections
with pass-throughs and sgraffito; low-fired, with
blue and pink glazes; 42 inches high. (Collection
of Mr. and Mrs. Erle Loran. Photographer:
Joseph Schopplein)

fingers and palms, smoothing wheel marks, poking from the inside and out, fingering, gouging, tearing, slicing, gently touching and smoothing all the time. Sometimes using a wooden paddle to get an eccentric tilt to the form here and there. Pushing fingers, especially that long curved thumb, to leave the imprint and shape at the base where it is grounded, as if he were thumbing gravity.

The plates are made by basically the same process. He turns the clay until he gets the rhythm and speed he needs, trimming and shaping with rib and smoothing with wet palms, paying a great deal of attention to edges, crusty and torn, as if a volcanic gas had hissed through, erupting and cracking the surface. To make the foot he turns the huge disc over with a quick flip, like a short-order cook turning a huge pancake. He starts the wheel in motion and with his blade cuts out the center, leaving the rim of the foot, which he trims with his

PETER VOULKOS

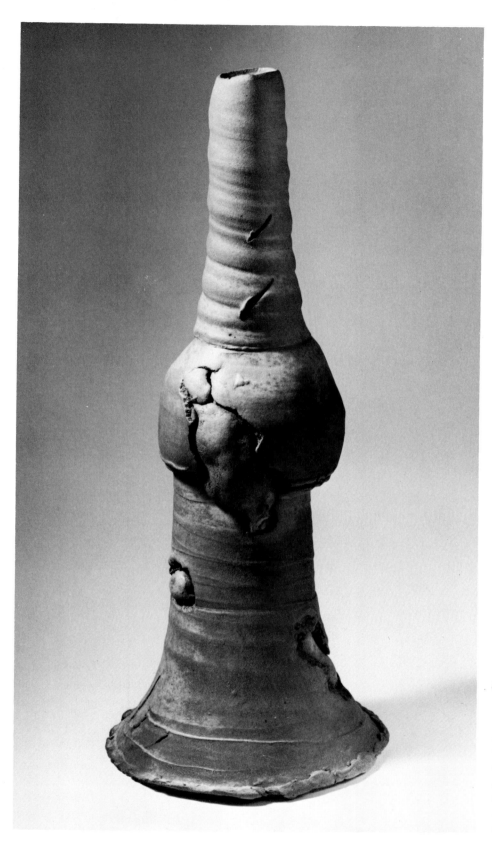

62. Vase, 1977
Made in Berkeley; stoneware with "patches" of clay and/or porcelain, wheel-thrown in three sections; iron wash lightly sprayed with clear glaze; 40 inches high. (Collection of Mr. and Mrs. Louis Honig. Photographer: Joseph Schopplein)

THE DEMONSTRATION

63. Plate, Plate #1, 1962
Made at Greenwich House, New York; stoneware, wheel-thrown; colemanite wash at left, contrasting clay pass-through at right, and natural glaze over entire plate; 9 inches in diameter. This plate was a seminal piece, precursor of those of ten years later. It was exhibited at the twenty-second Ceramic National in Syracuse. (Collection of Everson Museum of Art, Syracuse)

PETER VOULKOS

64. Plate, 1976
Made in Berkeley; wheel-thrown, slashes, holes, and porcelain pass-throughs;
21 inches in diameter. (Collection of Peter Voulkos. Photographer: J. P. Oren)

THE DEMONSTRATION

wooden spatula, shapes and smooths with fingers, palms, and wet sponge, turning constantly. "I got a sweat in my eye. That means it's about done. I got some leftover holes. Anybody want an extra hole?"

Between the large plates and stacked forms, he will throw a cup, cutting it off the wheel; he pats it, rubs it inside with his fingers, indents it here and there with his thumb, bends the lip here and there, carves and models the foot, agitates and caresses the surface leaving the unmistakable Voulkos imprint.

Rudy Autio said, "He has an unfailing aesthetic." One is never more conscious of this than when watching him work, as if he were incapable of making a wrong move, like an athlete at absolute peak, playing a winning championship game but acting all the time as if he were about to make a mistake, as if he were not sure, as if he were a reluctant witness to his own mastery.

"I like to work it around all sides. Maybe I overdid it because you were watching. When that fires, though, it will change the surface a little." He stands there, bowed legs apart, hands on hips of the wide pelvis, powerful shoulders always a little rounded as if he never quite straightens from hunching over the wheel, examining the work of the last two days. "Sure looks weird, strange"—he laughs softly.

5. Non-Technique Technique: The Way of Work

65. (overleaf) Plate, 1963
Made in Berkeley; stoneware, wheel-thrown, cut and slab construction; splashes of colemanite glaze and brushed dark-brown epoxy; 22 inches in diameter. This was one of the series of deliberately cracked plates, glued with epoxy. The crack and joinery are integral to Voulkos's articulation of the clay. He fragments the rim, giving it a fin or winglike character. (Collection of Lois Ladas. Photographer: Joseph Schopplein)

Aside from the sheer dynamics of his own creative presence, Voulkos's great contribution to modern ceramics is his "non-technique" technique. Whereas previously the ceramics medium had been too precious, or too humble, or too industrial, too laden with technical no-no's and virtuoso traps to encourage artistic freedom, the daring Voulkos challenged the medium to creative adventure. He trusted the material and what it would do and his own intuitive power with it; he committed himself to the energy that grew from this interaction.

From the time he saw clay on the huge tires of a lumber truck in Bozeman and tracked it down to Bear Canyon and Trail Creek, where he went to dig it up, refine it, and work it, to the time he went to work in Archie Bray's brickyard, mixing clay, making, firing, and salt-glazing the brick, to his arrival in Los Angeles, where he stunned the Alfred-trained potters by throwing over the rules and simplifying the mixtures, using only two types of clay (formula: 50 percent ball clay, 50 percent fire clay; 25 percent (of preceding) 30-mesh sand, 1 percent iron)—clay had become second nature to him.

Susan Peterson, an Alfred-trained potter teaching at Chouinard in 1954, says:

We were taught that the more variety you put into the clay, the more homogeneous and workable it would become. We mixed and measured and measured and mixed. So Pete says, the hell with that! Two grades of material together with some sand and some grog is enough. He wanted high workability and lamination to hold up the big pieces he was developing at the time. It worked. Those grains would laminate the fine clay particles perfectly. His clay body was as simple as you could make it and it turned out to be great. It wasn't a textbook clay body and it wasn't industrially approved. It was an innovative clay body for the innovative work he wanted to do.

There was no one around in Pete's class as a thrower. The only ones I know of who throw that big are some of the folk potters of Japan, who still make three- and four-foot rice-storage jars, and the jug makers of Appalachia, who used to make three- and four-foot crocks to brew corn liquor in the stills. It's learnable, but not everybody can learn it.

Voulkos at the wheel has the look of the pyramid with the sphere. He stands with legs apart, firmly planted, pelvis taut, a pyramid towering over the turning wheel. His body takes its particular stance to gear for the action, much as a baseball player prepares to swing the bat or a tennis player the racket. As Voulkos admits when he is being serious, "The whole thing is yourself and the clay in balance. If you're not balanced, it's a strain. It's all centering." Shoulder, neck, head, back, arm, and leg muscles are totally involved. The form grows naturally under Voulkos's touch and timing. He does not have to rework and rehash. When Voulkos pulls the clay, the form is there, as if his

NON-TECHNIQUE TECHNIQUE: THE WAY OF WORK

fingers had breathed the form, effortlessly. His coordination, his insight into his material, his ideas, his aesthetic restlessness and daring make him a unique artist—a synthesis of feeling, intellect, and muscle makes for the ideal union of Beauty and the Beast.

His early functional pieces—jars, bowls, vases, casseroles—have a "zing," a perfection of form, a classicism, that is an inevitable reminder of Voulkos's Greek heritage. They have a deep, lush, velvety surface that is the result of another of Voulkos's individual techniques. Brushing on color from slips and oxides, as a painter, he worked the surface under and over a matte glaze, laid on as a translucent shield and emphasis for the painting, not as a slick surface. Voulkos has always treated his ceramic surfaces as drawing and painting, also in keeping with the great tradition of Greek vase painting. "Clay with a lot of water in it or slip acts very much like oil paint and applies almost like it, put on with a spatula."

Voulkos's pursuits have been consistent and his conclusions always in the interests of simplification and clarity of purpose and medium. From 1949, when he was using elaborate wax-resist techniques to scratch his line into the clay and lay colored slips into the line, to today, he continues to draw by incising the clay. He has emboldened the scratch with the crack and the pass-through, the line with the slash. His palette, always limited, he has further simplified and reduced to the natural hues of the fired clay body and the most economical, occasional use of slips. His wary attitude toward glaze has not changed, the only modification being that he uses glaze even less now.

Voulkos's basic clay vocabulary is the cylinder, the dome or sphere, the disc or plate, and the slab. He will stack and join these in various combinations and sizes, or use them singly. These decisions he makes as he goes along, right on the spot, as he is making the piece. He does not plan or design in advance. He keeps his elements basic and achieves endless variety in form and surface within that simplicity. He is not a modeler or a carver. He is a thrower, and he limits his clay forms to those the wheel will spin and his hand or mallet can pound or press out. There is no sculptor working today who keeps to a more sparse formal inventory and whose methods are simpler.

In producing his monumental cast bronzes his methods are similar. He will cast the basic shapes—elbows of various sizes, spheres, cubes—during a production cycle of casting. The metal tubes or cylinders and sheets he buys ready-made from industrial sources. Everything is stockpiled on huge storage shelves in the studio until he is ready to compose the sculpture, which he assembles, welding as he goes.

The larger the starting mound of clay, the softer it has to be, and,

PETER VOULKOS

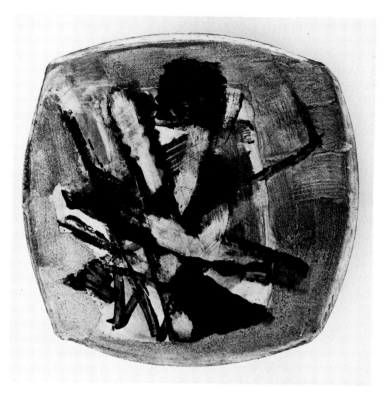

66. Plate, 1957
Made in Los Angeles; stoneware, wheel-thrown and cut; brushed cobalt and black slips over white sand slip; 17 inches in diameter. Voulkos was using similar colors and sand textures in his paintings on canvas at this time. He considers plates to be small paintings on clay. (Collection of Fred Marer. Photographer: Frank J. Thomas)

therefore, the more water it contains. Knowing when the formed clay has dried enough—cured to just the right leathery consistency and hard so it does not collapse but is still malleable, able to withstand more handling and the weight of more clay forms—is crucial to the way Voulkos works. If the clay is too soft it may collapse under his tough handling; if it is too hard and dry, he will lose control, it will become brittle, show breaks instead of gouges, show a burred line instead of a clean incision. "You just keep feeling it," says Voulkos. "It's a sensitivity that becomes a part of you. The clay gets a peculiar satiny, smooth quality. As the moisture goes away the real wet look goes, and then the sort of wet, and then the drier wet, and then the leathery look—those are all visual stages but they're each a degree apart. You have to learn to see as well as feel—to know the right moment for getting the right crack at the right time, the way it will rag at the edge." There is no way to reintroduce the moisture content into the formed clay body. Wetting the surface will allow only the surface to be worked, and the Voulkos way is to work and penetrate the entire clay substance. The surface and the form, the inside and the outside, the body and the soul, the mind and the matter, the spirit and the substance, the line, the shadow of the line, the clay on and into which it is made, the space around the line and inside and outside the clay

wall, the grains that make up the body of the clay and the water in the clay—they are all one in a Voulkos construction and are the subject of his art. This unity, this belonging together, the interaction of the thing with itself and with its medium—clay and water and air and man—is central to Voulkos's art.

Always alert to the innovations and methods of industry, early in 1955 Voulkos introduced the use of large humidifiers, like those used in fruit-packing plants, to control the moisture content and to keep his clay forms from drying out while he continued to throw enough forms to begin the assembling process. "Industry spends millions a year on technology. It's information. I spend a lot of my time driving around the industrial section finding out things," says Voulkos.

Voulkos entered the ceramics field at a time when it was new; there was a fresh interest in it as a creative medium and everyone was learning. Heretofore it had been used within limited circles to produce dinnerware or for industrial purposes. Technical know-how and experience were at a premium. As Voulkos began to push at the limits of clay, beyond the mugs and plates and pots, he had to learn and invent the technology that would allow the freedom and the scale in which he wished to work. Along with other potters in the Los Angeles area, he attended the monthly meetings of the ceramics engineers. There he met engineer Mike Kalan, of the Advance Kiln Company, who built Voulkos's high-fire reduction kilns. Kalan had already built two kilns at Chouinard, the first high-fire reduction kilns west of Ohio, firing up to 2,300 degrees. For Voulkos and the Los Angeles County Art Institute he built similar kilns that would accommodate pieces as large as six feet tall.

Voulkos obviously has great respect for clay technology and techniques, but he does not make a fetish of them and is willing to use anything, to borrow from other disciplines to get the results he wants.

Discussing Voulkos's methods in 1954 Rudy Autio says:

Pete's resourcefulness is everywhere evident in his workshop. All sorts of shortcuts are taken whenever practicable: sandpaper for smoothing, a stick with nails for scratching textures, throwing many pieces from a single lump of clay, electric wheels for large pots, mixing clay in half-ton batches, voluminous quantities of glaze, roto-tools, dentists' amalgams—any means to an end is all right if properly used. When trimming or turning the feet on some of his gigantic bottles (a seemingly impossible task to most potters), he uses a large sewer pipe as a turning chuck and sets his bottle in it for shaping. This results in a towering, turning structure at least four feet tall, which means that he has to stand on a stool to work on it.

While still at Bozeman, he was fond of utilizing the red clay and "trail

creek glaze" found near the town, and much of his earlier work is characterized by these materials. Pete now thinks that digging clay is nonsense if it is cheaper and more practical to buy it. The same is true of glazes. Earth or slip glazes are all right to use but their virtue is not in the fact that they are earth glazes. In contrast to Pete are the purists who dig and refine their clay, fire with wood, insist on using the most primitive of equipment, and perhaps spend so much time grubbing the earth they have little to show for their effort. On the other hand, all of the niceties of ceramic equipment such as high-fire reduction kilns and spray equipment, do not furnish the easy means to fine pottery. A good potter can make good pottery under the most limited circumstances; some of Pete's finest work has been done using low-fire kilns and other meager equipment. . . .

Pete disagrees with the interior decorators and other customers who have made lamp bases out of his rice bottles. It is singularly disturbing to him when others fail to see the simple, decorative purpose of pottery. Since potters cannot compete with the large volume of technically flawless factory

67. Vase, 1963
Made in Berkeley; stoneware, wheel-thrown, carved and slab construction, sliced foot; black epoxy paint, white slip; 8 inches high. Blowup in kiln produced crusty rim and surface. (Collection of National Museum of Modern Art, Kyoto, Japan)

NON-TECHNIQUE TECHNIQUE: THE WAY OF WORK

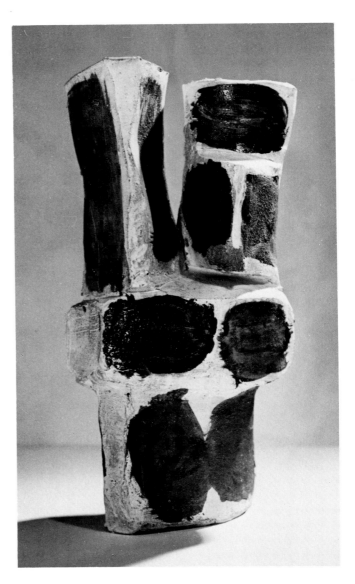

68. Double-neck vase, 1959
Made in Berkeley; stoneware, four wheel-thrown,
ribbed, and joined elements; white slip painted with
black iron and cobalt slips; 19 inches high. (Collec-
tion of Ted Weiner. Photographer: Elna Wilkenson)

ware, they must concentrate on each piece as a work of art, perhaps even sacrificing its functional purpose for its decorative one. And although Pete makes many useful pieces (bowls, cups, teapots, urns, wine sets, compotes, coffee pots, salad sets, tureens, etc.), each piece is conceived as a new and different art object. If it is a vase or bottle and prospective customers ask, "What shall I use it for?" Pete usually says, "To look at."

At a time when potters were making a religion of glazes and their mysteries, straining to rediscover ancient Oriental effects and other brilliant tours de force, Voulkos in 1958 introduced the use of epoxy paints to get the color he wanted. "You need red and you get red. It doesn't turn out green," he says, referring to the uncertain color effects of firing glazes. In addition, he relies on slips with oxides to get the

PETER VOULKOS

colors he wants—blue, black, brown and white being his favorites—firing his pieces first to stoneware, then painting with slips and refiring at a low temperature to maintain the color, since high temperature will burn them out. He frequently combines more somber color from slips with the brilliant epoxy colors.

During a discussion about the teaching practices at a certain school he was told that the students there had compiled an unbelievably large number of glaze tests, totaling thousands. "Sounds good," he remarked, "but I wonder if they'll ever get around to making the pots to put them on."

He also does not hesitate to use epoxy glue in those forms where cracks are openly encouraged and are part of the actual "decoration," such as his 1960–1964 series of cracked plates and bowls. "I can't make a bowl without a crack. All my ice buckets are cracked. I got a lot of plates that I glue back. I like that line."

From *Love Is a Many Splendored Thing* in 1955 to *Gallas Rock* in 1961, Peter Voulkos produced more than five thousand unique pieces in the form of plates "for people who don't like soup," "ice buckets," bowls "to put your old socks in"; over two hundred pot forms, not over four feet high; and seventeen major sculptures five to eight feet high.

Voulkos's productivity has rarely been equaled in quantity, quality, or diversity. In 1949 he won his first prize at the Everson Museum, Syracuse, Ceramics National Exhibition for bowls he decorated with wax inlaid line drawings, adapting the wax-resist technique heretofore used primarily for textile design—it was one of his early innovations in ceramics for which he became known. Rudy Autio describes Voulkos using wax resist:

Sitting in the midst of half a dozen of these giants [pieces he has thrown], a pot of red iron, a pot of blue slip, a jar of liquid wax, and a few brushes, nails and pear-pitters, he begins to decorate. If he is making a line drawing, he may brush in briefly large shapes with wax and scratch the design into the clay with a nail; then spinning the pot on the wheel and holding a brush dripping with red iron against it, he makes line, color, and pattern appear instantly and spectacularly in the areas not painted with wax.

Decorating with brushwork directly, he may use two or three colored slips or wax, relying merely on his superb dexterity with the Chinese brush to design the pot. His slip trailing is as decisive and sure as his line drawing, practiced so many times and done so quickly it seems effortless. Pressed down with the thumb, it sometimes becomes a thick flat line, sometimes a thin thread.

NON-TECHNIQUE TECHNIQUE: THE WAY OF WORK

During the next three years, from 1949 to 1952, he continued to learn his craft at Montana State University, California College of Arts and Crafts, and Archie Bray's brickyard in Helena—by throwing classical forms day and night. Since there was not much actual work to see in Montana at the time, information about what other ceramists were doing came to him largely through reproductions in magazines. He says, "Being as dumb as I was when I started—you have to remember I didn't see anything up there in Montana where I was at the time; there was *nothing* there except reproductions when they did come in, and there wasn't much of that either—I just assumed they had to be a certain way. And then I found out they could be any way. Any way I wanted—as long as I could make it work." He tells of seeing some Swedish pots enlarged in *Craft Horizons*, and thinking they were three feet tall, struggling to attain that scale. Years later he saw the actual pots, which turned out to be more like six inches tall. "What a shock," says Voulkos. By then, however, he had mastered the handling and throwing of massive quantities of clay.

Of this period Voulkos says:

Throwing became an intuitive thing. I could do it and read a newspaper at the same time. I did it until I became so facile it didn't have any meaning. You can't go on repeating. We're not an age of potters like the Greeks. The community doesn't need us. It's the responsibility of industry to do repetitive production. I know I can do it. No problem. That was the trouble. I made so many different kinds of things, a lot of pottery. Tons. Thousands. Individual and production. You can throw faster than you can keep up with. I could throw enough one day to keep me busy the next day—trimming, drying, decorating, setting the kiln, firing. Two hours' throwing time every day and I'd have so much it wasn't easy to keep up with. I was doing pretty controlled stuff, wax-resist inlays. Even the production stuff, there were certain patterns I liked to work out. I could be making a good living right now, if I'd have stuck with it. But now my intellect demands something in addition to this primitive energy in pottery. Primitive is the intuitive approach, the tactile approach. I decided that this wasn't all I was after.

His ideas came from both traditional and contemporary pottery, ranging from ancient Sung, Korean, American Indian, and Greek to contemporary Swedish and Japanese ceramics. No era passed without value in it for his work, and no art or craft, whether carpentry, weaving, plumbing, painting or sculpture, has been ignored. Voulkos learned and still learns from everything. Rudy Autio says that while visiting the livestock show in Great Falls, Pete was impressed by an enormous Black Angus bull. This impression may have coincided with a keen interest in the drawings of bulls by Picasso; in any case, bulls began to appear on his pots. Among his other motifs were abstract

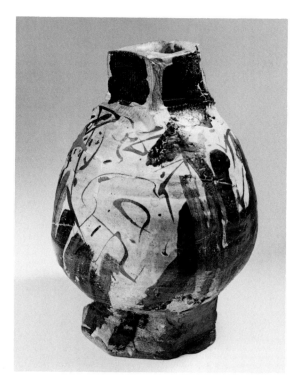

69. Pot, 1958
Made in Los Angeles; stoneware, wheel-thrown and carved construction; white slip painted with red iron slip and black glaze; 21 inches high. (Collection of Margaret Voulkos. Photographer: Joseph Schopplein)

flowers and leaves, faces, chickens, and a delicate reindeer in simple brushwork, which, for a while, practically became a trademark.

He was very much influenced by what he saw in reproductions of Picasso and Miró. Of Picasso he says,

I didn't like his pots but I liked the way he did them. I liked his attitude. I was not influenced by Picasso in a direct way. I admired the fact that he did what he wanted to do, what he thought was right. Looking at Picasso's painting and ceramics, I became interested in the powers of color on three-dimensional form and how to destroy a form using color. This hadn't occurred to me before. Miró and Artigas had a lot of technical things they were doing on clay and material that I hadn't seen before. They were making their own rocks, slip trailing on surfaces, very beautiful.

In the early fifties, I started to break the classical form and invent on it; some were good and some bad. Mostly bad. I broke almost all of two years' work into shards. They lacked the virtue of the classical pot and the spiritual inventiveness of a new form. I saved just a few pieces.

In 1953, influenced by Matisse's cutouts, he began to experiment with building the surfaces of his pots with stencil techniques, another innovation. Cutting patterns out of heavy blotting paper, he soaked them in water and brushed cobalt slip onto the edges. First laying a coat of white slip on the surface of the pot, he applied the wet slip-edged stencils and then another coat of white slip over the entire pot, producing a thin relief of about one thirty-secondth of an inch around

NON-TECHNIQUE TECHNIQUE: THE WAY OF WORK

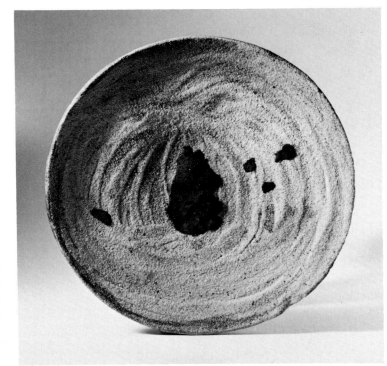

70. Plate, 1958
Made in Los Angeles; stoneware, heavy white
sand slip fired to bisque, rust scales exposed
to surface; similar to bird plate (Plate 2);
10 inches in diameter. (Collection of Frances
Senska and Jessie Wilber. Photographer:
Joseph Schopplein)

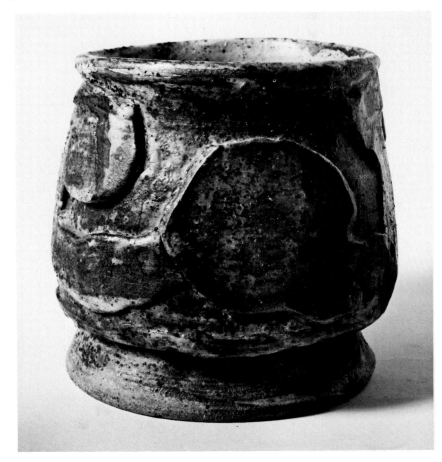

71. Bowl, 1956
Made in Los Angeles; stoneware,
wheel-thrown with slab cutouts
applied to surface; iron slip and
thin coat of natural glaze; 6¼
inches high. (Collection of Stephen
D. Paine. Photographer: Barney
Burstein)

PETER VOULKOS

Plate 17. Plate, 1959
Made at Greenwich House, New York. Stoneware, wheel-thrown with cracks glued with epoxy and breaks filled with contrasting clay; cobalt slip splash; 17 inches in diameter. (Collection of Oakland Museum. Photographer: Frank J. Thomas)

Plate 18. Painting, Untitled, *1958*
Made in Los Angeles; vinyl-based paint with sand; overlayers of various colored lacquers; 71½ inches square. (Collection of Peter Voulkos. Photographer: Joseph Schopplein)

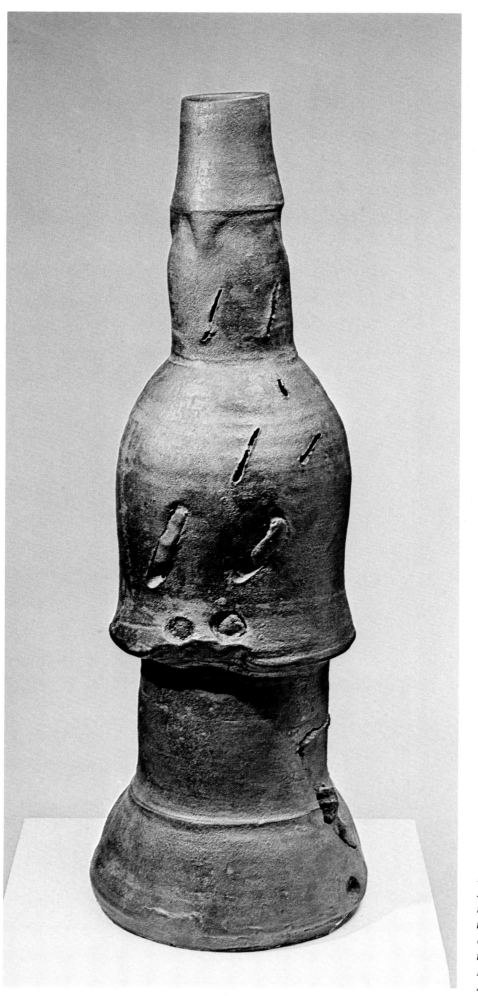

Plate 19. Vase, Anada, 1968
Made in Berkeley; stoneware, wheel-thrown in three sections, with pass-throughs; black iron slip and light clear glaze; 40 inches high. (Collection of San Francisco Museum of Modern Art. Photographer: Joseph Schopplein)

Plate 20. Vase, 1959
*Made at Montana State University; stoneware, wheel-thrown and paddled; white
slip and blue glaze brush painting on black iron slip; 24 inches high. Blackish-
gray epoxy was used on the right side for black-on-black painting. This piece is
notable for its bold brushwork. (Collection of James Galanos. Photographer:
Frank J. Thomas)*

Plate 21. Vase, 1962
Made at Greenwich House, New York; stoneware, wheel-thrown in three parts,
gouged and slashed; iron slip, thinly sprayed with clear glaze; 28 inches high.
(Collection of David Stuart. Photographer: Frank J. Thomas)

Plate 22. Plate, 1975
Made in Berkeley; stoneware and porcelain with pass-throughs; lightly sprayed glaze; 18 inches diameter. (Collection of Peter Voulkos. Photographer: J. P. Oren)

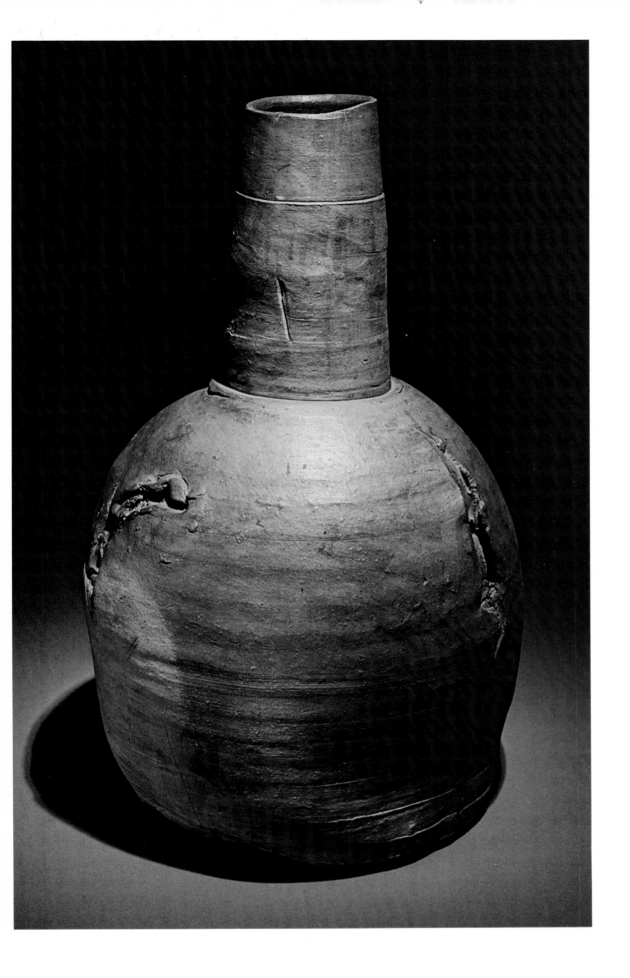

Plate 23. Vase, 1973
Made in Berkeley; wheel-thrown with pass-throughs, fired to cone 5; fire flash,
clear glaze thinly sprayed; 30 inches high. (Collection of Peter Voulkos. Photog-
rapher: J. P. Oren)

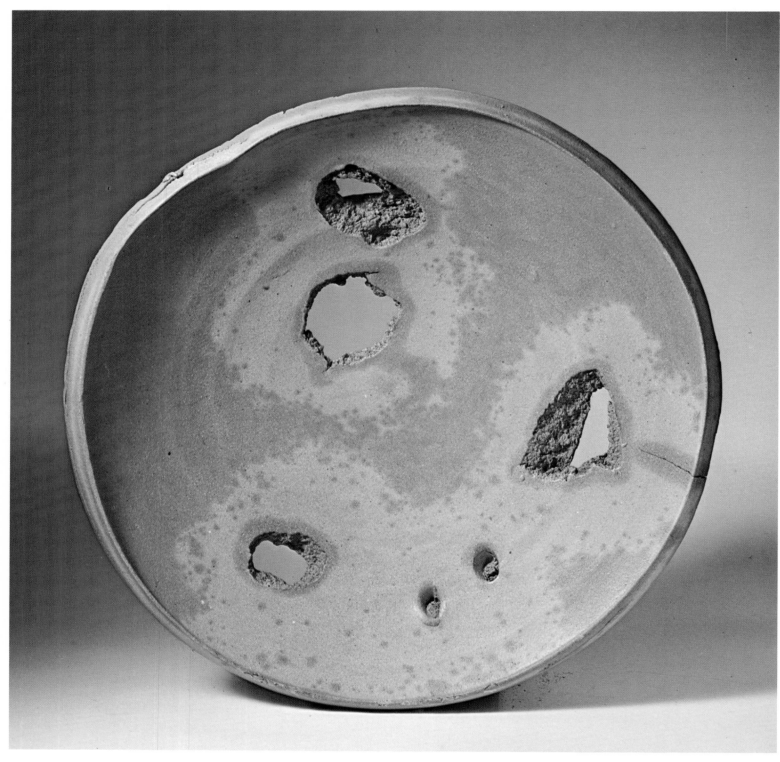

Plate 24. Plate, 1975
*Made in Berkeley; stoneware with pass-throughs; lightly sprayed glaze; 18 inches
in diameter. (Collection of Rose Slivka. Photographer: J. P. Oren)*

the indented patterns after he had peeled off the stencils. The outlines of the stencils were further enhanced by the bleeding of the cobalt color off the edges into the white slip. He then applied a thin glaze before firing.

In 1954, working further in the spirit of collage, he began to add other elements to his pots. He replaced the inlaid stencil with overlays of thin slabs of cut-out clay, joining them directly to the pot surface with slips. He added sand and rusted iron.

"I like to pick up what's around and use it on the pot, like using leftover strips. It's a beginning. It's like tools. If you don't have the one you want, you use what's there."

In 1955 he began to give his vessels challenging combinations of form and bolder brushwork, to realize the freedoms inspired by the abstract expressionists—to declare openly that the rebellion in ceramics was under way, to push pottery form into sculptural space. That was the year he was the only American to win a gold medal at the International Exposition of Ceramics at Cannes, France. But it was for some of his older work, of elegant classical form and superb wax-resist brushwork.

By 1956 he was adding manipulated slabs to thrown elements, building each on the other. Although some of his pot-sculpture themes in 1956 and 1957 were figurative, he soon discarded any reference to the figure (sarcastically downing it, "Don't give *me* any of that organic vitality"), stressing the absoluteness of his formal means—the cylinder, the sphere, the disc, the slab—and the complete and pure nature of those forms. "The form of pottery is its own thing. What I do with that form is mine."

He also continued to paint on canvas and on his thrown clay plates with slips and glazes and began to use color on pot forms to set tensions between form and color, rather than to emphasize and decorate the form, the traditional approach to painting on pottery.

As he reached for larger and larger scale, in 1957 and 1958 he began to experiment with the thrown forms as volumes to be balanced and cantilevered on a basic cylinder skeleton, paddling them to change and vary shape, and building them around the central core. These developed into the series of massive, voluptuous sculptures—perhaps the largest enclosed, self-contained, in-the-round ceramic works to be done in our time. All elements of the enclosed sculpture series were basic pot forms produced in basic wheel-thrown techniques. The individual parts and the way they were joined dictated the final consolidated form. The engineering of the support system of these ceramic constructions was in itself amazing. Using a series of inner cylinders to

72. Sculpture, Soleares
(also known as Rex
Rock), 1958
Made in Los Angeles; stone-
ware, wheel-thrown and
paddled parts assembled
in a bulbous, self-enclosed,
and monolithic-appearing
construction around a
central cylinder; this cylin-
der serves as an armature
and at the same time is an
integral part of the sculpture.
Covered with black iron slip
and lightly glazed; 68 inches
high. In Soleares, Voulkos
began to achieve the monu-
mentality he had been work-
ing for in ceramic sculpture.
This piece took over five
days to fire; the one that
preceded it had blown up in
the kiln. (Collection of
University of California,
Los Angeles. Donated by
John Rex)

PETER VOULKOS

support the outer forms, working the inside and the outside simultaneously with the leather-hard technology, he managed to build huge clusters of bulbous forms, each piling on itself, sometimes reaching out, miraculously holding on. There were many times when the ballooning shapes collapsed, caved in, toppled over. Voulkos had to work rapidly on both inner and outer structures simultaneously, since if one part dried out before the other they would not adhere properly. But he piled them up as far as he could make them go, just short of falling down.

All of them were painted with black iron slip and a thin wash of glaze. "I always thought black was beautiful," says Voulkos. There are no transitional elements in the thrown forms that make the composite sculptures. They are directly and abruptly joined to each other in different directions, groupings, and volumes. The sculptures are monolithic, massive, earthbound, the bulging volumes charged with pulsating energy, bellying, swelling, cleaving. They are full of dark mystery, like ponderous ancient beasts, silent and brooding in still timelessness.

The huge sculptures were fired to stoneware in his studio on Glendale Boulevard. Several blew up in the kiln. It was a herculean task. The fact that he made twelve in a year and a half in 1958 and 1959,

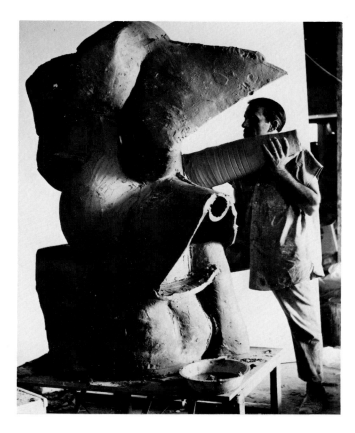

73. Voulkos working on a sculpture in 1960

NON-TECHNIQUE TECHNIQUE: THE WAY OF WORK

74. Sculpture, Little Big Horn, *1958
Made in Los Angeles; wheel-thrown, paddled and
slab construction; brushed with black, white,
and cobalt slips, sprayed with clear glaze; fluted
somewhat like piecrust along edges to emphasize
joinery; 62 inches high. (Collection of
Oakland Museum)*

before he began to break the cylinder open as he did with *Camelback
Mountain,* is amazing. In ceramic sculpture, as in his pots, he worked
rapidly through a series. This series, done largely in 1958, included
*5000 Feet, Burnt Smog, Flying Black, Rasgeado, Black Butte-Divide,
Soleares, Black Bulerias, Little Big Horn.*

There were three directions Voulkos explored in the large sculp-
tures within the three-year period from 1958 to 1961: One was the
piling-up/balancing of basic cylinder parts to create a churning, turn-
ing mass of bulging volumes that swallowed as much dark space inside
itself as it consumed and occupied outside. A second was the setting
up of contradictions of color and form to create new form, a dialogue,
a kind of yin and yang between color and form. (*Rondena* is the out-
standing example of this series, which also included works done in
1960, such as *Red River* and *USA 41.*)

PETER VOULKOS

75. *Sculpture,* Sitting Bull, *1959*
Made in Los Angeles; stoneware, wheel-thrown and paddled shapes assembled around the core of a central cylinder; iron, cobalt, and white slips, thin natural glaze; 69 inches high. (Collection of Santa Barbara Museum of Art, bequest of Hans G. M. Schulthess. Photographer: Karl Obert)

NON-TECHNIQUE TECHNIQUE: THE WAY OF WORK

76. Sculpture, 1959 Made in Berkeley; stoneware, wheel-thrown with over 60 elements; wood at bottom painted with epoxy; saturated iron slip with thin spray of clear glaze; 60 inches high. (Collection of Patricia and Philip Hack. Photographer: Joseph Schopplein)

PETER VOULKOS

"I brush color on to violate the form," he told me in 1959, "and it comes out a complete new thing which involves a painting concept on a three-dimensional surface, a new idea. These things are exploding, jumping off. I wanted to pick up that energy. That's different from decorating. Decorating enhances form, heightens the surface. I wanted to change the form, get more excitement going. The tall black one with the bulging feeling [later known as *Little Big Horn*] is bursting out through the skin. Why should I paint it? The forms are doing what I want them to do. You can afford to handle clay in different ways. It can become hard or soft. It is inherently so plastic. You have a lot of rope to hang yourself with."

The third direction was in the gouging out of volumes, in tearing them open so inside and outside were visible—surface and inner structure, skin and skeleton, were one. The pieces made in this mode in 1959 are precursers, in Voulkos's treatment of the clay wall, to the pot sculptures and plates that followed. After *Camelback Mountain*, the large sculpture series included *Sevillanos*, *Sitting Bull*, and *Gallas Rock*.

Julie Gallas Gillian tells the story of the commission:

My husband, Dr. Gallas, and I first met Peter Voulkos on the construction site of our new Gregory Ain house in 1959.

"I heard you thought my sculptures were too small," said Pete, looking amused. He was about to move out of the East Los Angeles studio he shared with John Mason to go to Cal Berkeley to teach. Dr. Gallas and I had been sent over there in a hurry by Ed Primus to look at three stoneware sculptures which must have weighed five hundred pounds apiece.

"They are too small for *this space*," I said, pointing at Gregory Ain's looming two-story wall on the north side of what was going to be the garden.

Pete gave the huge wall a casual glance. "I can make you something for there," he said. "But I don't think you want it by the window. You don't want it staring through the window at you all the time. It'd drive you nuts."

"No, I want it by the windows," I said. "It won't drive *me* nuts."

Both Greek men, Voulkos and Gallas, nodded reluctantly. Greeks know better than to argue with a pregnant woman.

We gave Pete two hundred dollars for clay and didn't see him, or the sculpture, until two years later, several days after his opening at the Primus-Stuart Gallery on La Cienega Boulevard.

Some intuition warned me that it would be unwise to attend the opening. How right I was.

When Digby Gallas (born Ysideros Exeinogallas) first looked at rough, craggy, two-ton, six-and-a-half-foot-tall *Gallas Rock*, he turned pale. His normally cheerful round face settled into lines of deep disappointment. The shapes of the three sculptures we had seen three years before at the Mason-Voulkos studio had been much closer to the classic Greek vase forms. They had also been glazed with a fairly heavy iron oxide solution that makes ceramic sculpture look like classic dark bronze. *Gallas Rock* had been fin-

NON-TECHNIQUE TECHNIQUE: THE WAY OF WORK

77. *Sculpture*, Gallas
Rock, *1959–1961*
See also Figure 78 and
Plate 9

PETER VOULKOS

ished with a very light iron-oxide solution that allowed hints of the natural clay color to show through. It had the look and feel of the granite boulders left by glaciers in the New England states.

Nobody could call *Gallas Rock* classical. It was, and still is, a huge primitive stony fetish to be placed in a high mountain meadow, and daubed with the blood of sacrificial oxen once a year to make crops grow, herds increase, and women have many children.

My husband, a Praxiteles fan, was deeply disturbed by all this. However, some things are better left unsaid. I squeezed his arm tightly and said something inane like, "Isn't it going to look stunning out in the garden?"

Dr. Gallas sighed, nodded, and managed a faint smile. He thought, no doubt, that since *Gallas Rock* would be outside the windows, he could always draw the curtains if its gaze became too much to bear.

Gallas Rock does seem to have a Caliban-like head and a many-eyed flat-face—like an old god. However, I have always felt that its aura is benign and guardianlike; the six-foot-tall Nootka Indian welcoming figures inspire similar positive feelings in me.

The negative feelings of my husband were resolved after *Gallas Rock* had been upon its three-foot pedestal in our garden for six months. He confessed to me as we were sitting at lunch one day that he had thought Pete's sculpture was the ugliest object he had ever seen in his whole fifty-three years, when he first set eyes on it at the Primus-Stuart Gallery.

"The UGLIEST?" I said incredulously. "The ugliest," he said.

The zeal of the convert always outstrips the zeal of the original believer. *Gallas Rock* inspired him to become interested in all sorts of new things, such as African primitive sculptures. A swift glance at examples of his very competent amateur photography over the years shows a startling change and broadening of his world. The 1950 photographs are of rather expected usual sights such as Buckingham Palace; the 1960s rolls of film show unusual shots of the oldest stone column on the temple at Olympia, and an Anthony Caro sculpture at Battersea Park. Before Voulkos he would not have even considered Caro's work worth photographing.

The last seven years of my husband's life were, I think, much more exciting, a time of much greater discovery, than any period before. Aestheticians have said that one definition of a great work of art is that it changes the viewers in some way.

If this is so, the *Gallas Rock* is certainly a great work of art, at least as far as it affected the man it was named for.

In 1954, Dr. Gallas decided to join an experimental Peace Corps project to send doctors and their wives and children to India for two years. Our Voulkos went to the Los Angeles County Museum on extended loan, and several other pieces of sculpture, primitive and modern, went to other museums.

Family health problems forced us to come back home after only a year in India; and two months after our return, Digby Gallas died of a coronary occlusion.

Shortly after his death I gave our Voulkos sculpture to the Franklin Murphy Sculpture Garden at the University of California at Los Angeles.

There were several reasons for this. The beauty and careful planning of the Murphy garden was an obvious factor in my decision. Also, the relative fragility of the material of which *Gallas Rock* was constructed, clay stone-

78. Sculpture, Gallas Rock, *1959–1961*
(detail)
See also Figure 77 and Plate 9

ware, made any more travels of the piece (whether from home to museum, or home to home) very unwise. Then, too, the ceramics department of UCLA was the place where Digby Gallas and I had first started studying clay—working with Bernard Kester.

We went on to study with several ceramists at the University of Southern California. This study made me and my husband too able to appreciate *Gallas Rock* as a technical tour de force as well as an artistic vision.

It is heartbreaking work, this building out of clay—earth. People speak of Mother Earth. Mother Earth can be kind and nurturing. But she can be tricky and treacherous. There are all kinds of hazards that can beset the artist during the building process.

Unexpected changes in the temperature or humidity of the studio can ruin weeks, maybe months, of work on a large clay sculpture. The sculpture may come out of the first drying stage intact, only to crack, split, or even explode in the final high firing when the water molecule is driven out forever and the hollow stoneware form becomes capable of holding a measure of water.

Gallas Rock, however—an outdoor sculpture—is not designed to hold water. In fact, quite the contrary. There is never any problem of trapped water in the shapes of this sculpture. Two towhees once built a nest in one of the upper portions of the *Gallas Rock* and successfully raised a family.

PETER VOULKOS

I doubt if any birds are ever allowed to build nests in *Gallas Rock* at UCLA.

Although Voulkos began working in bronze around 1961, he continued to produce smaller ceramics in the various clay workshops he gave. In the series of smaller plates, cups, bowls, and vases made during this extremely productive period, many when he was teaching at New York City's famous Greenwich House Pottery and Columbia University during the summers from 1960 through 1964, the cracks and fissures are openly encouraged as integral to his aesthetic with clay.

Bronze, however, was the focus of Voulkos's attention in the 1960s until 1967, when he returned from a five-week stay in Italy and felt the need to touch clay before turning to his commissioned bronzes. He produced a magnificent series of monumental single pots and plates—simple, stately black pots and plates, pierced, patched, and cracked.

In 1968 his show of massive black pots and plates at the Quay Gallery in San Francisco was received with joy from the clay world, which had begun to think Voulkos had abandoned the medium since his last clay show in 1964 at the Hansen-Fuller Gallery.

In 1972 he began to experiment with the basic disc, having been commissioned by the Johnson Wax Company through its art representative, Lee Nordness, to do an edition of two hundred plates. When the company withdrew from the project for business reasons, Voulkos was already so involved and intrigued by the challenge that he continued—and produced a series of plates that are among the most significant ceramic breakthroughs in our time.

In the edition of some two hundred plates Voulkos has turned out since 1972, he combines the properties and rhythms of clay with the action of the knife and the touch of the hand as the pen and the brush. He uses the concave plate as the body for clay drawing. Fingering, scoring, slitting, tearing, puncturing, gouging, making holes—passthroughs—and jagged edges within the perfectly thrown disc, he is drawing on/in/out the clay, drawing the clay, and claying the drawing with all the delicacy, power, speed, spontaneity, and consummate craftsmanship with which we identify his work. The plates are all stoneware, about nineteen to twenty-four inches in diameter, frequently with the holes and slashes plugged with white porcelain. A dark blue-black glaze underscores Voulkos's tracks, while the rest of the matte surface has rich, varying cream-to-brick coloration and connotation.

Again Voulkos has surprised us with a new art form. The plate has undergone the full metamorphosis—it has become sculpture-draw-

NON-TECHNIQUE TECHNIQUE: THE WAY OF WORK

121

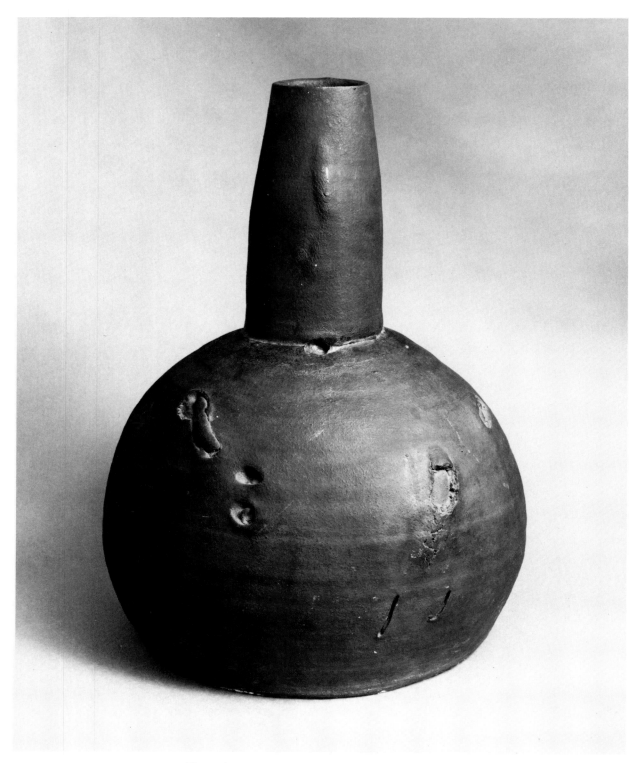

79. Vase, Aratsa, 1968
Made in Berkeley; stoneware, wheel-thrown with pass-throughs; black iron slip,
thinly sprayed with clear glaze; 28 inches high. (Collection of Herbert F. Johnson
Museum of Art, Cornell University, Ithaca. Photographer: Bobby Hanson)

PETER VOULKOS

ing. He has penetrated the plane of the plate as if it were a sheet of paper; light and space breathe through ragged crusted edges—we see through them to the next person, wall, object. Or he introduces porcelain for emphasis and contradiction—to fill up the holes, give them another weight, another white, another light. Air and porcelain, by contrast, evoke each other, set each other off, fulfill the same dimensional and volumetric function.

Voulkos has an unfailing touch, full of intuitive power; he *feels* his way as he makes his way—the high and risky art of imperfection.

The phenomenon of Peter Voulkos could have taken place in no other country in the world. He is truly an American artist. Taking their cue from Voulkos, clay artists in the United States are an irreverent crew and are not afraid to try anything. But it was the ceramists of his generation who made the first reconnaissance into all the possibilities of clay as a creative medium, pushing clay into new forms, new ideas, new areas of personal handling.

In the work of younger artists, the Voulkos influence is there in spirit, in attitude rather than in style and handling. While his own works are large, with a direct feeling of the clay, their pieces are fre-

80. Bowl, 1972
Made in Berkeley; stoneware, wheel-thrown, with porcelain pass-throughs; iron slip and clear glaze; 6 inches high. (Collection of Efrosine Voulkos. Photographer: Joseph Schopplein)

NON-TECHNIQUE TECHNIQUE: THE WAY OF WORK

*81. Bowl, 1969
Made in Berkeley; stone-
ware; manganese and cobalt
glazes over white slip; 6
inches high. (Collection of
John Voulkos. Photog-
rapher: Joseph Schopplein)*

quently small in size, with the clay subordinated to the demands of an objective imagery.

In the last fifteen years, the swing from abstract expressionist ceramics to object ceramics to funk ceramics to sanitary ceramics to fun-in-the-graveyard and in-the-bed ceramics to relic- and souvenir-making has encompassed such subjects as aesthetics and anti-aesthetics and violence and sex and politics and ecology and meditation and dissolution and ethics and big things made small and small things made big—and most of all, everything made human and with a history of action and use, past and future—the heritage of humanism constantly made fresh and essential and persistently moral. It underscores and continues the basic Voulkos message: not to make important things for the unimportant sake of being important, to desanctify, to be not reverential but at the same time to give value. In object, its mood and conceptual range runs from sheer corn to buffoonery to scourging wit to sad clowning to intelligent and elegant wryness. In fact, if there is any

PETER VOULKOS

one single element or direction one could point to in the dissident, diverse works of the sixties and seventies, it is the Voulkos humor and antiseriousness with profoundly serious purpose.

Essentially the younger artists make hybrid forms still involved with painting and drawing as surface values. The forms, wheel-thrown, slab-built, made from molds, or a combination of these elements (frequently taken from actual objects), then receive surface treatment of glazes and underglazes, paints of all kinds, including china paints and acrylics. And the technical skills of the clay alchemists are formidable. They can make clay look like fur or paper or wood or butter or diamonds or ice—concrete metaphors encased in meanings and opposites of the ceramic poetry.

Of himself and his own future development, Voulkos says: "I'm still screwing around trying to make the greatest pot in the world. When I start doing a demonstration, I start making a little bowl, a little cup. I'm just going backwards trying to find that little cup again. *The* cup . . ."

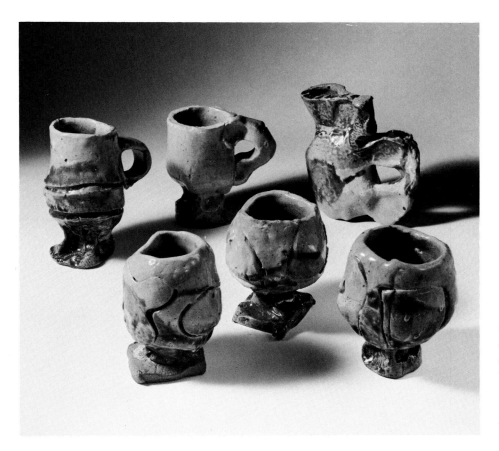

*82. Cups, 1961
Made at Greenwich House,
New York; stoneware,
wheel-thrown, celadon and
copper glaze; about 3
inches high. (Collection of
Margaret Voulkos. Photographer: Joseph Schopplein)*

NON-TECHNIQUE TECHNIQUE: THE WAY OF WORK

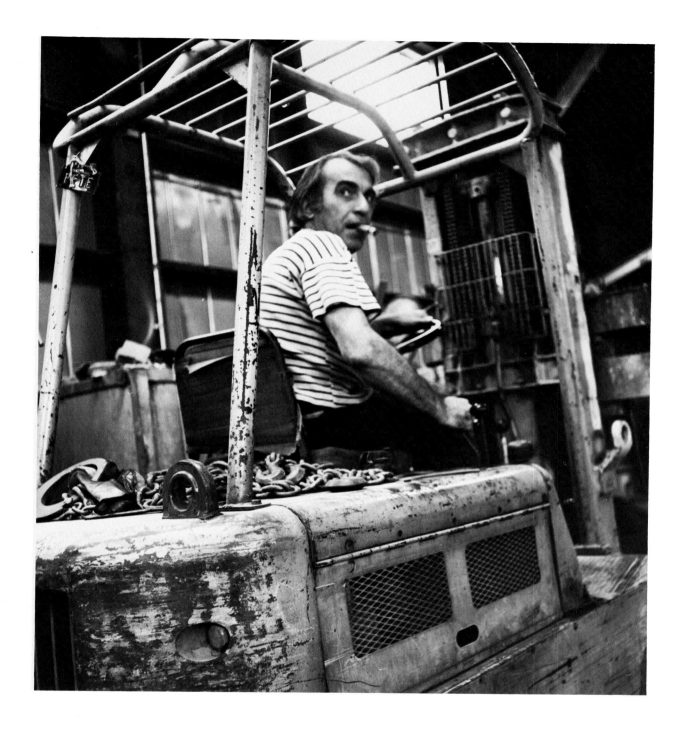

A Taped
Conversation

Peter Voulkos, Fred Marer, and Rose Slivka

83. (*overleaf*) *In studio in Berkeley*
Voulkos hoists, lifts, and travels with his forklift. (Photographer: Roger Gass)

SLIVKA: Fred, we heard about you back East. We heard that you were an eccentric, shy professor of mathematics with a love for ceramics. You were at that time [in the fifties] just about the only person we knew of who was buying contemporary American clay. How did you happen to start collecting ceramics?

MARER: It was all I could afford.

SLIVKA: How did you and Pete meet?

MARER: I went to a show at Otis in 1955. I don't remember whether it was a faculty show or a faculty-student show. I saw a little blue bottle by Pete and wrote him a note asking where I could buy it. He hadn't put a price on it. He didn't expect to sell.

VOULKOS: Never thought of pricing anything in those days.

MARER: He sent a note, "Sure, come on over," and when I got there it had been stolen.

VOULKOS: It was in fact the faculty show. I remember I had some new things and Millard Sheets came around and said, "You cannot put those in the show."

MARER: There was a lot of talking while you all worked in that basement. That was part of the scene too. The kids appreciated the arguments, and I remember you once saying that you would be worried if you got too popular. You had too big a following, you said. You were getting worried about it. So I'm asking you, are you worried?

VOULKOS: Well, there was a lot of feedback there . . . looking at it now. But I had no intentions of really doing anything, you know, besides working and teaching and enjoying the give-and-take. But it just turned out that way, I guess—even feeding back to Japan, which is sort of strange. It completely defies the tradition there. Actually what tradition we had here at that time was certainly not in the kind of thing I was after. Our tradition is still no tradition, but it's beginning to get a little traditional by now. I go up to school [University of California at Berkeley] now and I see four generations of students later. Those students' students' students' students are now teachers . . . it keeps coming around. There's quite a lot of interesting work, you know. Certainly it still has that intimate quality that clay has always been disposed to.

MARER: Well, that's what I like about it. And I resent very much this snobbish attitude toward clay. When it's made with clay, it isn't considered art. It's hard to understand, because clay has such immediacy. Watching Pete struggle with those big things he used to make during that period—it was such a direct struggle, just he and the clay.

VOULKOS: That's why I like a lot of David Smith's things, because I

can actually see a struggle in there. I see a lot of work today that's just laid out, and I feel that they're just designing.

SLIVKA: Well, it isn't that anything is ever that new. Maybe all the news is in the particular person. The temperament, ability, and energy that Pete put into the clay is so totally a personal quality.

VOULKOS: It's very tricky, a very intimate thing. It's very limited, you know, and you have to be able almost to talk to it. I hate to get romantic about it.

SLIVKA: What do you think were the particular conditions and circumstances in the fifties here that made for the same fantastic energy taking place in New York? It was very similar—happening around a particular group of people at a particular time—in a relatively small place. Here in Los Angeles in clay, and in painting, in New York.

VOULKOS: At the Cedar Bar, the Artists Club—that tremendous energy. It was all there. You went to the bar every night. It was fantastic; they were all there. It happened at that one time, you know. It's never been like that since.

MARER: Pete has to take the credit for what happened here. He was the catalyst—the original energy.

VOULKOS: Well, I just happened to be here, really. I happened to go to New York a couple of times—none of my students except McLain had been there yet. I picked up on that energy I saw there. It rubbed off on me. It was fantastic for me at that time. I was just ready to sop it up.

SLIVKA: But Pete, you never stayed there except for a few weeks at a time. You could never have done in New York what you did here.

MARER: I believe that to be true, too. Part of the reason is the physical setup.

VOULKOS: In those days there weren't many schools even offering ceramics. Working in clay was just sort of an adjunct to casting in bronze. But since then all these new schools have come up, and they all have ceramics departments and they have glass departments; they even have them in the high schools now. When I went to school they had a little tiny shop in the basement. It was a really primitive setup, sort of tacked on; if you were going to teach you had to take all these courses, a little of this and a little of that, and you had to take this clay course. But now, you know, it's a big thing. They have huge departments and new labs.

SLIVKA: What turns you on these days?

VOULKOS: Me? What turns me on? . . . besides alcohol and dope, you mean . . . not too much. I wouldn't say that right now there is any art that really turns me on. I find my energies now in other areas that are a lot more interesting to me. That is, besides working on my own things.

PETER VOULKOS

130

The things I am working on now are very quiet, very subdued. Like what I do with the plates, but the plates are very strong. I think they're the best ones I've ever done but it has taken a lot of working, you know, just making plates. I've made five hundred plates or so. I'm trying to get a couple of hundred really good ones out of all those plates. I still haven't got that. But I get turned on by a lot of other things besides art.

MARER: [Laughs] . . . real estate.

VOULKOS: Real estate [laughs] and things like that. Well, I meet interesting people and I'm out hustling around, doing different trips. Like tomorrow, I've got a big trip coming up. I'm hauling some steel. It doesn't sound very interesting, but it is to me.

MARER: That means you have a lot of steel coming in? Does that mean you're going back to metal sculpture?

VOULKOS: Well, if you're in clay so long, you actually feel like going back to making big sculpture, you know. Actually, right now, after working in clay over two years, I feel like I want to go back and do some metal sculpture. So I want to start a big piece quite soon. If you had told me that six months ago, I'd have said, "No, I don't even want to try." I wasn't turned on to it. I'm getting on to it now. Right now I have enough bronze and stuff to last for about three great big sculptures, so I'd like to get them together.

MARER: You have the parts for three.

VOULKOS: My parts, sometimes, after a while, become obsolete and I have to remelt them, but these are still viable. They're like found objects; they're still sitting there. After some years, I do remelt them. These are still at that point where they make sense—others I've discarded. You know, I get very demanding on that sort of precision. A certain edge has to be just like that, and if it's different, it's no good, you know.

SLIVKA: Is it because you're not interested in solutions? You don't start with a solution, you start with a problem, with a struggle.

VOULKOS: I like to make problems. Take David Smith—you can see the man just worked his ass off. He did these things with a fast, intense pouring of energy.

SLIVKA: To him, the problem was worth the art—not the solution.

VOULKOS: Sure, he goes out on a limb, he always did. Some of them were successful and a lot weren't. It certainly beats a lot of the stuff I see now. You know, so many squares on the floor, and then another so many squares. What the hell is all that? I mean, what risk is there? What is the risk?

A TAPED CONVERSATION

SLIVKA: Maybe the risk is in the risklessness and how far can you push it.

VOULKOS: How far can you push bullshit! Smith always worked with his hands a lot. His sensibilities always came out of working with his hands, and he was involved with it all the way, and he solved technical problems along the way. He had a lot to do with a lot of the stuff. I see the stuff that comes out of Lippincott and all those places—there's nothing there. The workers are doing the work—they're having the fun. I can't understand what the hell the artist does. He makes a model of something and they just blow the goddamn thing up. Well, I mean I have to be sitting on it and grinding it, and I have to get involved in the sounds. Making sculpture to me is going with it all the way. Just looking at the final thing is nothing—it's absolutely nothing. You know, you're just looking at an object. I'm involved in all that stuff in between—that's important. If you don't see that in-between stuff day in and day out, well, hell, you're just making a product. That's shit. In standing up with the sculpture—that's keeping my head going all this time, all this time. Who needs it anyway? Hell, you can get your kicks a lot of different ways. You don't have to look at art. There's a lot of things wilder than art. But you have to start *doing* something, using your body, doing something. You can't just sit there looking at things. You have to be turned on in some way, respond to some other kind of information. It comes into you and you gotta make yourself open to feedback. That's what I do now. It could be through real estate, it could be through a lot of things like working solid plumbing problems and things like that which I have to do. Like, how do you get shit to go down to a sewer?

MARER: How many people back East who are well-known artists could handle plumbing problems?

SLIVKA: [indignantly] A lot of people. Everybody struggles with plumbing problems. You think it's a special California virtue, like oranges.

VOULKOS: Well, I am very conscious of plumbing, especially when it's exposed. I know the codes by now—you know, that's an A code, that's a B code, stuff like this. I'm sitting there in somebody's toilet and I start checking the plumbing. I found out that shit travels downhill at the rate of one foot every four minutes. That's how fast it has to travel. You're just part of the dirt down the shit chute. I've talked to plumbers about that; they get all involved in it and they go on and on about it. I got this plumber you wouldn't believe. I can't stand to be around him because he just sits there and talks and talks about this stuff for hours and hours. And all this time I'm thinking are we going

to get the plumbing in? You know, all the money it's costing and I don't see the shit chute in. You run into all this kind of information—and the same with electricians. I've learned about electricity and it's interesting stuff, what it does and how you break it down, things like that. It's not directly connected to what you're doing, but it does feed back simply because it keeps your mind going and you're just not bogged down with your own dumb little trip all the time. It's really fantastic—you go into the building when they're putting all these things in. Visually it's exciting to see the pipes, all the space before they put up the walls and stuff. All the pipes are coming down through it and just visually, spatially, if you put your head onto it long enough, it's very exciting before you realize it's a building and the best part is going to be covered up, of course. You know, I saw [so-and-so] putting that piece up in the San Francisco Museum—they worked up there for about a week or so putting up the structure before they put the plywood on it. All the framework and stuff of this thing going up looked like a huge dinosaur skeleton—two-by-fours—that's where all the thing lives, and they covered it all with plywood.

SLIVKA: He hides the carpentry so they won't confuse it with art.

VOULKOS: You know he's afraid to let it show. He's afraid of, maybe, being accused of being a craftsman. Because to artists that's always a dirty word. To me it's great. It depends on who's saying it, too. "You're a good craftsman but you're no artist." What the hell is that supposed to mean? A good artist is a good craftsman.

SLIVKA: Have you ever considered making small sculpture?

VOULKOS: My dealer always says, "Make some small sculpture, like that little piece you made." I say, "That's a model—I'm not going to sit there and make models for you." Sure, I can make ten proposed models, have them in his gallery. He sells the models. What the hell is that? They are not sculptures because they are meant to be in a different scale. Sometimes I'm forced to make two models because of the size of the job, the politics involved, timing, money, but they're certainly not sculptures. They sit nice on the mantle and all that, but I couldn't sit there and make a bunch of those things. It's a struggle to make the maquette anyway and then I've got to see it big. I'm not going to sit there and make ten maquettes. I could sell them in a gallery, which a lot of dealers would just love. I can't do it. A model is a model, a maquette is a maquette, and as soon as I make it, then I want to start making it large. Actually, I know how it'll go together. If I have to redo the whole thing, it becomes very costly that way, which is all right if I can hack it. If the risk says it might become a better piece, that's great. I dig changing it just for a complete head trip, you know. You

have to have this different kind of head trip. It's beautiful because it never falls together the same way anyway. I like the changing and sometimes to just completely annihilate it, just completely make a new piece. Actually, that's where you discover the new stuff, in between, that in-between when you're fucking up out here. You stick your neck out and once that's all resolved in your head, that's a beautiful thing. Pottery is much the same way, but the risk is more subtle—very subtle—should that hole be there or should it be over here?—is that glaze going to make it when it comes out?—and lots of times it doesn't, so you have to break it. You do something important and then the kiln takes over.

SLIVKA: The clay is not worth as much as metal—you can always break it up and make it over. You're not that self-conscious. You're freer. The pressures are not that hard.

VOULKOS: Yeah, there's a lot of difference between clay and a five-hundred-pound casting. My ideas, you know, still come from feeding back on the clay when I first touched it, and everything that happened between then and now.

PETER VOULKOS

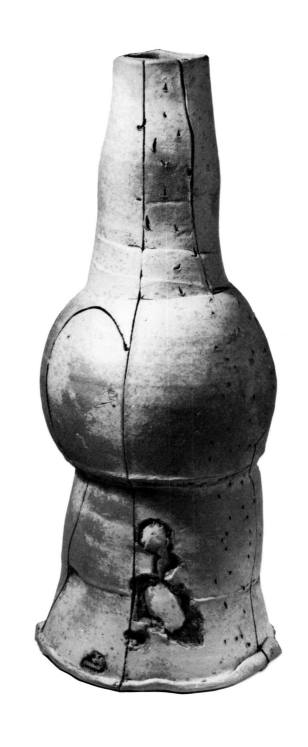

An Excerpt from
The New Ceramic Presence
Bibliography

84. (overleaf) Vase, 1977
Made in Berkeley; wheel-thrown in three sections; stoneware with pass-throughs,
zits, and sgraffito; cobalt is rubbed into lines and clear glaze sprayed over the
pot; 40 inches high. (Collection of Mr. and Mrs. Louis Honig. Photographer:
Joseph Schopplein)

An Excerpt from The New Ceramic Presence

In the past, pottery form, limited and predetermined by function, with a few outstanding exceptions, has served the freer expressive interests of surface. Today, the classical form has been subjected and even discarded in the interests of surface—an energetic, baroque clay surface with itself the formal "canvas." The paint, the "canvas" and the structure of the "canvas" are a unity of clay. . . .

Form and surface are used to oppose each other rather than complement each other in their traditional harmonious relationship—with color breaking into and defining, creating, destroying form. This has led the potter into pushing the limits of painting on the pot into new areas of plastic expression: sculptured painting, with the painted surface in control of the form. The potter manipulates the clay itself as if it were paint—he slashes, drips, scrubs down or builds up for expressive forms and textures. Or around the basic hollow core he creates a continuum of surface planes on which to paint. In so doing, he creates a sculptural entity whose form he then obliterates with the painting. This, in turn, sets up new tensions between forms and paint. It is a reversal of the three-dimensional form painted in two. Now the two-dimensional is expressed in three—on a multiplaned, sculptured "canvas." As a result, modern ceramic expression ranges in variety from painted pottery to potted painting to sculptured painting to painted sculpture to potted sculpture to sculptured pottery. And often the distinctions are very thin or nonexistent.

The current pull of potters into sculpture—in every material and method, including welded metals, cast bronze, plaster, wood, plastics, etc.—is a phenomenon of the last five years. So great a catalyst has been American painting that the odyssey from surface to form has been made through its power. Manipulating form as far as it could go to project the excitement of surface values, the potters found even the slightest concession to function too limiting. From painter-potters, they were impelled to become painter-sculptors. Instead of form serving function, it now serves to develop the possibilities of the new painting. However, while this painting generates the creation of forms for itself—often massive in scale—it tolerates the dominance of no presence other than itself. In his new idea of a formal synthesis, the potter is inevitably pushing into space—into the direction of sculpture.

As a fusion between the two-dimensional and the three-dimen-

sional, American pottery is realizing itself as a distinct art form. In developing its own hybrid expression, it is like a barometer of our esthetic situation.

(Reprinted from *Craft Horizons*, July/August 1961)

PETER VOULKOS

1952

Exhibitions, *Crafts Horizons,* January 1952, p. 6, ill.
Exhibitions, *Craft Horizons,* October 1952, p. 46.
Exhibitions, *Crafts Horizons,* December 1952, p. 47.

1953

Stevenson, Branson G. "Craftsman's World, Clays and Glazes of Montana," *Craft Horizons,*
 February 1953, p. 42.
Exhibitions, *Craft Horizons,* April 1953, p. 43.
Craftsmen's Calendar, *Craft Horizons,* June 1953, p. 5.
Craftsman's World, *Craft Horizons,* June 1953, p. 47.
Craftsmen's Calendar, *Craft Horizons,* August 1953, p. 4.
Craftsman's World, *Craft Horizons,* August 1953, p. 49.
"Designer Craftsmen USA," *Craft Horizons,* December 1953, p. 17.

1954

Exhibitions, *Craft Horizons,* October 1954, p. 43.
Exhibitions, *Craft Horizons,* December 1954, p. 42.
Autio, Rudy. *Montana Institution of the Arts Quarterly,* Fall 1954.

1955

Exhibitions, *Craft Horizons,* January/February 1955, p. 46.
Bulletins, "Craftsman's Index," *Craft Horizons,* May/June 1955, p. 44.
Exhibitions, *Craft Horizons,* July/August 1955, p. 45.
Mailliard, Dominique. "The International Exposition of Ceramics at Cannes," *Craft
 Horizons,* September/October 1955, p. 11.
"Gold Medals: Voulkos (USA)," *Craft Horizons,* September/October 1955, p. 15.

1956

Petterson, Richard. "Ceramic Textures," *Craft Horizons,* March/April 1956, p. 24.
"The Trials of Jurying," *Craft Horizons,* March/April 1956, p. 30, ill. p. 34.
Exhibitions, *Craft Horizons,* May/June 1956, p. 46, ill. p. 47.
Bulletins, *Craft Horizons,* July/August 1956, p. 52.
Brown, Conrad. "Peter Voulkos, Southern California's Top Potter," *Craft Horizons,* Septem-
 ber/October 1956, pp. 12–18, ill.

1957

"Sticks and Chunks of Stone," *Craft Horizons,* May/June 1957, p. 4.

1959

"Work at the Pasadena Art Museum," *Craft Horizons,* January/February 1959, p. 42.
Langsner, Jules. "Art News from Los Angeles: Voulkos, Strombotne," *Art News,* February
 1959, p. 49.
Felix Landau Gallery, Los Angeles. *Peter Voulkos: Sculpture, Painting, Ceramics,* May 4–
 May 23, 1959 (exhibition catalogue).
"New Talent 1959, Sculpture," *Art in America,* Spring 1959, pp. 36–37 (illustrations:
 Soleares; Funiculation Smog).

1960

"Exhibition at the Museum of Modern Art's Penthouse," *Craft Horizons,* January/February
 1960, p. 47.
Museum of Modern Art, New York. *Sculpture and Paintings by Peter Voulkos,* New Talent
 in the Penthouse, February 1–March 13, 1960 (exhibition catalogue).
Ashton, Dore. "New Talent Exhibition at the Museum of Modern Art," *Craft Horizons,*
 March/April 1960, p. 42 (illustrations: *Tientos; Falling Red).*
Dennison, George. "In the Galleries: Peter Voulkos" (exhibition at Museum of Modern
 Art), *Arts,* March 1960, p. 61.

Ashton, Dore. "Art," *Arts and Architecture*, April 1960, pp. 7–8 (review of Museum of Modern Art exhibition).

"Ceramic Sculpture at the Museum of Modern Art," *Arts and Architecture*, April 1960, p. 8.

Drew, R. "Dimensions 1960; Exhibition at the New Mexico Highlands University Art Gallery, Las Vegas," *Craft Horizons*, November/December 1960, p. 44.

1961

Wurdemann, H. "Los Angeles—Poet in Paint," *Art in America*, 1961, p. 136.

Slivka, Rose. "The New Ceramic Presence," *Craft Horizons*, July/August 1961, p. 31.

1962

Langsner, Jules. "Abstract Sculptures at the Primus-Stuart Galleries in Los Angeles," *Craft Horizons*, January/February 1962, pp. 39–40.

"Art News from Los Angeles," *Art News*, January 1962, p. 52 (illustration: *Lady Remington*).

San Francisco Museum of Art. *Molten Image, 7 Sculptors*, June 9–July 8, 1962 (illustration: *Big Remington*).

Polley, E. M. "San Francisco," *Artforum*, August 1962, p. 34 (review of exhibition *Molten Image*; illustration: *Vargas*).

"Gallas Rock," *Artforum*, September 1962, p. 26.

"Blumenfeld Gallery Shows Significant Works of Artist-Craftsman," *Interiors*, November 1962, p.148.

Reed, Gervais. "Adventures in Art," *Craft Horizons*, November/December 1962, p. 40.

Art Gallery, State University of Iowa. *Clay Today*. Introduction by Abner Jonas.

1963

Coplans, John. "Notes from San Francisco," *Art International*, May 25, 1963, pp. 73–74.

Magloff, Joanna. "Reviews: 82nd Annual Exhibition of the San Francisco Art Institute," *Artforum*, May 1963, p. 11.

Leider, Philip. "West Coast Art: Three Images," *Artforum*, June 1963, pp. 21–25.

"California Sculpture Today," *Artforum*, August 1963 (special issue); note especially the following articles:

 John Coplans. "Sculptures in California," pp. 3–6.

 Joanna Magloff. "Peter Voulkos," p. 29.

 Joseph A. Pugliese. "Casting in the Bay Area," pp. 11–14.

 John Reuschel. "32 Americans, I Gallery, LaJolla," p. 17.

"The Clay Movement," *Time*, August 23, 1963, p. 51.

Coplans, John. "Notes from San Francisco," *Art International*, October 25, 1963, pp. 91–94 (Voulkos: p. 93).

Ventura, Anita. "Field Day for Sculptors: The Kaiser Center Roof Garden in Oakland." *Arts*, October 1963, pp. 62–63 (illustration: *Sevillanos*).

Coplans, John. "Out of Clay; West Coast Ceramic Sculpture Emerges as a Strong Regional Trend," *Art in America*, December 1963, p. 40.

1964

Magloff, Joanna. "California Sculpture at the Oakland Museum," *Art News*, January 1964, p. 51.

Reuschel, John. "Fourth Annual of California Painting and Sculpture," *Artforum*, January 1964, p. 43.

Magloff, Joanna. "Al Proom, Peter Voulkos, Sam Tchakalian, Art Unlimited," *Artforum*, February 1964, p. 45.

Pyron, Bernard. "The Tao and Dada of Recent American Ceramic Art," *Artforum*, March 1964, pp. 41–42 (illustration: *Sacred Matador*, p. 43, fig. 10).

Coplans, John. "Circle of Styles on the West Coast," *Art in America*, June 1964, p. 31 (illustration: *Red River*).

Fuller, M. "San Francisco Sculptors," *Art in America*, June 1964, p. 58.

"Fifty-six Painters and Sculptors," *Art in America*, August 1964, pp. 72–73.

1965

Hess, Thomas B. "The Disrespectful Handmaiden," *Art News*, January 1965, pp. 38–39, 57–58, ill.

Coplans, John. "Los Angeles: the Scene," *Art News*, March 1965, p. 57.

Coplans, John. "Peter Voulkos," *Art News*, April 1965.

Marmer, Nancy. "Peter Voulkos," *Artforum*, June 1965, pp. 9–11, ill.

Coplans, John. "Voulkos: Redemption through Ceramics," *Art News*, Summer 1965, pp. 38–39, 64-65, ill.

"Peter Voulkos Sculpture," Los Angeles County Museum of Art *Catalog*.

1966

"West Coast Ceramics—a Taped Conversation between Peter Voulkos and Paul Soldner," *Craft Horizons*, June 1966.

"Old Crafts Find New Hands," *Life*, July 29, 1966, pp. 34–43, ill.

Giambruni, Helen. "Abstract Expressionist Ceramics," *Craft Horizons*, November/December 1966.

Coplans, John. "Abstract Expressionist Ceramics," *Catalogue*, University of California, Irvine.

1967

Livingston, Jane. "Los Angeles," *Artforum*, September 1967, p. 61, ill.

1968

Melchert, James. "Peter Voulkos: a Return to Pottery," *Craft Horizons*, September/October 1968.

1969

Selz, Peter, and Richardson, Brenda. "California Ceramics," *Art in America*, May 1969, pp. 104–5, ill.

1970

Albright, Thomas. "Voulkos, Oakland Sculpture—Almighty Mister Ishi," *San Francisco Chronicle*, March 12, 1970, ill.

Ashbery, John. "Johnson Collection at Cranbrook," *Craft Horizons*, March/April 1970.

McCann, Cecile N. "Voulkos Bronze," *Artweek*, March 21, 1970, p. 1, ill.

Art and Architecture, "Mister Ishi: Cast Bronze Sculpture for the Oakland Museum" (ill. only) *Craft Horizons*, May/June 1970, p. 5.

1971

" 'Abomination' say San Fran Police of Voulkos Sculpture for Hall of Justice," The Craftsman's World, *Craft Horizons*, October 1971, p. 3.

1972

Carroll, Nancy. "A Conversation with Voulkos," *North Shore Art League News*, Winnetka, Ill., March 1972, pp. 4–6, ill.

Shorr, Mimi. "A Survey of Crafts Today," *American Artist*, April 1972, pp. 21–25, 78–80.

Foley, Suzanne. "A Decade of Ceramic Art 1962–1972. From the Collection of Professor and Mrs. R. Joseph Monsen," *Catalogue*, San Francisco Museum of Modern Art.

Nordland, Gerald. "Peter Voulkos, Bronze Sculpture," *Catalogue*, San Francisco Museum of Modern Art.

1973

Pugliese, Joseph. "The Decade: Ceramics," *Craft Horizons*, February 1973, p. 50.

Leopold, Michael. "Los Angeles Letter," *Art International*, Summer 1973, pp. 86–87.

Hamilton, David. "Fine Art Ceramics," *Studio*, November 1973, p. 192.

Tarskis, Jerome. "Letter from San Francisco," *Studio*, November 1973, p. 192.

Ratcliff, Carter. "Peter Voulkos," *The Britannica Encyclopedia of American Art*, p. 579.

1974

Kester, Bernard. "Los Angeles" Exhibition Review, *Craft Horizons*, April 1974, p. 46.

O'Doherty, Brian. "Public Art and the Government: a Progress Report," *Art in America*, May 1974, pp. 44–49, ill. p. 49.

SELECTED BIBLIOGRAPHY

Melchert, James, and Soldner, Paul. "Fred Marer and the Clay People," *Craft Horizons*, June 1974.

Slivka, Rose. "The New Clay Drawings of Peter Voulkos," *Craft Horizons*, October 1974.

1975

Craft World, "Pyroman and Gorilla Cavort in Clay Circus," *Craft Horizons*, August 1975, p. 6.

1976

North, Charles. "Review of Exhibitions: Voulkos and Tchakalian at Braunstein/Quay," *Art in America*, January 1976, p. 99, ill.

Wooster, Ann-Sargent. "Peter Voulkos, New York, Preview," *Artforum*, February 1976, p. 60.

"A Voulkos Workshop," *Ceramics Monthly*, February 1976, pp. 27–33.

Craft World, "Portlands First Gallery Grows," *Craft Horizons*, February 1976, p. 6.

Craft World, "Wanted: Voulkos" (ill. only), *Craft Horizons*, April 1976, p. 6.

Cermactivities: "Voulkos at Exhibit A," *Ceramics Monthly*, April 1976, p. 83.

Ballatore, Sandy. "The California Clay Rush," *Art in America*, July–August 1976, p. 84.

1977

Craft World, "Supermen Throw Supermud," *Craft Horizons*, February 1977, p. 8.

Hall, Julie. *Tradition and Change* (New York: E. P. Dutton), p. 78.